LANDSCAPE INTO ART

OTHER WORKS BY KENNETH CLARK

THE GOTHIC REVIVAL

LEONARDO DA VINCI

LEONARDO DA VINCI DRAWINGS AT WINDSOR CASTLE

THE NUDE

LOOKING AT PICTURES

RUSKIN TODAY

REMBRANDT AND
THE ITALIAN RENAISSANCE

CIVILISATION

THE ROMANTIC REBELLION

HENRY MOORE DRAWINGS

ANOTHER PART OF THE WOOD

HARPER & ROW, PUBLISHERS New York, Hagerstown, San Francisco, London First published 1949 © New Edition, Kenneth Clark, 1976

All rights reserved. Printed in Great Britain.

No part of this book may be used or reproduced in any manner whatsoever without written permission except in the case of brief quotations embodied in critical articles and reviews. For information address Harper & Row,

Publishers, Inc., 10 East 53rd Street, New York, N.Y. 10022.

FIRST U.S. EDITION

ISBN: 0-06-010781-2

LIBRARY OF CONGRESS CATALOG CARD NUMBER: 75-23876

TO MAURICE BOWRA

CONTENTS

Introduction viii

Illustrations xi

I The Landscape of Symbols 1

II The Landscape of Fact 33

III Landscape of Fantasy 73

IV Ideal Landscape 109

V The Natural Vision 147

VI The Northern Lights 181

VII The Return to Order 205

Epilogue 229

Index 242

INTRODUCTION

The chapters which follow are based on lectures given during my first year as Slade Professor to the University of Oxford. The Slade professorship is a peculiar institution, very different in intention from the professorships of Art history which are usual in the universities of America and the Continent, but which (with one exception) do not exist in England. Its founders, Ruskin and Sir Henry Acland, did not intend that the professor should give his pupils a detailed survey of the history of art, or should make them proficient in such branches of the subject as stylistic criticism and iconography. They intended, in Ruskin's words, that he should 'make our English youth care somewhat for the arts'.

The kind of art which interests young people, arouses their curiosity and excites them to argument, is the art of their own time: and it seemed to me that the Slade Professor's first course of lectures should be enough concerned with the past to allow of a settled perspective, but should also touch, and if possible clarify, the puzzles of modern painting. I chose the subject of landscape painting, because this, in an even fuller sense than Ruskin realised, was the chief artistic creation of the nineteenth century: and without a clear understanding of nineteenth-century art, no evaluation of contemporary painting is possible. People who have given the matter no thought are apt to assume that the appreciation of natural beauty and the painting of landscape is a normal and enduring part of our spiritual activity. But the truth is that in times when the human spirit seems to have burned most brightly the painting of landscape for its own sake did not exist and was unthinkable. By the time he reached the third volume of Modern Painters Ruskin realised this, and wrote a section entitled *Of the Novelty of Landscape* in which he claims that mankind has almost acquired a new sense. He concludes characteristically: 'The simple fact, that we are, in some strange way, different from all the great races that have existed before us, cannot at once be received as the proof of our own greatness; nor can it be granted, without any question, that we have a legitimate subject of complacency in being under the influence of feelings with which neither Miltiades nor the Black Prince, neither Homer nor Dante, neither Socrates nor St. Francis, could for an instant have sympathised'.

To examine all that this sentence implies would require an immense grasp of the history of ideas. In this book I have taken a more limited objective, although I have tried to bear the main principle in mind. The first half describes how, in spite of classical traditions and the unanimous opposition of theorists, landscape painting became an independent art. I have not done this historically, which in a short course could have meant no more than skimming the surface of names and dates, but by suggesting four ways of seeing landscape as a means of pictorial expression. In the second half I relate these ways to the painting of the nineteenth century. Partly because landscape painting has now become the dominant art, and partly because this section leads directly to the painting of our own time, there is a change of focus, and individual artists are treated in greater detail. In the epilogue I attempt to apply what I seem to have learnt to the peculiar difficulties which have afflicted painting during the last twenty-five or thirty years.

Let me repeat that anyone who expects this book to be a treatise on the history of landscape painting will be disappointed. I have been constrained, by the form I have chosen, to leave out a few painters whose names occupy the labours of historians, but who do not seem to have added anything to the imaginative experiences of mankind. There is, indeed, room for a history of landscape painting, but it would have to be at least five times as long as the present volume, and conceived on different lines.

In particular, it could not be composed in the form of lectures. And, in spite of copious rewriting, lectures these pages remain. One may remove the words 'next slide, please' from the text, but not from the sequences of thought. The publication of lectures is a well-known form of literary suicide. I indulge in it now because the audiences who heard them endured, with much patience, extremes of heat and cold. I am grateful, and can only show my gratitude by giving them the text to criticise under more agreeable conditions.

1949

This book was written in the form of lectures during the winter of 1945–6, and tidied up in the following year. Reading it through again for the first time after twenty-six years I have found some serious omissions, a number of judgments, confidently expressed, with which I no longer agree, and a few

INTRODUCTION

sentences written in rather a pompous style. I have had the opportunity to make some changes which I believe to be improvements. It is usually dangerous to tamper with an old book, but I do not think the reader will be conscious of any change in the character of the text as a whole. Two or three serious omissions could not be worked into the original version, and I have therefore included some new paragraphs in square brackets. I should like to mention two books that have helped me to change my mind on important matters, Carlo Pedretti's *Leonardo da Vinci* and Jack Lindsay's *Turner*.

John Murray has allowed me many more illustrations, which will make the book more useful to students, and these have been inserted into the text as far as possible where the pictures are mentioned. Once more I must thank Peter Campbell for the extraordinary skill with which he performs this difficult feat.

K.C. 1976

ACKNOWLEDGEMENTS

My thanks are due to the Curators of the Galleries and Museums who have kindly given permission to reproduce illustrations, and to the following: The Mansell Collection for plates 3, 17, 32, 50, 56, 57a, 61, 69, 72, 73, 74, 77; Manso for plates 36, 37, 50; Giraudon for plate 13; and Thomas-Photos for plate 124.

Black and White Illustrations

- I Hellenistic Fresco, The Boat of Ulysses drawn to the Island of Circe. Vatican
- 2 The Utrecht Psalter (ninth century), top, and the Canterbury Psalter (c. 1150), bottom. Illustrations to the Psalm 'Usquequo, Domine'. University Library, Utrecht, and Trinity College, Cambridge
- 3 Fresco, from the House of Livia. National Museum, Rome
- 4 Manuscript illustration from Tacuinum Sanitatis. Austrian National Library, Vienna
- 5 Mosaic (twelfth century). Cappella Palatina, Palermo
- 6 Foliage capitals (c. 1293). Chapter House, Southwell Minster
- 7 Simone Martini, Title page of a Virgil belonging to Petrarch. Biblioteca Ambrosiana, Milan
- 8 Frescoes (c. 1343) showing birdcatchers. Palace of the Popes, Avignon
- 9 Tapestry (French, c. 1510), Lady with the Unicorn. Musée de Cluny, Paris
- 10 Stefano da Zevio, Madonna in a Rose Garden. The Castello, Verona
- 11 Cologne School, Paradise Garden. Städelsches Kunstinstitut, Frankfurt
- 12 Unknown Florentine (c. 1410), The Thebaid. Uffizi, Florence
- 13 The Limbourg Brothers, The Temptation and Expulsion, from the 'Très Riches Heures du Duc de Berry'. Chantilly
- 14 Giovanni di Paolo, *The Young Saint John going into the Wilderness*. National Gallery, London
- 15 Manuscript illustration of rabbits from *Livre de Chasse de Gaston Phébus* (c. 1400). Bibliothèque Nationale, Paris
- 16 The Limbourg Brothers, Scenes from the Calendar of the 'Très Riches Heures du Duc de Berry'. Chantilly
- 17 Benozzo Gozzoli, Journey of the Magi. Riccardi Palace, Florence
- 18 Uccello, The Hunt in the Wood (detail). Ashmolean Museum, Oxford
- 19 Unknown painter (c. 1415), Occupations of the Months. Castello del Buonconsiglio, Trent
- 20 Jan van Eyck, *The birth of John the Baptist* and the *Baptism of Jesus* from the 'Hours of Milan'. Museo Civico, Turin
- 21 van Eyck, Landing of William of Bavaria, from 'The Hours of Turin', (now destroyed)
- 22 Jan van Eyck, The Virgin of Chancellor Rollin (detail). Louvre, Paris
- 23 Jan van Eyck, Saint Barbara (unfinished panel). Antwerp

- 24 Robert Campin, The Nativity. Musée des Beaux-Arts, Dijon
- 25 Hugo van der Goes, The Portinari Altarpiece (detail). Uffizi, Florence
- 26 Konrad Witz, The Miraculous Draught of Fishes. Musée des Beaux-Arts, Geneva
- 27 Dürer, View of Arco, Louvre, Paris
- 28 Dürer, Fisherman's Hut on a Lake. British Museum, London
- 29 Dürer, Pond in a Wood. British Museum, London
- 30 Pollaiuolo, Martyrdom of St Sebastian (detail). National Gallery, London
- 31 Pollaiuolo, The Rape of Dejanira. Jarves Collection, New Haven, Connecticut
- 32 Piero della Francesca, reverse sides of the Montefeltro portraits. Uffizi, Florence
- 33 Antonello da Messina, Crucifixion. Hermannstadt, Transylvania
- 34 Giovanni Bellini, Resurrection. Berlin-Dahlem
- 35 Giovanni Bellini, St Francis in the Wilderness. Frick Collection, New York
- 36 Patenier, Rest in the Flight into Egypt (detail). Prado, Madrid
- 37 Bosch, Triptych of Adoration (detail). Prado, Madrid
- 38 Pieter Breughel, Winter, the Dark Day. Kunsthistorisches Museum, Vienna
- 39 Rembrandt, Canal with a Rowing Boat. Chatsworth
- 40 Jacob van Ruisdael, View near Haarlem. National Gallery, London Jacob van Ruisdael, The Banks of a River. National Gallery of Scotland, Edinburgh
- 41 Vermeer, View of Delft. Mauritshuis, The Hague
- 42 Pieter Saenredam, Old Town Hall, Amsterdam. Rijksmuseum, Amsterdam
- 43 Jan van der Heyden, A View in Cologne. National Gallery, London
- 44 Canaletto, The Stonemason's Yard. National Gallery, London
- 45 Canaletto, Richmond Terrace. Goodwood Collection Guardi, The Tower of Maestre. National Gallery, London
- 46 Altdorfer, Satyr Family. Berlin-Dahlem
- 47 Grünewald, Isenheim Altar (Two Hermits). Colmar
- 48 Altdorfer, St George. Alte Pinakothek, Munich
- 49 Piero di Cosimo, Forest Fire (detail). Ashmolean Museum, Oxford
- 50 After Giorgione, Orpheus and Eurydice. Bergamo
- 51 Patenier, Charon's Boat. Prado, Madrid
- 52 Lorenzo Lotto, St Jerome. Louvre, Paris
- 53 Pieter Breughel, The Fall of Icarus. Brussels
- 54 School of Lucas van Leyden, Lot and his Daughters. Louvre, Paris
- 55 Jacopo da Valencia, St Jerome. Pinacoteca, Bologna
- 56 Mantegna, Virgin of the Quarries. Uffizi, Florence
- 57 Leonardo da Vinci, Landscape drawing (dated 1473). Uffizi, Florence Deluge drawing. Royal Library, Windsor
- 58 Leonardo da Vinci, The Virgin and Child with St Anne (detail). Louvre, Paris

- 59 Giulio Romano, The Fall of the Giants (fresco). Palazzo del Tè, Mantua Niccolò dell'Abate, Landscape with Orpheus and Eurydice. National Gallery, London
- 60 Tintoretto, St Mary of Egypt. Scuola di San Rocco, Venice
- 61 Veronese, St Anthony Preaching to the Fishes. Borghese Gallery, Rome
- 62 Rubens, Philemon and Baucis. Kunsthistorisches Museum, Vienna
- 63 El Greco, Mount Sinai. (whereabouts unknown)
- 64 El Greco, View of Toledo. Metropolitan Museum of Art, New York
- 65 Polidoro da Caravaggio, Frescoes in San Silvestro al Quirinale, Rome
- 66 Inigo Jones, Night scene, for Luminalia. Chatsworth
- 67 Elsheimer, Flight into Egypt. Alte Pinakothek, Munich Rubens, Tournament before a Castle. Louvre, Paris
- 68 Giorgione and Titian, Fête Champêtre. Louvre, Paris
- 69 Giovanni Bellini, Allegory of the Progress of the Soul. Uffizi, Florence
- 70 Giorgione, Trial of Moses (detail). Uffizi, Florence
- 71 School of Giorgione, Scenes illustrating an Eclogue by Tebaldeo. National Gallery, London
- 72 Giorgione, La Tempesta. Accademia, Venice
- 73 Titian, Sacred and Profane Love. Borghese Gallery, Rome
- 74 Titian, St Margaret. Prado, Madrid
- 75 Claude Lorrain, *Drawing of trees*. Teyler Museum, Haarlem *Ascanius and the Stag*. Ashmolean Museum, Oxford
- 76 Claude Lorrain, The Temple of Apollo. Gemäldegalerie, Dresden
- 77 Claude Lorrain, Landscape with Acis and Galatea. Gemäldegalerie, Dresden
- 78 Claude Lorrain, Landscape with the Flight into Egypt. Pinakothek, Dresden
- 79 Nicolas Poussin, The Deluge. Louvre, Paris
- 80 Nicolas Poussin, Landscape with Diogenes. Louvre, Paris
- 81 Nicolas Poussin, Summer. Louvre, Paris
- 82 Nicolas Poussin, St John on Patmos. Art Institute of Chicago
- 83 Nicolas Poussin, The Gathering of the Ashes of Phocion. Knowsley Hall
- 84 Gaspard Poussin, A Road near Albano. National Gallery, London
- 85 Francisque Millet, Destruction of Sodom. National Gallery, London
- 86 J.R. Cozens, View of Lake Albano. Ashmolean Museum, Oxford Samuel Palmer, Valley with a Bright Cloud. Ashmolean Museum, Oxford
- 87 Caspar David Friedrich. Woman in front of the Setting Sun. Museum Folkwang, Essen
- 88 Constable, Sketch for The Leaping Horse. Victoria and Albert Museum, London
- 89 Constable, A View on the Stour and Willows by a Stream. Both Victoria and Albert Museum, London

- 90 Constable, Brighton Beach and Cottage in a Cornfield. Both Victoria and Albert Museum, London
- 91 Thèodore Rousseau, Village of Becquigny. Frick Collection, New York and A Summer Day. Louvre, Paris
- 92 de Valenciennes, Sky Study. Louvre, Paris Corot, A View near Volterra. National Gallery, Washington, D.C.
- 93 Corot, Le Vallon and View of St-Lô. Both Louvre, Paris
- 94 Corot, St-André-du-Morvan. Louvre, Paris
- 95 Corot, The Lake. Frick Collection, New York
- 96 Courbet, Snow Scene. Ashmolean Museum, Oxford
- 97 Courbet, Cliffs at Étretat. Barber Institute, Birmingham
- 98 Daubigny, Étretat, Berwick-upon-Tweed, and The Quarry. Louvre, Paris
- 99 Camille Pissarro, Lower Norwood. National Gallery, London Leader, February Fill Dyke. City Art Gallery, Birmingham
- 100 Monet, The Beach at Sainte-Adresse. The Art Institute of Chicago
- 101 Monet, Antibes. Trees near the Mediterranean. The Art Institute of Chicago
- 102 Turner, Sketch for Walton Bridges. National Gallery, London
- 103 Turner, Rain, Steam, Speed. National Gallery, London
- 104 Monet, Old St-Lazare Station. The Art Institute of Chicago
- 105 Turner, Light and Colour. Tate Gallery, London
- 106 Turner, A Stormy Shore. Tate Gallery, London
- 107 Turner, Norham Castle. Tate Gallery, London
- 108 Turner, Fire at Sea. Tate Gallery, London
- 109 Van Gogh, Stone Seat, in the Hospital Garden, St-Remy. Van Gogh Museum, Amsterdam
- 110 Van Gogh, Fading Daylight. Van Gogh Museum, Amsterdam
- 111 Van Gogh, Road with Cypresses. Kröller-Müller Rijksmuseum, Otterlo
- 112 Van Gogh, Cottage with Cypresses, near St-Remy. Stedelijk Museum, Amsterdam
- 113 Camille Pissarro, Entrance to the Village of Voisins. Louvre, Paris
- 114 Seurat, Sketch for the Grande Jatte. Metropolitan Museum of Art, New York
- 115 Seurat, Entrance to the Harbour at Gravelines. Courtauld Institute, London
- 116 Seurat, *The Hospice de la Phare at Honfleur*. Kröller-Müller Rijksmuseum, Otterlo and *The Bridge at Courbevoie*. Courtauld Institute, London
- 117 Cézanne, The Cutting with Mont-Sainte-Victoire. Neue Staatsgalerie, Munich and Houses at L'Estaque. Private Collection, New York
- 118 Cézanne, Trees at the Jas de Bouffan (Les Grandes Arbres).
 Courtauld Institute, London
- 119 Cézanne, Mountains at L'Estaque. National Museum of Wales

- 120 Cézanne, Mont-Sainte-Victoire. Private collection, Switzerland
- 121 Gauguin, Martinique Landscape. National Galleries of Scotland, Edinburgh
- 122 Douanier Rousseau, The Merry Jesters. Philadelphia Museum of Art
- 123 Mondrian, Composition. Kröller-Müller Rijksmuseum, Otterlo
- 124 Underhill, Marine Biology. Private collection, Mansfield, Notts.

Colour Illustrations

- I Giovanni Bellini, The Virgin of the Meadow (detail). National Gallery, London, f. p. 64
- II Gainsborough, Mr and Mrs Andrewes (detail). National Gallery, London, f. p. 80
- III Altdorfer, The Battle of Alexander (detail). Alte Pinakothek, Munich, f. p. 128
- IV Rubens, Landscape with Rainbow. Wallace Collection, London, f. p. 144
- v Turner, Sunset: Rouen. British Museum, London, f. p. 160
- VI Turner, Yacht Approaching Coast. Tate Gallery, London, f. p. 176
- VII Monet, An Impression. (Impression Soleil Levant). Musée Marmottan, Paris, f. p. 208
- VIII Cézanne, Mont-Sainte-Victoire, Environs de Gardanne. National Gallery of Art, Washington, D.C., f. p. 224

1 Hellenistic Fresco, The Boat of Ulysses drawn to the Island of Circe

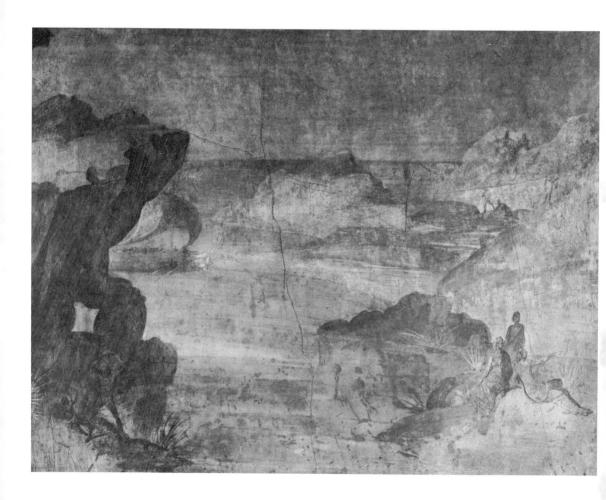

THE LANDSCAPE OF SYMBOLS

We are surrounded with things which we have not made and which have a life and structure different from our own: trees, flowers, grasses, rivers, hills, clouds. For centuries they have inspired us with curiosity and awe. They have been objects of delight. We have recreated them in our imaginations to reflect our moods. And we have come to think of them as contributing to an idea which we have called nature. Landscape painting marks the stages in our conception of nature. Its rise and development since the middle ages is part of a cycle in which the human spirit attempted once more to create a harmony with its environment. The preceding cycle, that of Mediterranean antiquity, had been so deeply rooted in the Greek sense of human values that this concept of nature had played a subordinate part. The Hellenistic painter, with his sharp eye for the visible world, evolved a school of landscape painting; but, in so far as we can judge from the few surviving fragments, his skill in recording effects of light was used chiefly for decorative ends. Only the Odysseus series in the Vatican suggests that landscape had become a means of poetical expression, and even these are backgrounds, digressions, like the landscapes in the Odyssey itself [1].

Yet the colouristic style of antique painting was well adapted to landscape, and traces of it remain, whenever landscape is required, long after other elements of the classic style have disappeared. In that precious document of the junction of two worlds, the Vienna *Genesis*, executed in Antioch about the year 560, the artist known as the Illusionist was capable of true impressions of atmosphere, of the totality of landscape, even when his figures were formalised in what we call the Byzantine manner. As late as the ninth century the Utrecht Psalter is full of landscape motives taken from Hellenistic painting, and its impressionistic scribbles still imply a sense of light and space. There is no simpler way to show the triumph of symbol over sensation in the middle ages than to compare its pages with those of the 'copy' made by the monk Eadwine for the monastic house of Canterbury in the middle of the twelfth century [2].

[There was another tradition of antique landscape which I omitted from the original version of this book. Instead of taking a high panoramic point of

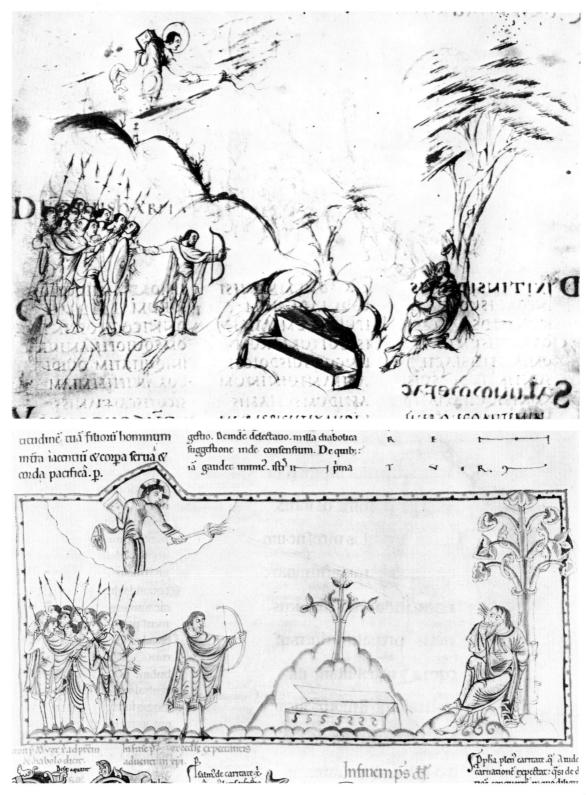

² The Utrecht Psalter (ninth century), top, and the Canterbury Psalter (c. 1150), bottom. Illustrations to the Psalm 'Usquequo Domine'

view, the painter stood rather close to a mass of greenery and filled the whole of his space with trunks, leaves or flowers. This procedure is best known to us from the wall paintings from the so-called House of Livia, now in the National Museum, Rome [3]; it is also to be found in Pompeii (new Excavations Region I) and was evidently current in Byzantium. The tradition was strong enough to have had an influence on the mosaic decoration of the great Mosque in Damascus. Roman wall paintings in this style were probably known to the painters of the middle ages. Another form of transmission was the series of herbals depicting the plants used to preserve health, of which an antique manuscript still survives. The most elaborate example of this genre is a fourteenth century manuscript called the Tacuinum Sanitatis, also in Vienna, which must resemble the pattern books used by early fifteenth century tapestry designers. The leaves and fruit are carefully observed, but on a much larger scale than the figures [4]. I mention this tradition of landscape when I refer to the frescoes in the Palace of the Popes at Avignon [8], but do not describe its origins. That it was a natural and recurrent way of looking at nature is confirmed by the jungle landscapes [122] of the Douanier Rousseau.]

All art is to some degree symbolic and recognition depends on certain long accepted formulae. The symbols by which early mediaeval art acknowledged the existence of natural objects bore unusually little relation to their actual appearance. But they satisfied the mediaeval mind. To some extent they were the outcome of mediaeval Christian philosophy. If our earthly life is no more than a brief and squalid interlude, then the surroundings in which it is lived need not absorb our attention. If ideas are Godlike and sensations debased, then our rendering of appearances must as far as possible be symbolic, and nature, which we perceive through our senses, becomes positively sinful. St. Anselm, writing at the beginning of the twelfth century, maintained that things were harmful in proportion to the number of senses which they delighted, and therefore rated it dangerous to sit in a garden where there are roses to satisfy the senses of sight and smell, and songs and stories to please the ears. This, no doubt, expresses the strictest monastic view. The average layman would not have thought it wrong to enjoy nature; he would simply have said that nature was not enjoyable. The fields meant nothing but hard work (today agricultural labourers are almost the only class of the community who are not enthusiastic about natural beauty); the sea coast meant danger of storm and piracy. And

LANDSCAPE INTO ART

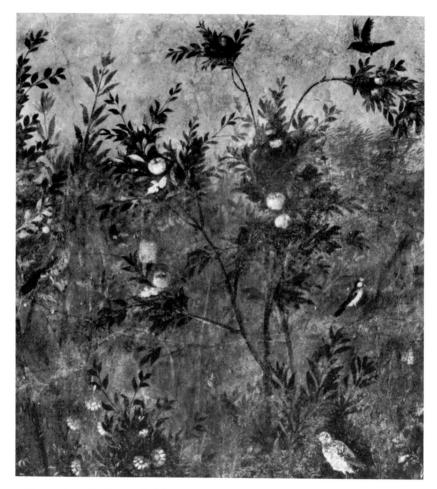

3 Fresco, from the House of Livia

beyond these more or less profitable parts of the earth's surface stretched an interminable area of forest and swamp. Mr Aldous Huxley once observed that if Wordsworth had been familiar with tropical forests he would have taken a less favourable view of his Goddess. There is, as he says, something in the character of great forests which is foreign, appalling, and utterly inimical to intruding life. No wonder that the few references to nature in the early epics, the sagas and Anglo-Saxon poetry, are brief and hostile or dwell on its horrors, as in the description of Grendel's Mere in *Beomulf* where the poet sets out to make us share his terror.

4 Manuscript illustration from Tacuinum Sanitatis

Parallel with this mistrust of nature was the symbolising faculty of the mediaeval mind. We who are heirs to three centuries of science can hardly realise a state of mind in which all material objects were thought of as symbols of spiritual truths or episodes in sacred history. Yet unless we make this effort of imagination, mediaeval art is largely incomprehensible, and Durandus's instructions for the decoration of a church are mere nonsense. Now it was this power of immediately substituting an idea for an object, or an object for an idea, which allowed mediaeval man to accept without question such unconvincing equivalents as the trees and moun-

tains in Eadwine's psalter. And although this attitude to nature could never produce landscape painting in our modern sense, it prepared the way for the kind of art which I have called the landscape of symbols.

The less an artefact interests our eye as imitation, the more it must delight our eye as pattern, and an art of symbols always evolves a language of decoration. The references to nature in such purely symbolic works as the Mosaics in St. Mark's or in the Cappella Palatina, Palermo [5], add a new and precious element to design. More important still, as soon as men look with pleasure at the actual details of nature, the symbolising habit of mind gives to their regard an unusual intensity; for they look at flowers and trees not only as delightful objects, but as prototypes of the divine.

The leaves, flowers and tendrils, carved on the capitals of Rheims and Southwell, which, in the thirteenth century, break through the frozen crust of monastic fear, have the clarity of newly created things [6]. Their very literalness and lack of selection is a proof that they have been seen for the first time.

And, in the meadows and the lower grounds Was all the sweetness of a common dawn.

The flowers of Rheims and Southwell were premature, nipped by icy winds of doctrine. Yet gradually, in the thirteenth century, leafy ornament begins to appear on capitals as a matter of course, and in the margins of manuscripts, and the followers of St. Francis are able to refer to the episodes of his life as *fioretti*.

Natural objects, then, were first perceived individually, as pleasing in themselves and symbolical of divine qualities. The next step towards land-scape painting was to see them as forming some whole which would be within the compass of the imagination and itself a symbol of perfection. This was achieved by the discovery of the garden. In a sense discovery is the wrong word, for the enchanted garden – be it Eden, or the Hesperides, or Tir-nan-Òg – is one of humanity's most constant, widespread and consoling myths; and its reappearance in the twelfth century is only a part of the general reawakening of the imaginative faculty. That very multiplicity of sensations which St. Anselm had believed to be so dangerous now became accepted by the Church as a foretaste of paradise. Paradise is the Persian for 'a walled enclosure', and it may well be that the peculiar value set on gardens in the later middle ages is a legacy of the Crusades. At all events,

5 Mosaic (twelfth century)6 Foliage capitals (c. 1293). Chapter House, Southwell Minster

the idea of a flowery meadow cut off from the world of fierce accidents, where love, human and divine, could find fulfilment, appears in Provençal poetry at the same time as other gifts from the East. In the most magic of all gardens, that which is the setting of the Romance of the Rose, the trees, we are told, were brought from the land of the Saracens. And a feeling for gardens was not confined to the poets. Albertus Magnus, the most encyclopaedic of mediaeval philosophers, describes, in his *de Vegetabilibus*, an orchard or pleasaunce with vines and fruit trees growing in the smooth grass, and adds 'behind the grass plots are planted in quantity aromatic herbs the perfume of which gratifies the sense of smell; also some flowers such as the violet, columbine, lily, rose and iris which by their diversity charm the sight.' St. Anselm's monasticism is far away.

As with everything else in the middle ages, this new spirit finds its most concentrated expression in Dante. Nineteenth-century students of the Divine Comedy have been at pains to note every reference to nature, and have discovered some beautiful images, as clear as the carvings on thirteenthcentury capitals. True, the part played by natural beauty in Dante's mind is infinitesimal compared to the part played by the divine beauty of theology. But in the course of his poem we can feel the change from the menacing world of the early middle ages, to the gentler world of the *microtheos*, when God might be manifest in nature. Dante begins his journey (it is the only fact which is generally remembered) in a dark wood; he nears its end when the wood thins out, and he sees beyond a stream a lady singing and picking the flowers with which her whole path is embroidered (Purg. XVIII, 40–60). Forty years later the garden provides a refuge for Boccaccio's charming companions, who withdraw to 'a plot of ground like a meadow, the grass deep-spangled with a thousand different flowers', to tell their stories, while the plague festers outside the wall. Perhaps this very plague¹ is commemorated in one of the first garden groups in painting, the fresco in the Campo Santo which was famous in the nineteenth century as a work of Orcagna, but is actually by an unknown Pisan follower of the Lorenzetti. It represents a number of solid-looking revellers, seated under the trees, a

¹The plague of 1348. There are documentary objections to dating the fresco so early, but they are not conclusive; on stylistic grounds the date is possible, although there are features which suggest that 1368, the plague year in which Petrarch lost so many of his friends, would be a more acceptable date.

carpet of flowers at their feet. They make music and look at each other with amorous glances, which frequent restorations have rendered rather grotesque. We are left in no doubt that they are enjoying the pleasures of the senses, but to emphasise the fact there hang above their heads two cupids, who seem to have flown up from the antique sarcophagi which, then as now, were lined along the walls of the Campo Santo. This fresco is an offshoot of Sienese art. Landscape had no part in the pictorial traditions of Florence. The bare, economical rocks which do duty for background in the paintings of Giotto admirably support the plastic balance of each group; but Giotto, who was so great an observer of human gesture and expression, has disdained to record his observations of plants and trees. How far this tradition of monumental art determined his style is apparent when we remember that he was the painter of the life of St. Francis. If only Giotto had put in a few more flowers, how gratefully would the art historian have quoted from St. Francis's canticles to show that the spirit of union with nature was evident in his work.

So it is in Sienese painting that we must look for the sense of natural beauty which we have discovered in the poets of the early fourteenth century; and we find it in the work of Simone Martini and the Lorenzetti. The first surviving landscapes, in a modern sense, are in Ambrogio Lorenzetti's frescoes of *Good and Bad Government*. These are so factual that they hardly belong to the landscape of symbol and remain unique for almost a century. Simone, on the other hand, was the born interpreter of heavenly beauty in sensuous terms. His golden fabrics are such as are laid up in heaven for the blessed, and the rhythmic flow of his draperies echoes the angelic song. In all this he was at one with the finest Gothic art of France, and it was no accident that, in 1339, he found his way to Avignon.

It was presumably in Avignon that Simone met the man whose name has come to stand for the junction of the mediaeval and the modern worlds, Petrarch. The two must have become intimate, for not only does Petrarch refer to the painter as 'il mio Simone', but he mentions in his sonnets that Simone painted his portrait and that of Laura; and we know that, after his first youth, the poet only mentioned this lady to his intimate friends. The portraits are lost, and I can think of few works of art which I would sooner discover. But by a miracle (for his library went through horrible vicissitudes) we still possess Petrarch's favourite copy of Virgil, which not only contains his account of the death of Laura, but has a frontispiece by Simone [7]. It

represents the poet seated in a flowery orchard, while near him a shepherd and a vine-tender symbolise the *Ecloques* and the *Georgics*. For the first time since antiquity the pursuits of country life are represented in art as a source of happiness and poetry.

Petrarch appears in all history books as the first modern man; and rightly, for in his curiosity, his scepticism, his restlessness, his ambition, and his self-consciousness, he is certainly one of us. But anyone who turns from the letters to the strange, self-searching work which he called his Secret, will find that these modern characteristics are still dominated by a monastic philosophy. So it is with Petrarch's responsiveness to nature. He was probably the first man to express the emotion on which the existence of landscape painting so largely depends; the desire to escape from the turmoil of cities into the peace of the countryside. He went to live in the solitudes of Vaucluse not, as a Cistercian would have done, in order to renounce his life on earth, but in order to enjoy it the more. 'Would that you could know', he writes to a friend, 'with what joy I wander free and alone among the mountains, forests and streams.' That, certainly, is a very different note from the forest fears and mountain panics of all mediaeval poets, including even Dante. Then Petrarch was a gardener in the modern sense, not merely delighting in the decorative profusion of flowers, but studying their habits, and keeping a day-book in which he recorded the success or failure of certain plants. Finally he was, as everyone knows, the first man to climb a mountain for its own sake, and to enjoy the view from the top. But after he had feasted his eyes for a few minutes on the distant prospect of the Alps, the Mediterranean and the Rhône at his feet, it occurred to him to open at random his copy of St. Augustine's Confessions. His eyes fell upon the following passage: "And men go about to wonder at the heights of the mountains, and the mighty waves of the sea, and the wide sweep of rivers, and the circuit of the ocean, and the revolution of the stars, but themselves they consider not." I was abashed, and asking my brother (who was anxious to hear more) not to annoy me, I closed the book, angry with myself that I should still be admiring earthly things, who might long ago have learned from even the pagan philosophers that nothing is wonderful but the soul, which, when great itself, finds nothing great outside itself. Then, in truth, I was satisfied that I had seen enough of the mountain; I turned my inward eye upon myself, and from that time not a syllable fell from my lips until we reached the bottom again.' Nothing could give a clearer idea of the state of

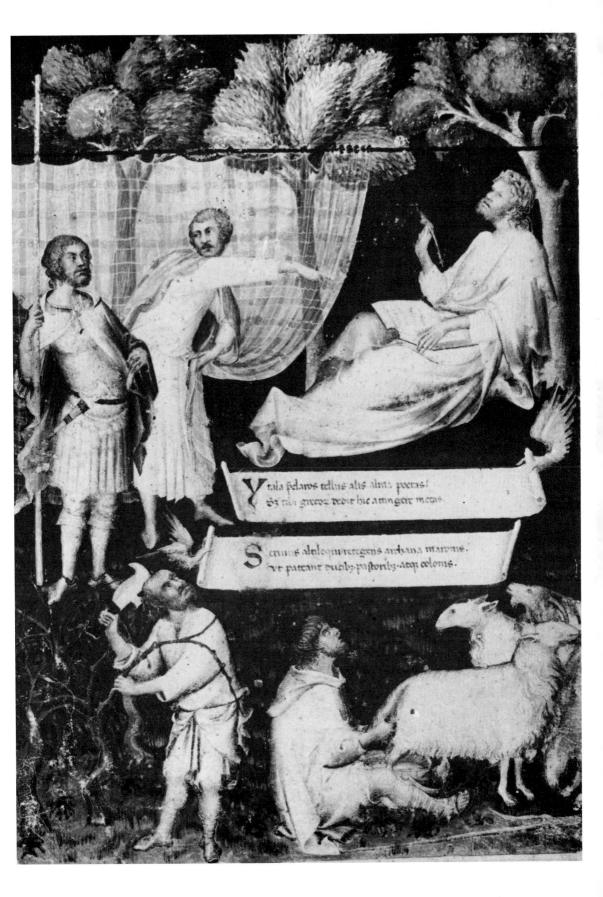

8 Frescoes (c. 1343) showing birdcatchers

mind which produced the landscape painting of the later middle ages. Nature as a whole is still disturbing, vast and fearful; and lays open the mind to many dangerous thoughts. But in this wild country man may enclose a garden.

It is, appropriately enough, at Avignon that we find the first pictorial expression of this new feeling, in the landscape frescoes which decorate the Tour de la Garde-Robe in the Palace of the Popes [8]. They are datable 1343, but there are many indications that they represent a well-established style, of which no other trace remains. I think there can be little doubt that they are the kind of design which was already being woven in tapestry, but this must remain a hypothesis, for, of all the great series of tapestries produced in Paris and Arras during the fourteenth century, only the Angers Apocalypse survives. Almost equally complete has been the loss of profane decoration, for castles were redecorated, abandoned or destroyed far more frequently than churches. The result is that we have an unusually imperfect view of the early stages of secular art, and we would probably be mistaken in regarding these decorations at Avignon as exceptional in anything but the fact of their preservation.

The frescoes at Avignon are the first complete examples of the landscape of symbols, both in subject and style. They show people fishing in a garden pool, hawking and ferreting, with an untroubled enjoyment of open-air life. And they preserve, from the more narrowly symbolic vision of the middle ages, a full mastery of decoration. The tree trunks are spaced with a subtle sense of interval, the leaves create a pattern as rich as the side of an enamelled chasse. Naturalism of detail has not yet destroyed that feeling for texture which was the legacy of Byzantine art. This feeling for decorative richness, first appearing in the tapestry-like frescoes of Avignon, is apparent throughout the fifteenth century in the actual tapestries of which great numbers have survived. In these the dark woods of the middle ages are made to fill, with beautiful patterns of leaves and branches, the whole upper portion of each design, while the lower half is as richly sprinkled with flowers as the meadows of Boccaccio. There is not a square inch without some delightful reminder of the visible world, all translated into a poetry more real and yet more formal than Spenser's Faerie Queene. From a hundred examples, that which comes first to mind is the series of the Lady with the Unicorn in the Cluny Museum, where the subject itself symbolises the triumph of delicacy over the wild impulses of nature [9].

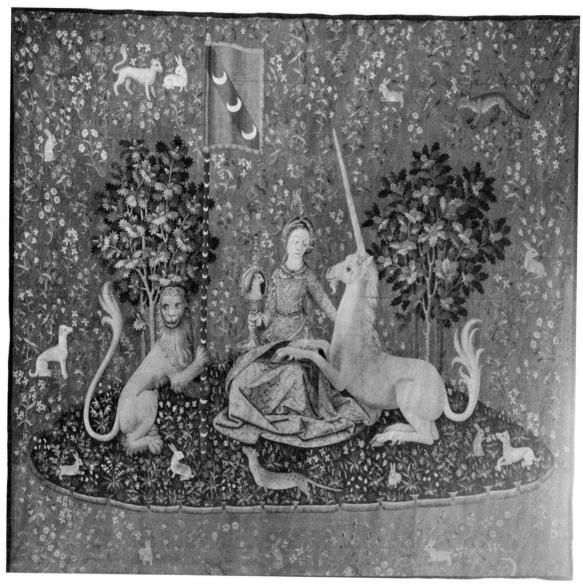

9 Tapestry (French, c. 1510), Lady with the Unicorn

In religious art the theme of the Unicorn tapestries, and the whole idea of embroidered nature, finds expression in the subject of the Hortus Conclusus. Curiously enough the origin of this theme appears to be unknown; there are few examples earlier than 1400, whereas the Virgin and the Unicorn appeared in the thirteenth century; and it is suggestive that in one

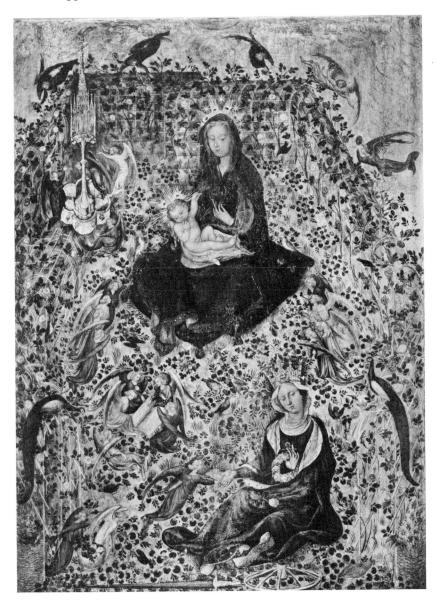

LANDSCAPE INTO ART

of the first paintings of the Hortus Conclusus, a picture in the Weimar Gallery, datable about 1400, the Unicorn has entered the garden and kneels before Our Lady. This variant of the theme was too unorthodox to survive, but the beautiful subject of the enclosed garden, where out Lady can sit on the ground and her Son play with the birds, was popular throughout the fifteenth century. At first the garden is very small, only a symbol of enclosure, as in the sweet Christmas cards of Stephan Lochner. But sometimes they are large enclosures, orchards as Boccaccio and Albertus Magnus described them. We can see such a flowery orchard in the Stefano da Zevio in Verona [10]; and in this I think there can be no doubt that the source of inspiration was a Persian miniature. Most Persian manuscripts with garden illustrations are fifteenth or sixteenth century, but a few of the fourteenth century survive, and some of these must have found their way to Europe, either through the Moors in Spain or through Venice. Of all paradise gardens the jewel and crown - for it is indeed like the enamelled crown of a Gothic goldsmith – is the little picture in the Frankfurt gallery [11]. It

11 Cologne School, Paradise Garden

contains the elements of late mediaeval landscape in their most perfect form, and distils a world of delicate, sensuous perception, where flowers are there to please the senses of sight and smell, fruit to satisfy the taste and the sound of a zither, mingled with that of falling water, to delight the hearing. Yet all these sensations still have some immaterial quality, for they are conceived as testimonies of heavenly joy; and the picture is full of Christian symbols, the fountain, the birds on the battlements, the Holy Child making music and the dragon of evil lying with his belly in the air. In Venice, a century later, these pleasures no longer reflected another world. The senses alone, tuned to a delicacy of pitch which has never been surpassed, were enough to establish harmony with nature. But in the North, where diseases of belief made this vision of happiness untenable, the paradise gardens soon disappeared and were only revived about a hundred years later in a grotesque and terrifying form by Hieronymus Bosch, who used a neo-Gothic style as the best means of conveying his encyclopaedic disgust at human condition.

Outside the garden wall were mountain and forest, and for each the middle ages had contrived a symbol. The mountains of Gothic landscape, those strange, twisted rocks, which rise so abruptly from the plain, are in fact part of a very ancient pictorial tradition. They certainly go back to Hellenistic painting, and survive in those manuscripts, like the Utrecht Psalter, which are based on antique models. They were common in Byzantine art, as it has come down to us, in mosaics and illumination; and they become the central motive of those icons which represent the desert of Sinai.¹ There is a proliferation of such mountain forms in the various pictures of the Thebaid, a Byzantine motive revived with great zest in the early fifteenth century. The inexhaustibly entertaining representation of this subject in the Uffizi [12] is the first landscape panorama since Lorenzetti, and in it the fantastic rocks have a convincing function. That they represent the World beyond the Garden is clear from the beautiful Miniature of the Expulsion from Paradise in the Très Riches Heures [13], and from such a picture as Giovanni di Paolo's young St. John going into the wilderness [14]. But they do not survive solely as symbols of desert places. When Petrarch wishes to give an idea of his beloved Vaucluse and the source of the Sorgue,

¹An icon of Sinai was used directly by the Limbourgs as background of the miniature of Hell in the *Très Riches Heures*. It is also the subject of El Greco's earliest surviving painting, see Plate 63. Such fantastic rocks actually exist in Cappadocia and were for long inhabited by desert monks.

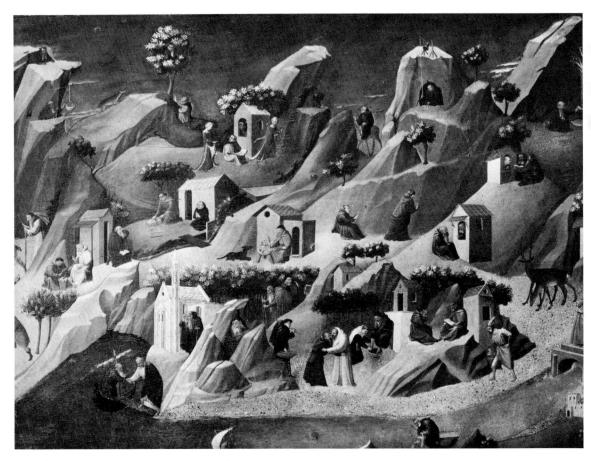

12 Unknown Florentine (c. 1410), The Thebaid

he draws in the margin the conventional Byzantine mountain and inscribes it 'my most delightful transalpine solitude'. They survive simply because they were a convenient symbol; and if we ask why it was still necessary to use a sort of ideogram for mountains when other natural objects were treated realistically, one answer is that mountains were so large and inapprehensible.

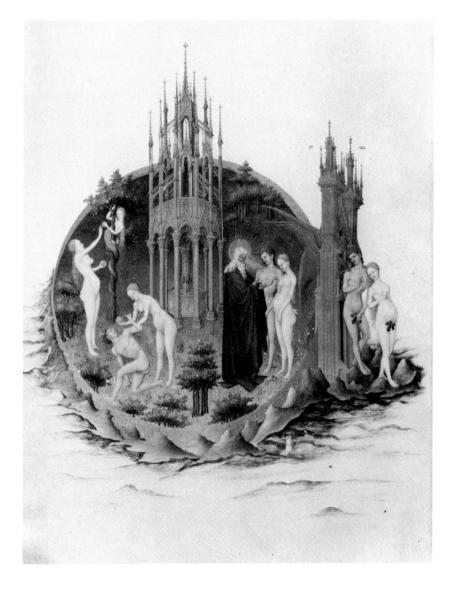

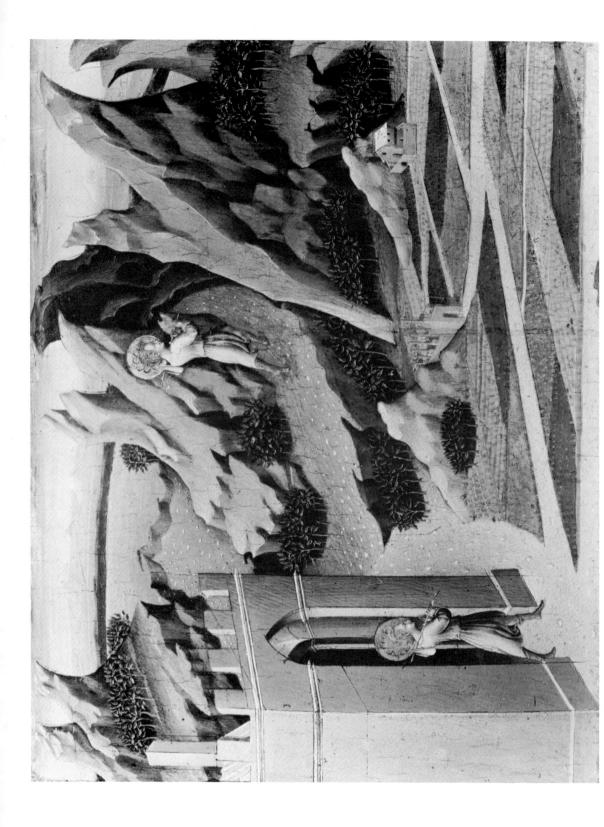

The art of painting, in its early stages, is concerned with things which one can touch, hold in the hand, or isolate in the mind from the rest of their surroundings. This is the feeling which underlies the advice of Cennino Cennini, the last spokesman of the mediaeval tradition of painting, when he says 'if you wish to acquire a good manner of depicting mountains and make them look natural, get some large stones, which should be rough, and not cleaned, and portray them from nature, applying the lights and darks according as reason permits you'. We must admit that Cennino's contemporaries succeeded in producing mountains further from nature and more irrational than any before or since. But that, no doubt, is because they found in their arbitrary shapes excellent material in which to display the fantastic rhythms of the late Gothic style. These spiny projections, standing out against the horizon like the teeth of a saw, or twisting into the distance like a gigantic corkscrew, are the equivalent of the pinnacles and flying buttresses of flamboyant architecture; and often, as in the backgrounds of Lorenzo Monaco they play an important part in the composition. When, later in the century, they appear in more classical designs, they have obviously been left over from another style. They shoot up surprisingly out of the flat, prosaic landscapes of Patenier; and Breughel, that master of natural observation, puts into the background of his St. John Preaching, a rock as crazily improbable as any in a Byzantine mosaic, but modelled with an air of truth, as who should consciously enjoy the telling of a tall story. It is one of the last survivors from the landscape of symbols.

Another reason why the mountains of Gothic landscape remain unreal is that mediaeval man did not explore them. He was not interested. Petrarch's mountaineering expedition remained unique until Leonardo climbed 'Monboso'. But the forests which lay outside the garden wall were different. Dark woods had always appealed to the depths of the mediaeval imagination, and from the fourteenth century onwards man began to penetrate them. For one thing, he went hunting. The Avignon frescoes themselves portray hunting, fishing and falconry; and the earliest pictures concerned entirely with natural observation are in manuscripts on sport. The little picture of rabbits in a wood in the *Livre de Chasse* of Gaston Phébus (c. 1400) [15] is done with real love, and supports the paradox, familiar enough in

¹But Cennino's advice also had a naturalistic basis. Poussin and Gainsborough followed the same practice. Degas went further, and said that if he wanted to draw a cloud he only had to crumple his pocket handkerchief and hold it up to the light.

literature, that it is chiefly through the instinct to kill that man achieves intimacy with the life of nature.¹

Hunting is traditionally the occupation, often the sole occupation, of the aristocracy, and the style of painting which made hunting one of its chief subjects was an aristocratic style. It grew up in the courts of France and Burgundy about the year 1400, and its most perfect surviving expression – no doubt many tapestries and wall paintings have been lost - is in the manuscripts illuminated for that great bibliophile, the Duke of Berry. One of these, the Très Riches Heures, to which the brothers de Limbourg made their contribution from about 1409 to 1415, is crucial in the history of landscape painting, for it stands half-way between symbol and fact. Before the sacred text comes the calendar. Now calendars, with the occupations of the months, are, throughout the middle ages, the best illustrations of everyday life; and the new profane art of the fifteenth century fastened on these as an available form in which to explore its new interests. In the calendar of the Très Riches Heures are several episodes of the chase: in August the cortège departing, dressed with the utmost elegance, the ladies with falcons on their wrists; in December dogs killing the wild boar in the wood [16]. But most remarkable of all as proof of the new confidence in nature is May, which shows a cavalcade of ladies and gentlemen, crowned with leaves, riding into the country out of the town of Riom, simply in order to enjoy the pleasure of spring. All these scenes of country life are done in the exquisite decorative manner and something of the fairy-tale spirit of the paradise gardens. But Pol de Limbourg, and all the other artists who created this style, though they were employed by princes, came from the bourgeois Low Countries, from a land of work and fact. Of the months in the Très Riches Heures, more than half represent the work of the fields, and in these we are aware of an eye for fact so keen that the symbolical inheritance of the middle ages is almost forgotten. The men sowing in front of the Louvre who illustrate the month of October, the scarecrow and the osiers by the bank of the Seine and the little figures opposite, all are rendered with an objectivity and a truth of tone only surpassed by Pieter Breughel.

Although aristocratic landscape painting originated in the courts of France and Burgundy, it spread immediately to Italy, where Gentile da

¹Bibliothèque Nationale. In these hunting MSS. we once more touch on the question of Oriental influences, as some of them were copied from Perso-Arabic originals, such as Moamin on Falconry.

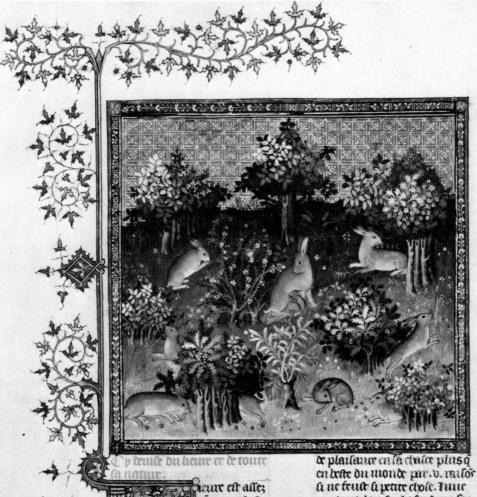

control alles comme befor fine me con ment in dur or la facon.

fort qui bien nen apen vin .

ils puient des bles et autres gang
nages de levites de fueilles de close
ces durbies de muluis et daname
autres finizamonte et bonne
lettelete un heure et moult pa

or plaisance en la cinica plus q en trate du monde par de raiso la ne feuit la peute ciple. Tune car tout lan la ciple dune leus neus ciparguer, et de mulle : autre telte ne le fair. Le austi le peut on ciplear au nelpre t au matur. au selpre quant sont seleces au matur quat sont seleces au matur quat sout alces au gute, et des autre teres non, car su pluce au ma tur vous aure; pour vie courine et des licures non. Lantre le q ur et cercher on heure est top

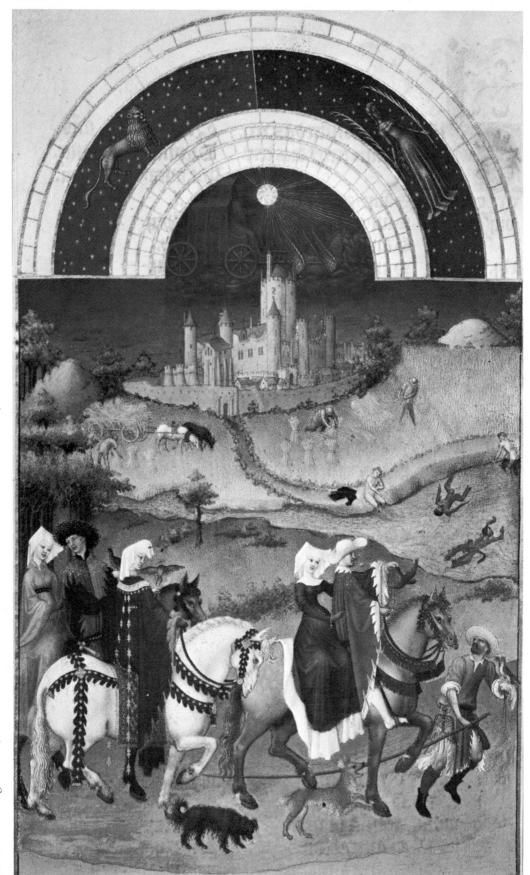

16 The Limbourg Brothers, Scenes from the Calendar of the 'Très Riches Heures du Duc de Berry'

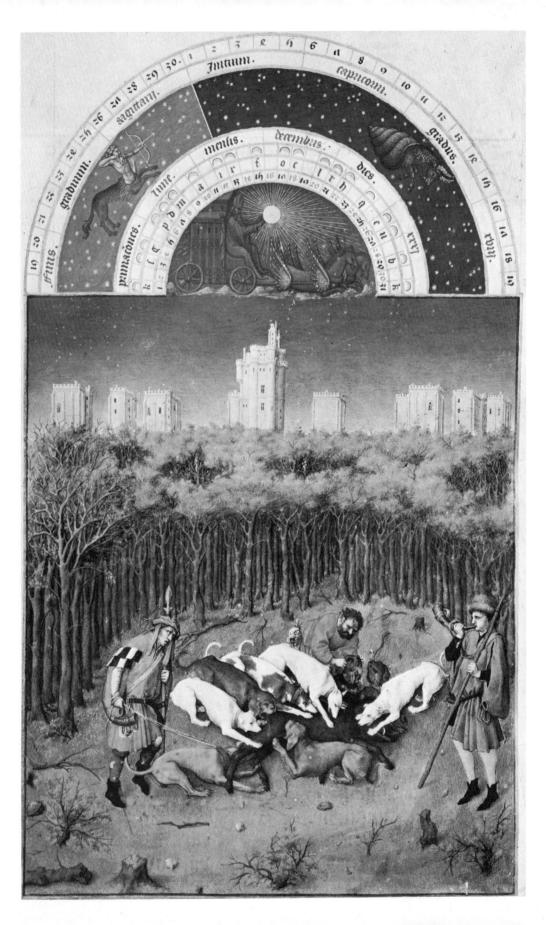

Fabriano gave to the international Gothic style a fullness, Pisanello a finality, beyond the range of the Duke of Berry's illustrators. From Pisanello's drawings we know that he had an almost Leonardesque curiosity about nature; and one of his few surviving pictures shows his feeling for forest life, the St. Eustace in the National Gallery. It is so dark in the wood that only after a few minutes can we discover all the animals; and this darkness was part of the imaginative perception of the time, as we can tell from several other sous-bois of the fifteenth century, above all from the supreme hunting picture by Paolo Uccello in the Ashmolean [18], which used to be described as a night scene, where a group of young Florentines, vital and elastic as the figures on a Greek vase, have invaded the forest and broken its ancient silence with their cries. We know that Pisanello painted many wall decorations in the Palace of Mantua¹ and elsewhere, with small figures in landscapes, which must have developed the style of the Limbourg calendar. Of these nothing remains, except some preparatory drawings; but we may perhaps judge of their effect from the frescoes at Trent, in the Torre del Aquilo of the Castle [19], painted by an artist whose name, date and nationality are all unknown, but who may be taken as a perfect representative of the international Gothic style of about 1420. Like the calendar of a manuscript, they represent the occupations of the months, peasants working in the fields while their masters picnic, make love, go hunting and even throw snowballs at one another. It is not surprising that these images of a pleasant earthly life were a favourite motive of profane decoration throughout the fifteenth century, and reappear on plates, chests and such wall decorations as that in the Casa Borromeo, Milan.

The most elaborate and extensive landscape of symbols, however, comes not from the manuscript, but from the tapestry tradition. It is Benozzo Gozzoli's *Journey of the Magi* in the Riccardi Palace, Florence [17], where all the details of late Gothic landscape, the carpets of flowers, the little woods, the fantastic rocks, the formalised trees and the cypresses already formalised by nature, are combined to decorate and to delight. The procession, which winds its way through the Val d'Arno, is destined to arrive at the Hortus Conclusus which fills the whole sanctuary of the chapel. Perhaps the fairy tale is a little long, and to some extent self-conscious; but by 1459, when the

¹These frescoes have now been discovered in ruinous condition and reveal the remains of vast panoramic landscapes.

fresco was painted, the landscape of symbols had already ceased to reflect the true creative impulses of the time.

What was it which made men no longer content to put together the precious fragments of nature into some decorative whole? The answer is: a new idea of space and a new perception of light. In the landscape of symbols the nexus of unity was the flat surface of the wall, panel or tapestry. This is not a childish or irrational way of recording visual experience, for our eye does not dwell on a single point, but moves, and we move, and a procession of objects passes before it. But about the year 1420, some change in the action of the human mind demanded a new nexus of unity, enclosed space. In a very extended sense of the term, this new way of thinking about the world may be called scientific, for it involved the sense of relation and comparison, as well as the measurement on which science is based. But it antedates the real rise of science by almost two hundred years, and we find it in the work of artists who do not seem to have been troubled by the mathematics of perspective, in the Blessed Angelico and the manuscript illuminators of the North. And then it is combined with another unifying medium, light. It has often been said that the sun first shines in the landscape of the Flight into Egypt which Gentile da Fabriano painted in the predella to his Adoration of 1423. To a great extent his style is still symbolic, for the rising sun itself is a solid disc of gold, and the light it sheds on the hillside is rendered by allowing the gold ground to show through the paint. But Gentile, by a sure sense of values, has united this golden light with the rest of his landscape, with the shadows cast by the olive trees, and with the cool tone of the valley which lies on the shady side of the hill. Here, for the first time, the details of landscape are united by light and not solely by decorative arrangement. A similar beauty of morning or evening light pervades the landscape backgrounds of the Blessed Angelico. Their ingredients are as economical as the cast of classic drama - a flowery background, a bare hill, a few cypresses, a city wall; but these are held together by a purity of tone equal to that of Corot.

But in spite of these moments of enchantment, it was not in Italian art that light first became the *primum mobile* of painting. Already in 1410 Pol de Limbourg, in his eagerness to record the truth of country life, has achieved a new unity of tone. And fifteen years later Hubert van Eyck has painted in the *Adoration of the Lamb* the first great modern landscape. From one point of view this marvellous work may be considered as the culmination of the

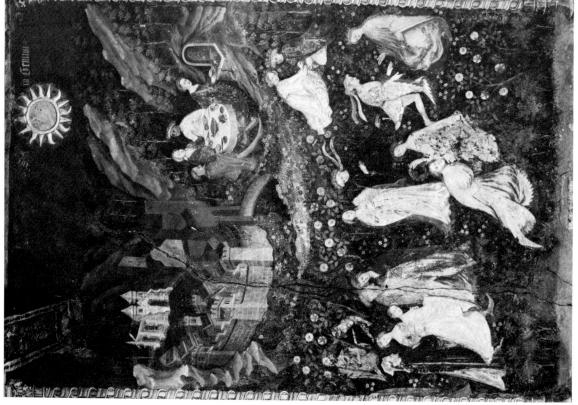

landscape of symbols. It is still conceived in terms of a paradise garden, in the centre of which stands the fountain of life. Leaves and flowers are all rendered with a Gothic sense of their individual entity and decorative possibilities. Round the garden there are still the remains of the Gothic forest, dense thickets of trees, with their trunks very close together. But the garden is not shut in with trees, nor even with a hedge of roses. As in a landscape by Claude, our eye floats over the flowery lawns into a distance of golden light. We have escaped from the middle ages. We have entered a new world of enraptured perception which is the subject of the next chapter.

THE LANDSCAPE OF FACT

Facts become art through love, which unifies them and lifts them to a higher plane of reality; and, in landscape, this all embracing love is expressed by light. It is no accident that this sense of saturating light grew out of a school of manuscript illuminations, and first appears in miniatures. For in such small images a unity of tone is more easily achieved, and the whole scene can be given the concentrated brilliance of a reflection in a crystal. Throughout history landscapes of perception have been small. Large landscapes, with all the artifice of construction, have been studio made. The impressionists seldom went beyond a scale which could be taken in by a single focus. When their followers, in England and elsewhere, forgot this, their pictures disintegrated. The first modern landscapes were exceedingly small - only about three inches by two inches. They were painted between 1414 and 1417 in a manuscript known as the Hours of Turin, executed for the Count of Holland, and I believe that there is sufficient evidence for us to say that they were by Hubert van Eyck.1 Viewed historically they are certainly amongst the most surprising works of art in the world, for in spite of all the researches undertaken in the last fifty years, no one has been able to point to their real precursors. Hubert van Eyck has, at one bound, covered a space in the evolution of art which the prudent historian would have expected to stretch over several centuries. The finest pages of this manuscript were destroyed by fire in 1904, a few years after they were discovered. One survives, in the Trivulzio library [20], and shows how van Eyck achieved by colour a sense of the saturation of light. The tone of the landscape has a subtlety hardly observed again until the nineteenth century, and the reflection of the evening sky in the water is exactly the kind of effect which was to become part of the popular landscape imagery of the last hundred years.

Of the destroyed pages we can gain a blurred impression from two old photographs. One of them shows a sailing boat on a lake, with the light sparkling on little waves, an effect which the van Eycks may have carried

¹ My theory of Hubert van Eyck is now (1976) rejected by all responsible critics.

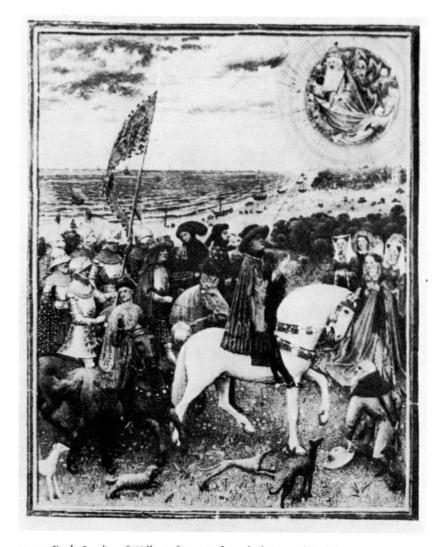

21 van Eyck, Landing of William of Bavaria, from the 'Hours of Turin'

out in other works now lost to us, as it was frequently imitated in the fifteenth century. It is a pure landscape; for Hubert van Eyck is so much in love with effects of light that the figures are entirely subordinate and the legend depicted is the slightest possible pretext. The other is of a sandy shore on which William of Bavaria has landed on his way back from England in 1416 [21]. The figures in the foreground are in the chivalric

style of the de Limbourgs; but the sea-shore behind them is completely outside the fifteenth-century range of responsiveness, and we see nothing like it again till Jacob van Ruisdael's beach-scenes of the mid-seventeenth century.

If we allow that these miniatures are by Hubert van Eyck, and if we accept the inscription on the Ghent altarpiece saying that it was largely his work, then we may believe that he was responsible for those heavenly distances in the Adoration of the Lamb when the landscape melts into light as in a Claude. And we may observe that in the pictures painted after his death in 1426, which are certainly by Jan van Eyck, the landscapes are more factual, more urban and less imaginative. Those who deny that Hubert existed may explain this by saying that Jan, like the rest of us, grew less poetical as he grew older. But they must also admit that in the earlier scenes, which I believe to be by Hubert, there is a remarkable sense of our being in the landscape - of our being able to proceed smoothly from foreground to distance. It is this low viewpoint, that hardly occurs again in fifteenthcentury Flemish landscape, which seems to me to distinguish him from the distant views reliably attributed to his brother Jan. In these the composition is divided into a foreground with figures, and a very distant landscape - or usually townscape - cut off from the foreground by a parapet and a large intervening space. The altar-piece of the Virgin with the Chancellor Rollin in the Louvre, probably painted about 1430, is the clearest example [22]. The landscape, when we get there, is miraculous enough and the rendering of light is most delicate. Landscape is to Flemish painting rather what the representation of movement is to Florentine. It heightens our sense of wellbeing by enlarging the range of our physical perceptions. It gives us magic spectacles.1 But in these tiny distances Jan van Eyck does not colour our vision by emotion, by a sudden feeling that the moment is blessed and eternal; and so he is less the ancestor of modern landscape than Hubert.

Later in life, however, in 1437, Jan did begin what would have been his finest landscape, and the one which most clearly anticipates the greatest landscape painter of the Netherlands, Pieter Breughel. This is the *St. Barbara* in Antwerp [23], of which only the preliminary drawing is completed. Perhaps the Breughelish effect of snow is an accident due to the pale priming

¹Jan van Eyck's pupil Petrus Christus and his chief rival 'Campin' continued to paint landscapes as if seen from a second story window in order to avoid the difficulty of realising a smooth transition from foreground to background.

22 Facing Jan van Eyck, The Virgin of Chancellor Rollin, (detail)

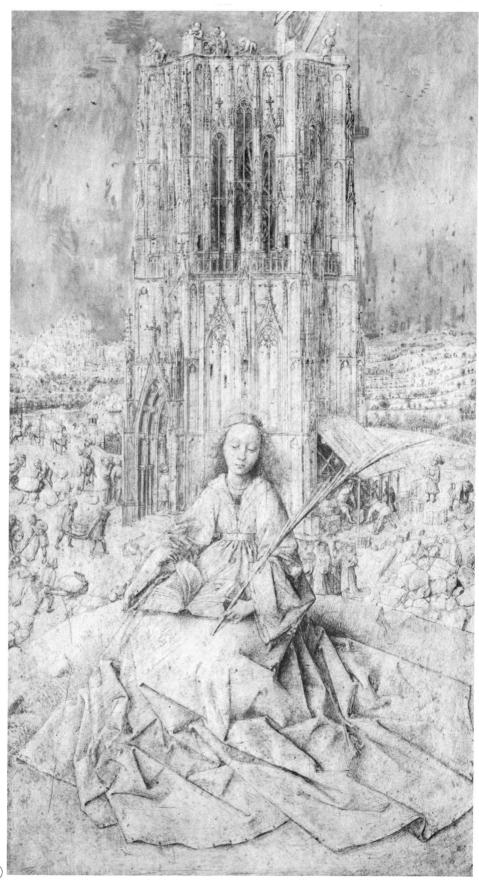

Jan van Eyck, Saint Barbara, (unfinished panel)

24 Robert Campin, *The Nativity*

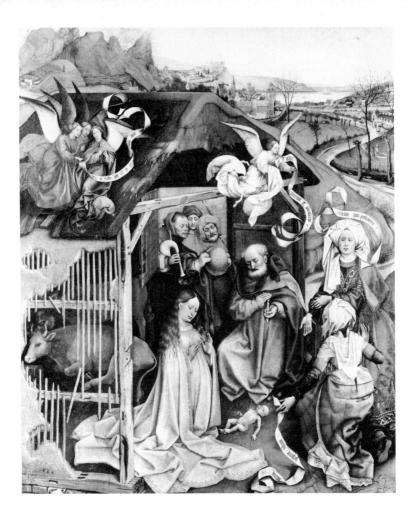

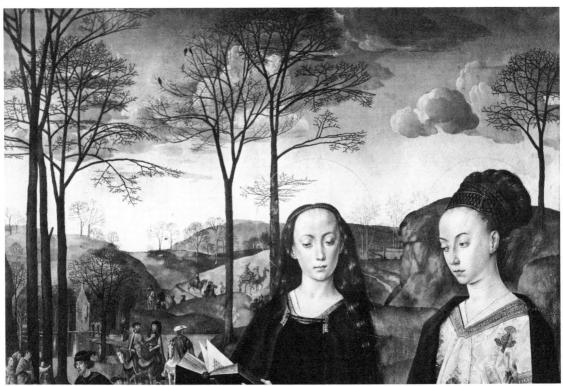

and the already tinted sky; but the sense of movement round the tower and the way in which all the small figures hold their positions in space shows a mastery which is not equalled till after 1550.

The other tradition of painting in the Netherlands, that which springs from Tournai and from the artist whom historians call either Campin or the Maître de Flemalle, was also concerned with the facts of landscape, but remains closer to the tradition of the de Limbourgs. 'Campin's' backgrounds are as sharp and crystalline as the view through the wrong end of a telescope but they show little of the van Eycks' rapture at the all enriching envelopment of light. Occasionally, as in the Nativity at Dijon [24], they have a kind of winter poetry, which is in harmony with the hard, sculptured character of his figures. The Nativity was, of course, a winter scene, but we may suppose that there was also a pictorial reason why the painters of this group preferred a season in which the forms of nature have the angularity and the linear clarity of their serious late Gothic style. The most beautiful of all these winter landscapes is in the background of Hugo van der Goes's Portinari Altarpiece [25], where the austere silhouettes of trees, as decorative in design as if they were by the Douanier Rousseau, recede into the distance with a sure sense of interval.

The resolute search for truth in these early Flemish landscapes, and the eagerness with which the artists' eye seems to have fed on each object leads us to ask how they were done. They can hardly have been painted from memory; but are they put together from drawings, or are they portraits of actual places? Hubert's miniatures are so sure in their sense of colourvalues that they must be based on studies made direct from nature, probably in water colours. The beach scene in the Turin miniature was certainly the record of an actual scene. Jan's townscapes were probably based on silver point drawings, of which the St. Barbara must give an impression, no doubt studies of individual buildings were combined for pictorial effect; for example in Hubert van Eyck's Virgin and Child in the Frick collection, an accurate rendering of old St. Paul's is placed in a town which can never have been London. The first undisputable piece of topography in art is by a follower of 'Campin', the Swiss Konrad Witz. This is in the background of his picture of The Miraculous Draught of Fishes in the Geneva Gallery, dated 1444 [26], which portrays, in Pre-Raphaelite detail, the shores of the lake of Geneva. It remains exceptional for fifty years, and we can see from his other paintings that Konrad Witz was one of those artists, who are haunted by

26 Konrad Witz, The Miraculous Draught of Fishes

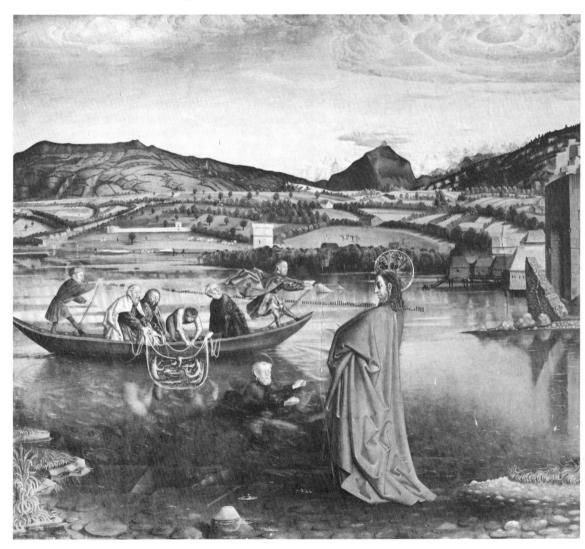

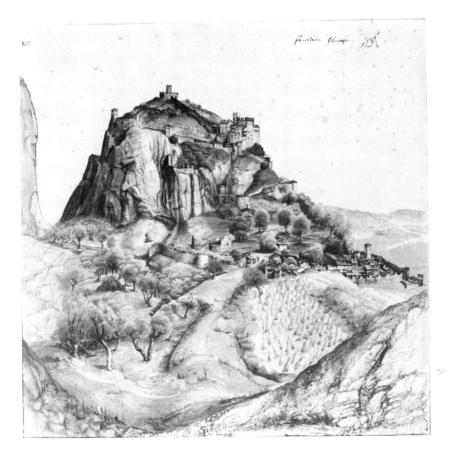

27 Dürer, View of Arco

the strangeness of certain shapes, and tend to absorb themselves in absolutely literal representation as a kind of escape from their obsessive dreams.

The curiosity about the precise character of a particular spot, which was a part of the general curiosity of the fifteenth century, culminated in the topographical water-colours of Dürer. They begin in 1494 with some drawings which, in their earnest desire to give every available fact, are almost like the work of a Sunday painter. But a few months later Dürer produced the water-colour of Innsbruck, now in the Albertina, which is not only the first portrait of a town, but shows a delicate perception of light. The drawings of the Castle of Innsbruck done at the same time are pure topography, and are more remarkable for curiosity and dexterity than for those

LANDSCAPE INTO ART

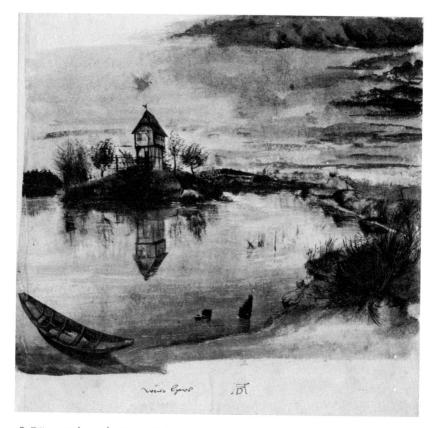

28 Dürer, Fisherman's Hut on a Lake

qualities which we nowadays call aesthetic. Yet this curiosity, by its intense concentration, has a compelling effect. 'He holds us with his glittering eye.' We move through the olive grove, and scale to the summit of Arco [27], led on by the force of Dürer's unfaltering hand. This drawing was done on the way back from Venice in the spring of 1495 and is the first of a series of water-colours which not only show Dürer's phenomenal skill, but are timeless. In his figure drawings he mastered, almost too completely, the idiom of the time. In his landscapes he is the master of all styles and subjects, from rocks, like Cézanne's quarry, to visions of poetical solitude [28 and 29] that strangely anticipate the sentiment of the nineteenth century.

I have said that one condition of the landscape of fact was a new sense of space. This appears simultaneously in Flemish and Italian art, but although

producing a similar result it is different in means and in intention. In van Eyck it is instinctive, a by-product of his perception of light; and throughout the course of Flemish painting it remains empirical. Now this empirical rendering of space, this tracing, as it were, on a transparent screen, fulfils the needs of naturalistic painting. But it could not satisfy the mathematically minded Florentines. They demanded, in the words of Luca Pacioli, that art should be concerned with certezze, not with opinioni; and they believed that such certezze could only be established by mathematics. Their definition of the real was that which could be proved to occupy a given position in space. The result of this thirst for certainty was scientific perspective, invented, as we are told, by Brunelleschi, first put into words by Leon Battista Alberti, and given its fullest treatment by Piero della Francesca. As a geometrical proposition Brunelleschian perspective is 'true', but its application to the art of painting involves a number of conditions which are seldom found in combination; in fact we may doubt if it has ever been applied with complete accuracy except by its inventor. A contemporary biographer of Brunelleschi tells us how he made a painting of the piazza of

29 Dürer, Pondin a Wood

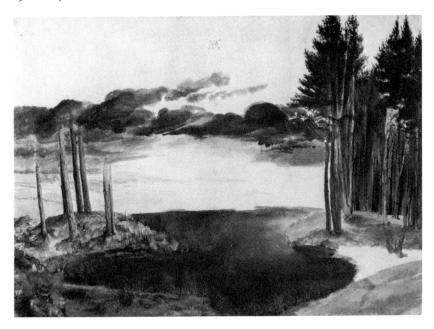

San Giovanni, diminishing all the lines in accordance with his mathematical rules; and then, in order to establish the position of the spectator, he made a hole in his picture at the vanishing point. The spectator looked through this hole from the back and saw the picture reflected in a mirror which was placed at the exact distance of Brunelleschi's original point of view. Thus perspective achieved *certezze*. But there was one element in landscape which could not be brought under control: the sky. The continual flux of change in the sky can only be suggested from memory, not determined by mathematics; and Brunelleschi, perfectly recognising the limitations of his own approach, did not attempt to paint the sky behind his *piazza*, but put instead a piece of polished silver.¹

Clearly scientific perspective is not a basis for naturalism, and the fact that it continued to be taught in school, by professors who have long forgotten its purpose to pupils who will never apply its laws, is an example of the inherent platonism of all academic teaching. Even in Florence of the fifteenth century its abstract character was not fully understood, and Alberti himself varies between a mathematical and a realistic approach to appearances, without recognising that the two are incompatible. Like many of the finer spirits of the time he had come to take pleasure in the spectacle of nature. His autobiography describes how the sight of fields of corn and well-grown trees moved him to tears, and his friend, Pius II, records with equal emotion his delight in the vineyards and oak forests of Siena.

To concentrate these visual experiences, Alberti invented a device which seems to have been a sort of *camera obscura*, the images of which he called 'miracles of painting'. He has described the vast and varied panoramas obtained in his magic box, and we see that this conception of landscape was related to the first realistic backgrounds of Italian art. They appear about 1460 in the work of Baldovinetti and the brothers Pollaiuolo. The notion of a distant view from a high terrace must owe something to Flemish influence, but the literal truth with which these artists depict their native Val d' Arno suggests that their real motive was scientific naturalism. The background of Baldovinetti's *Nativity* in the Annunziata (1460) is much perished; Pollaiuolo's *Labours of Hercules* (1460) are lost and only known to us through

¹Brunelleschi's demonstration is lost, but it started a fashion for perspective views of ideal towns, of which at least four survive. Three of these come from the workshop of Piero della Francesca, and are inspired by the architecture of Alberti; a fourth may be by Francesco di Giorgio.

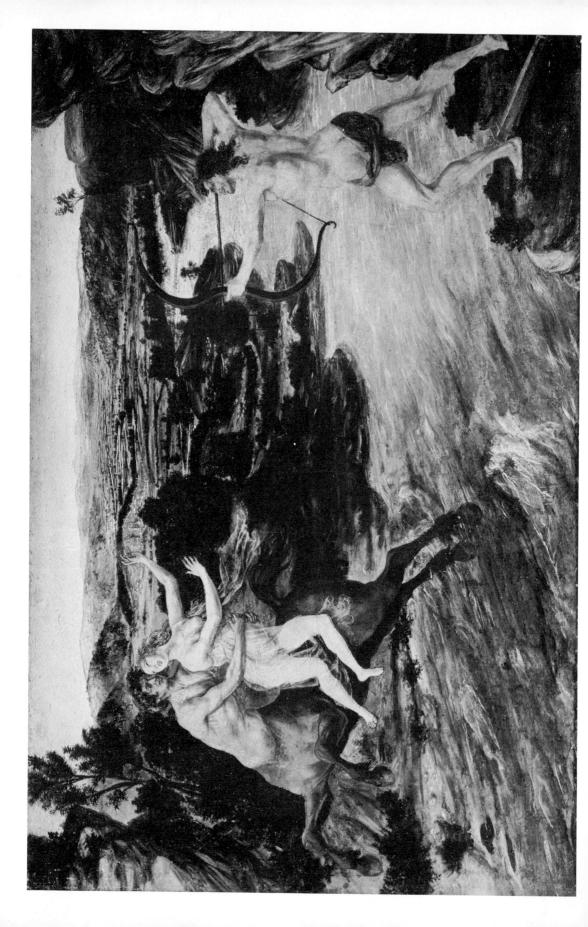

his miniature replicas. But fortunately we still have his later *Martyrdom of* St. Sebastian, 1475 [30], with a landscape of astonishing sweep and truth. This is a very high order of topography resting on a curiosity and a sharpness of vision quite strong enough to make the landscape in the picture as important as the nude. But in the whole picture the jump from foreground to background is unusually disconcerting because Pollaiuolo does not even put his figures on a plateau or terrace, and we are uneasily conscious that something has gone wrong with the middle distance. It is this which mars the first Italian picture in which landscape is not incidental, but essential, Pollaiuolo's Rape of Dejanira in the Jarves Collection, New Haven [31]. The observation is fresh and brilliant, but the rendering of space is much less consistent than in the Flemish paintings of fifty years earlier, and we see how, for practical no less than theoretical reasons, it was difficult for the Florentines to combine a mathematical with a realistic position. The panorama of the camera obscura demanded a high point of view, but Brunelleschian perspective was feasible only when the receding plane was at right angles to the plane of vision. The two most beautiful distance landscapes of the 1460s recognise this fact and adopt the traditional device of a high ledge. These are the reverses of Piero della Francesca's portraits of the Duke of Urbino and his wife [32]. Piero was the greatest living master of perspective; he was also the friend of Alberti and must have known his camera obscura. But when it came to the painting of light he realised the superiority of the North, and of all his contemporaries made the most intelligent use of the late Quattrocento fashion for Flemish painting. His assimilation is complete. The shining lake behind the Duke's white horses may recall the river distances of the van Eycks, but the character of the landscape and the quality of light is entirely Umbrian, and may be seen there to this day. This is the light, and these the soft undulations, which continued to inspire Perugino long after his Florentine contemporaries had given up all pretence of painting the landscape which surrounded them, and had come to rely on the round hills and bushy trees of Roger van der Weyden to furnish their backgrounds in the fashionable taste. For the naturalism of Alberti's magic box and Pollaiuolo's panoramas was a freak, an experiment without roots, like so much of the art and thought of that infinitely curious century. It was not in Tuscany, but in Venice that the revelation of the van Eycks was to be understood and expanded.

We say 'in Venice'; but we mean 'in the art of Giovanni Bellini'. No other

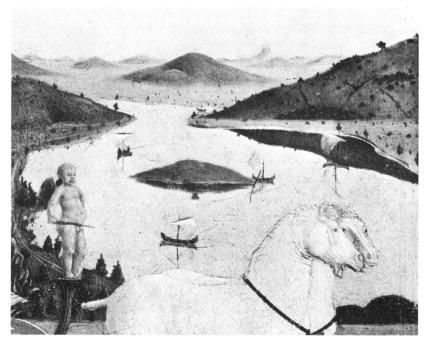

32 Piero della Francesca, reverse of Montefeltro portrait

school of painting is to the same extent the creation of one man; and there was no reason why the Venetians should have excelled in landscape, had it not been that Bellini was by nature one of the greatest landscape painters of all time. How far he was directly influenced by Flemish art it is impossible to say. In portraiture, he certainly studied the van Eycks and even Memlinc; and he was probably affected by the mysterious and powerful personality of Antonello da Messina, who was in Venice in 1475, and who, through Petrus Christus, was the direct heir of the van Eyck tradition. Antonello's landscapes have all the dispassionate precision of his Flemish masters, and in at least one of his surviving works, the early Crucifixion at Hermannstadt (c. 1460-65) [33], the minutiae of his distances are fused into a total impression of great beauty. The scene itself, with its dark sea and mountainous, irregular coast, clearly represents his native Sicily. Antonello was not only a master of Flemish realism, but also of systematic perspective. In the St. *Jerome* of the National Gallery it is used to create the illusion of space, and in the Dresden St. Sebastian we find a strict, ideal perspective combined with the direct observation of sunshine. We know too little of the period to say

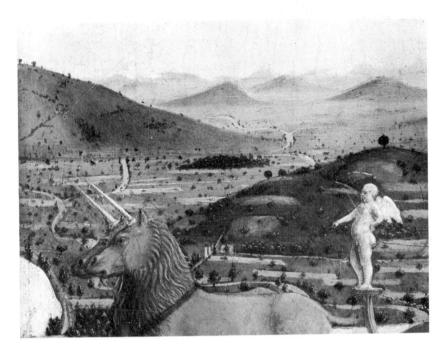

Piero della Francesca, companion to 32 opposite

whether Antonello influenced Bellini, or whether both were inspired by the example of Piero della Francesca; and in any case Bellini's responsiveness to nature required no pressure from outside. He was born with the landscape painter's greatest gift: an emotional response to light. To realise this we need only make the eternally rewarding comparison between his Agony in the Garden and that of Mantegna. Even at the period when the skill of hand and firm convictions of his formidable brother-in-law seemed to him the highest achievement of art, Bellini makes an effect of light the motive power of his picture. He chooses, to symbolise his subject, the moment when the plain is still in shadow, but the rising sun has touched the hilltops. Deeply imaginative as it is, this effect is also perfectly true, as anyone who has visited the walled towns of the Veneto will remember, and it is clearly the result of impassioned observation. Bellini's landscapes are the supreme instance of facts transfigured through love. Few artists have been capable of such universal love, which embraces every twig, every stone, the humblest detail as well as the most grandiose perspective, and can only be attained by a profound humility. Ruskin, in his chapter on the pathetic

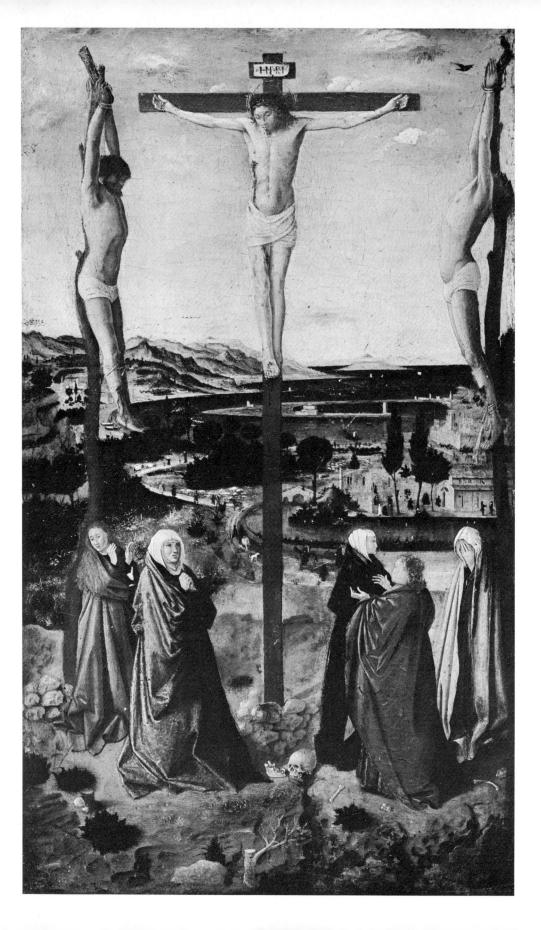

fallacy, in volume three of *Modern Painters*, distinguishes three classes of perception: 'The man who perceives rightly, because he does not feel, and to whom the primrose is very accurately the primrose, because he does not love it. Then, secondly, the man who perceives wrongly, because he feels, and to whom the primrose is anything else than a primrose: a star, or a sun, or a fairy's shield, or a forsaken maiden. And then, lastly, there is the man who perceives rightly in spite of his feelings, and to whom the primrose is

34 Giovanni Bellini, Resurrection

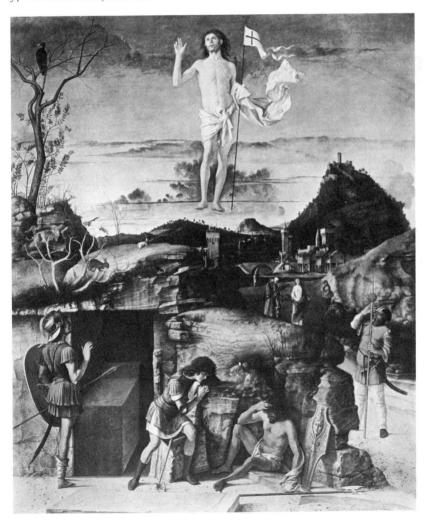

for ever nothing else than itself – a little flower apprehended in the very plain and leafy fact of it, whatever and how many soever the associations and passions may be that crowd around it.'

Bellini was of the third class, and to it, as Ruskin says, belong poets of the highest order. In his early work he had loved the poignant light of sunrise and sunset, and these moments of heightened emotion he continued to portray when they could intensify the meaning of his subjects, as in the Resurrection in the Berlin Gallery [34]: it is typical of Bellini's charity that the light which irradiates Our Lord has already crept round the tomb to bathe the sleeping soldiers. But as he grew older he became more in love with the full light of day in which all things can expand and be completely themselves. This is the feeling which pervades the picture of St. Francis now in the Frick Collection [35]. Here, at last, is a true illustration of St. Francis' hymn to the sun. No other great painting, perhaps, contains such a quantity of natural details, observed and rendered with incredible patience: for no other painter has been able to give to such an accumulation the unity which is only achieved by love. 'As the air fills everything and is not confined to one place', says Sebastian Franck, the sixteenth-century mystic, in his Paradoxa, 'as the light of the sun overflows the whole earth, is not on earth, and yet makes all things on earth verdant, so God dwells in everything and everything dwells in Him.'

The *St. Francis*, though full of light, is painted with a rigorous sense of the individual identity of forms; but in many of Bellini's later works forms are more fused in the general atmosphere. He loved especially the soft, palpable air of a summer evening, when forms seem to give back the light which they have absorbed all day. But he could respond to very different moods of nature. The *Virgin of the Meadow* in the National Gallery [1], shows a chilly day in early spring when the rigid lines of winter are just beginning to relax and the poplars have put out their first russet leaves. A pale sunshine is on the distant towers, but the stony foreground is chiefly in shade. Yet this evanescent effect of light is fixed with a certainty and simplicity which gives it the indestructible look of a Greek marble.

Piero's landscapes date from the 1460s; Pollaiuolo's *St. Sebastian* from 1475, Bellini's *St. Francis* from about ten years later. Soon after this the landscape of fact disappears from Italy, and, with one great exception, from northern Europe. It does not reappear till the mid-seventeenth century. Of course, plenty of fact gets into landscapes: the backgrounds of Raphael, Giorgione,

Titian and Paul Veronese are full of wonderful passages of observation. But none of these painters considered that the recording of a true visual impression of nature was a sufficient end in itself. Landscape had to carry with it some literary association, or scenery be intensified to heighten some dramatic effect. The high Renaissance style, which dates from the first years of Raphael and Michelangelo in Rome, was based on the study of antique sculpture which made the human body an omnipotent medium of expression. All theories of art – and theorists abounded – insisted that the value of a painting depended on the moral or historical importance of its subject. The pleasures of recognition were considered unworthy, and even portraiture attempted the heroic. Perhaps these theories alone would not have changed the course of art, but for almost fifty years they had the support of Michelangelo's overwhelming genius. Michelangelo saw quite clearly that landscape was inimical to his ideal art; and he also saw that it was a Flemish invention.

'They paint in Flanders,' he said to Francisco de Holanda, 'only to deceive the external eye, things that gladden you and of which you cannot speak ill. Their painting is of stuffs, bricks and mortar, the grass of the fields, the shadows of trees, and bridges and rivers, which they call landscapes, and little figures here and there. And all this, though it may appear good to some eyes, is in truth done without *reason*, without symmetry or proportion, without care in selecting or rejecting.' Michelangelo, steeped in neo-Platonism and perpetually struggling with an ideal of art so strenuous and exalted that the mere pleasures of perception seemed to him beneath contempt, might justifiably regard the flowery meadows of Gherard David and the panoramas of Patenier as suitable (as he said) for 'young women, monks and nuns, or certain noble persons who have no ear for true harmony'.

At the moment when Flemish painting had become timid and conventional and the formula of landscape backgrounds was twisting itself into mannerism, there appeared one of the most disturbing figures in the history of art, Hieronymus Bosch. He was, of course, one of the great geniuses of fantasy, and as such will reappear in my next chapter. But one reason why his fantasies of the unconscious are so convincing, even when the fables of popular mysticism which inspired them are forgotten, is that they are based on the most delicate perception of nature. Bosch's backgrounds contain some of the most truthful landscapes of fact painted in the Netherlands since the van Eycks; and in this, as in much else, he consciously reverts to the art

of the early fifteenth century. As a young man Bosch seems to have realised that the art of his own time – the late 1470s – was tame and conventional compared to that of fifty years earlier, and he looked back to the illustrators of the late middle ages both for their revivalist imagery and for their surprised delight in what they saw. We can see the result in a hundred details and in such landscapes as that which fills the background of his *Adoration* of the Prado [37]. The sensitive touch with which he registers every subtlety of tone is closer to Guardi than to his Flemish contemporaries, and in this he even surpasses the more massive understanding of his greatest follower, Pieter Breughel.

[In establishing the link between Bosch and Breughel I left out a most important work in the history of the landscape of fact: The Rest in the Flight by Joachim Patenier in the Prado. Patenier was the first painter to

make his landscapes more important than his figures, and will reappear in a later chapter as a precursor of poetic mannerist landscape. But here I must draw attention to the right-hand side of the Rest in the Flight [36], which is a remarkable link between the truthful observation of the Limbourgs and Breughel. It precedes similar effects in Breughel by about forty years.]

Breughel is, of course, the exception I mentioned on an earlier page, the one master of naturalistic landscape who comes between Bellini and the seventeenth century. He was probably born in the 1520s, after the death of Bosch, but we know nothing of his work before an engraving executed in Rome in 1553. Italian landscape painting at the time was entirely dominated by the elaborate fantasies of mannerism, in which, as we shall see in the next chapter, the essential ingredients were a high viewpoint, a range of craggy mountains and a distant prospect of river and sea coast. Breughel mastered this mannerist style, and it remains the scaffolding for a great part of his work. Many of his paintings, indeed, fall clearly into my category of the landscape of fantasy. But he was so continuously excited by what he saw, and possessed such prodigious powers of observation and memory, that his place is with the masters of fact; and his study of Bosch and Patenier showed him how this love of truth could be made to carry a Rabelaisian wealth of invention, a weight of anecdote and popular mythology which would have sunk a lesser painter in depths of triviality.

In so far as we can trace a development in Breughel's short career, it is in his ability to make his criticism of life implicit rather than explicit. He begins with proverbs and allegories, in which landscape is a setting and an accessory; he evolves to the great landscapes in which the accidents of human life are one with the weather and the seasons. Few works of art are less in need of commentary. They are like Handel's *Messiah* and the *Pilgrim's Progress*, amongst those very rare works of the first order which have a widespread, immediate appeal. His *Hunters in the Snow* has come to hold almost the same place in the popular imagination as was held by the madonnas of Guido Reni and Sassoferrato a hundred and fifty years ago, and in wintry weather people may be heard muttering the name of Breughel much as, in the eighteenth century, travellers invoked the name of Salvator Rosa, and with a good deal more justice.

Even these compositions of his maturity conform to the mannerist pattern [38] – which, indeed, with its affectation of world landscape, suited Breughel well enough. But at the same time these are full of reminiscences of early

Flemish painting - for example the trees in the January landscape remind us of Hugo van der Goes's Portinari Altarpiece, although the composition is closer to Niccolo dell' Abate. When a primitive means gave added directness to his effect Breughel was a shameless archaiser, and many of his pictures must have looked old fashioned to his contemporaries. The horseman on the left of the Massacre of the Innocents has come straight from a Gothic illuminated page. But Breughel was not one of those archaisers who simplify in order to evade difficulties. If, in the Census in Bethlehem, certain details like the carts and trees are of archaic simplicity, others, like the group round the window, are incredibly complex and show complete mastery of illusionist painting. And if Breughel sometimes reminds us of van Eyck, as in his distant towns, or even of de Limbourg, in his snow and corn-fields, he was also capable of anticipating van Goyen, and van de Velde. The farm-house to the right of his Birdsnester, for example, might have been painted at any time during the later seventeenth century. Such landscapes as those in which he places the Blind Men and the Misanthrope are dateless.

The confidence with which Breughel looks back and forward in time and seizes any weapon which comes to hand, is almost Shakespearean, and is used

for a similar end: the expression of an all-embracing sympathy with humanity. For although his human beings, their faces simplified to mere discs, seem sometimes to lose their individualities, and become part of the mechanism of the universe, yet in the end it is the struggles and miseries and scarce animal pleasures of their lives which really absorb him, and dictate the character of his landscapes. Breughel's work remains unique. Though he had many imitators, none was able to use his style for a fresh creative purpose. The course of landscape painting was set towards a totality of impression and away from the rich accumulation of incidents with which Breughel's landscapes were filled. But now that impressionism has run its course, some painter who believes that the life of man is linked with nature may once more turn to him for inspiration.

We now come to the landscape of fact which directly influenced, or even created nineteenth-century vision, the landscape of seventeenth-century Holland. It bears no resemblance to Breughel, and its kinship with the backgrounds of Bellini and Pollaiuolo depends solely on similarity of aim, for these early Italian landscape painters were entirely unknown in Holland. How can we account for it? There is no single answer, and even a series of convincing looking reasons omits the vital principle upon which all movements in art depend. We may, however, give answers in three different modes which help to an understanding of the situation.

First, sociological. The landscape of fact, like all portraiture, is a bourgeois form of art. Seventeenth-century Holland was the great, we may say, the heroic epoch of bourgeoisie, and its art reflected the desire to see portrayed *recognisable* experiences. Actually the Dutch bourgeoisie got much better artists than it deserved: it lavished its wealth on Dou and Mieris, let Hals go to a poorhouse, Rembrandt go bankrupt, Ruisdael and Hercules Seghers starve, and Hobbema, who, like Rousseau, was a *douanier*, give up painting. But it is not the extent and quality of patronage which influence an art form so much as the general sense of what is needed. And the Dutch felt the need of recognisable, unidealised views of their own country, the character of which they had recently fought so hard to defend.

Secondly, philosophical. This was an age in which men once more felt free to ask questions about the workings of nature. The curiosity of the Renaissance had been repressed by the Counter-Reformation, though never quite destroyed. Now that the wars of religion were over – in Holland at least – a revival of science was possible. This has been called the Age of Observation.

It could almost be called the age of lenses. Leuwenhoek and Boerhaave looked through lenses of a microscope and discovered new worlds in a drop of water; Galileo, 'The Tuscan artist with his optick glass' discovered new worlds in the sky. The details of nature were arranged and classified by Christian Huyghens. In England Newton evolved his theory of light and, as so often happens, art anticipated intuitively what science was to formulate.

We may also, I think, count landscape painting as a symptom of quietism. After the pandemonium of religious war and the hurly-burly of, shall we say, Ben Jonson's plays, men needed an interval of calm. The Dutch landscape painters, like Izaak Walton, make no very ambitious claims for their art. But at least it is 'the contemplative man's recreation'.

Thirdly, the reasons within the art itself. By 1600 the tradition of mannerist landscape was exhausted. It was still conventionally accepted by grand collectors, as we may see by examining those pictures of their galleries, which were so frequently painted in the seventeenth century, and which suggest that fashionable taste in the seventeenth century took as much pleasure in mediocre art as it does today. Meanwhile, the old Netherlandish love of representing the thing seen had never been completely smothered and was there to reassert itself when the pressure of fashion was relaxed. It would be a mistake to suppose, however, that Dutch landscape painting is admirable in proportion to the degree of fact it contains. The most naturalistic painters like Adrian van de Velde are by no means the most inspired, and often showed their inheritance from miniature painting in a too literal minuteness. On the other hand, some of the greatest pictures of the period are ideal landscapes, like Rembrandt's Mill and Hercules Seghers' mountain prospect in the Uffizi. As a painter, indeed, Seghers must be reckoned as one of the great masters of the landscape of fantasy, but his etchings and drawings show him to have been the first discoverer of Dutch scenery, both its oak woods with grassy paths, and its panoramic views over flat country. Thirty years later Hobbema and de Koninck were to carry out these discoveries in paint.

This difference between drawings and paintings proves the immense prestige of ideal landscape, and is nowhere seen more clearly than in the work of Rembrandt. Here was one of the most sensitive and accurate observers of fact who has ever lived, and one who, as time went on, could immediately find a graphic equivalent for everything he saw. In his landscape drawings of the 1650s, every dot and scribble contributes to an effect of space and light;

39 Rembrandt, Canal with a Rowing Boat

problems which had baffled earlier landscape painters, for example, the difficulty of the middle distance, of getting into a picture smoothly from a low point of view, did not exist for him. The white paper between three strokes of the pen seems to be full of air [39]. And Rembrandt loved the facts of landscape: he had an appetite for the movement of rushes, the reflection of canals, the shadows on old mills, as voracious as that of Constable. Yet when he came to paint he felt that all these observations were no more than the raw material of art. For him, as for Rubens, landscape painting meant the creation of an imaginary world, vaster, more dramatic and more fraught with associations than that which we can perceive for ourselves. Looking at his drawings and etchings we may regret this high ambition which has deprived us of masterpieces in our own mode of seeing. But Rembrandt's greatest landscapes, with their solemn, legendary atmosphere, may in the end seem more satisfying than the transparent records of perception, however miraculous their precision and delicacy.

Brunelleschi's attempt to reduce nature to terms of measurement had been defeated by the sky; and it was the sky which inspired those Dutch painters who first made an impression of landscape their whole subject. Holland is a country of great skies and it was through the influence of what Constable called 'the chief organ of sentiment' that her painters transformed the man-

40 Jacob van Ruisdael, View near Haarlem and (facing) The Banks of a River

nered picturesque of Velvet Breughel and de Momper into a true school of landscape painting. Jan van Goyen, the oldest of the group, had inherited this artificial style, but the loving delicacy with which he observed every nuance of a cloudscape gradually extended to the scene as a whole. He is removed from naturalism only by his colour which seems often to be little more than monochrome, but is always based on a subtle contrast of warm and cool tones. When sky was reflected in water, there was achieved that unity of luminous atmosphere which is one of the chief qualities of Cuyp and the whole point of van der Capelle and van de Velde. Any second-rate painter of sea and sky may enchant us, while an artist as skilful as Hobbema grows tedious when the elaborately described trees in his woodland scenes are not subordinated to a general principle of light. To this there is one great exception, Jacob van Ruisdael, who must be reckoned the greatest master of the natural vision before Constable. This grave, lonely man was evidently subject to fits of depression in which he worked without a spark of feeling or vitality. But when his emotions were rekindled he felt the grandeur and pathos of simple nature with a truly Wordsworthian force [40]. This feeling he expressed, as all the greatest landscape painters have done, through the large disposition of light and dark, so that even before we approach his pictures we feel their dramatic significance: it is only on looking more closely that we find them full of observed facts. Once more light lifts these facts on to a new plane of reality; but here light has a new character. It is no longer static and saturating as in Bellini. It is in continual movement. Clouds pile up in the sky, shadows sail across the plain. Constable said that the best lesson on art he ever had was contained in the words, 'Remember light and shadow never stand still'. Nowhere, in the art which preceded him, was this lesson so beautifully demonstrated as in the paintings of Ruisdael [40], and in fact Ruisdael was to become the model for the whole East Anglian school of landscape painting.

In the middle of the seventeenth century the Dutch school also perfected the painting of towns and buildings. This was part of a curious (and, I believe, unexplained) revival of classic principles of design, as opposed to the mannerist principles of the earlier genre painters. Of this revival Vermeer was the most distinguished and consistent representative, but for a time it affected de Hooch, Terborch, Metsu and even Jan Steen; and it is the basis of such exercises in perspective as the architectural pieces of Saenredam, Berckheyde and de Witte. Into the clear geometrical structure of Brunelleschi

and Alberti, the Dutch could slip as much detail as they liked without embarrassing us by its triviality. They could also include a greater or lesser realisation of atmosphere. In Saenredam the atmosphere is, so to say, used decoratively [42]; in Berckheyde it is uncomfortably reminiscent of the camera lucida; in van der Heyden [43] it reveals a sharpness of detail carried to a point of mania, which the painter manages to communicate to us. We find ourselves beginning to count the bricks in his buildings. In one instance the rendering of atmosphere reached a pitch of perfection that for sheer accuracy, has never been surpassed: Vermeer's View of Delft [41]. This unique work is certainly the nearest which painting has ever come to a coloured photograph. Not only has Vermeer an uncannily true sense of tone, but he has used it with an almost inhuman detachment. He has not allowed any one point in the scene to engage his interest, but has set down everything with a complete evenness of focus. Such, at least, is our first impression of the picture, and the basis of its popularity with those who do not normally care for painting. But the more we study the View of Delft the more artful it becomes, the more carefully calculated its design, the more consistent all its components. Truth of tone in painting is like a perfect night's sleep. One cannot explain it; one knows only that by some miracle all the contradictions of daily life are quietly resolved.

By the end of the seventeenth century the painting of light had ceased to be an act of love and had become a trick. The *camera lucida* was no longer an object of wonder, but an habitual artist's companion. In this strange Indian summer of humanism man was so well satisfied with his own works that he did not wish to look beyond them. Amongst his recent creations was the mechanistic universe, which from having been an exciting discovery had become a commonplace. Nature, as Carlyle said, had become an old eight-day clock which could be taken to pieces and put together again according to taste. No wonder that landscape painting became mere picture-making according to certain formulas; and that fact was confined to topography.

Occasionally, when the topographer happened to be an artist, he could not suppress his interest in the beauty of atmosphere, and once more the land-scape of fact was raised to the condition of art. With Canaletto the fresh impact of a scene roused him to transcend his ordinary style. The *Stonemason's Tard* [44] was painted because the scene appealed to him, and not for sale to some travelling Englishman; his first views of the Thames express his pleasure in a new kind of light [45]. It is sad to think that this clear, smoke-

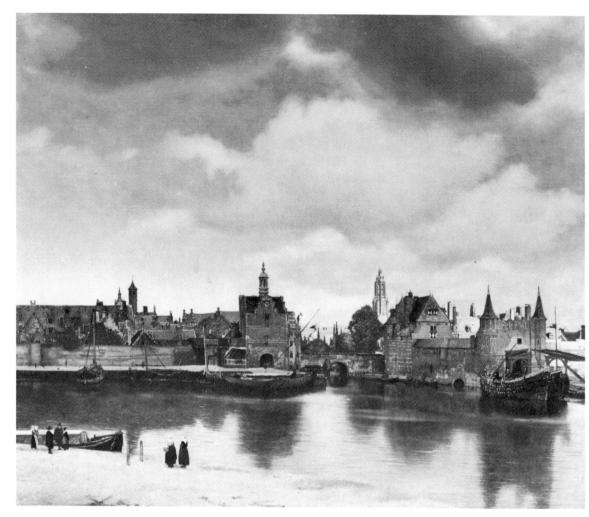

41 Vermeer, View of Delft

free London with its orderly buildings would, in a hundred years, have become the London of Gustave Doré. Canaletto was too successful and as commissions began to pour in, the atmosphere leaked out, until he sank to the condition of an industrious topographer. His successor, Francesco Guardi, had an impressionist's quickness of eye. He could catch the most delicate tone of a sail against the sky, the most tremulous light reflected from a canal on the faded plaster of a Venetian palace [45]. He is, as singers say, always in the middle of the note. But he was committed to a rococo principle of composition and a brilliant calligraphic style of drawing which belonged to the world of artifice.

To realise how difficult naturalistic painting had become in the eighteenth century, we have only to consider the case of Gainsborough. At the very beginning of his career his pleasure in what he saw inspired him to put into his pictures backgrounds as sensitively observed as the cornfield in which are seated Mr. and Mrs. Andrewes [11]. This enchanting work is painted with such love and mastery that we should have expected Gainsborough to go further in the same direction; but he gave up direct painting, and evolved the melodious style of picture making by which he is best known. His recent

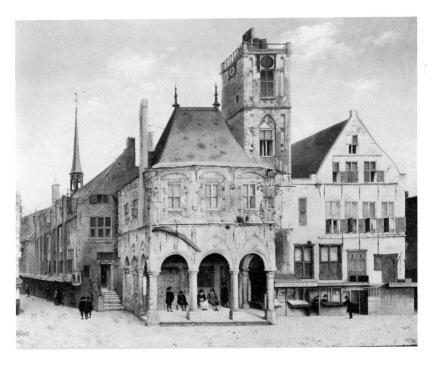

LANDSCAPE INTO ART

biographers have thought that the business of portrait painting left him no time to make studies from nature, and they have quoted his famous letter about being 'sick of portraits and wishing to take his Viol de Gamba and walk off to some sweet village where he can paint landskips' in support of the view that he would have been a naturalistic landscape painter if he had had the opportunity. But the Viol de Gamba letter is only a part of Gainsborough's Rousseauism. His real opinions on the subject are contained in a letter to a patron who had been so simple as to ask him for a painting of his park: 'Mr. Gainsborough presents his humble respects to Lord Hardwicke, and shall always think it an honor to be employ'd in anything for His Lordship; but with regard to real views from Nature in this country, he has never seen any place that affords a subject equal to the poorest imitations of Gasper or Claude. Paul San[d]by is the only Man of Genius, he believes, who has employ'd his pencil that way. Mr. G. hopes Lord Hardwicke will not mistake his meaning, but if His Lordship wishes to have anything tollerable of the name of G., the subject altogether, as well as figures, etc., must be of his own Brain; otherwise Lord Hardwicke will only pay for encouraging a man out of his way, and had much better buy a picture of some of the good Old Masters.'

A few years later Fuseli, the keeper of the Royal Academy, whose lectures

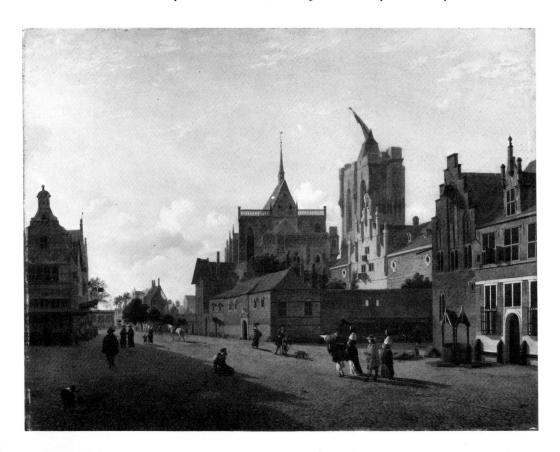

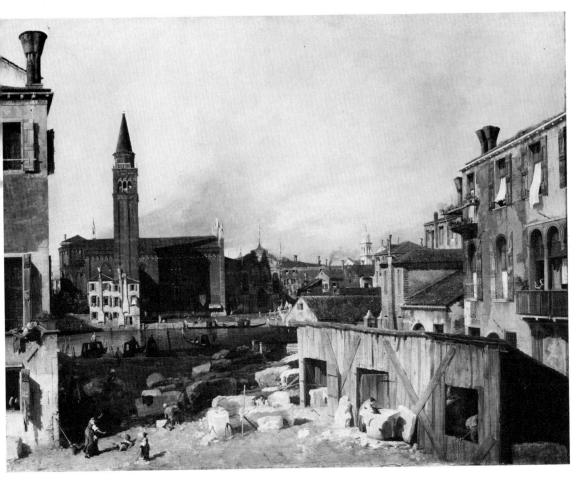

44 Canaletto, The Stonemason's Yard

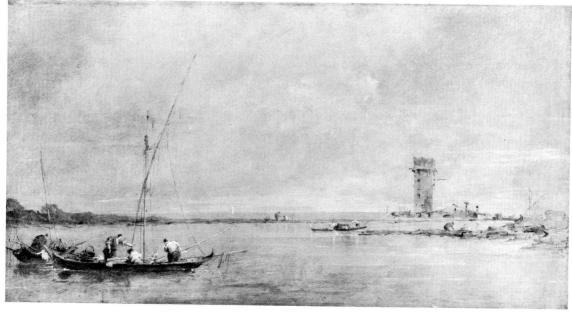

represented the most enlightened teaching of the day, referred to 'the last branch of uninteresting subjects, that kind of landscape which is entirely occupied with the tame delineation of a given spot'. These must go into the category of famous last words, for when they were spoken Constable was already a student at the Academy and Wordsworth had published his *Lyrical Ballads*. Man's relation with nature was about to enter upon a phase of greater intimacy, in which Bellini's love of all creation became a new religion, explicit, dogmatic and ethical.

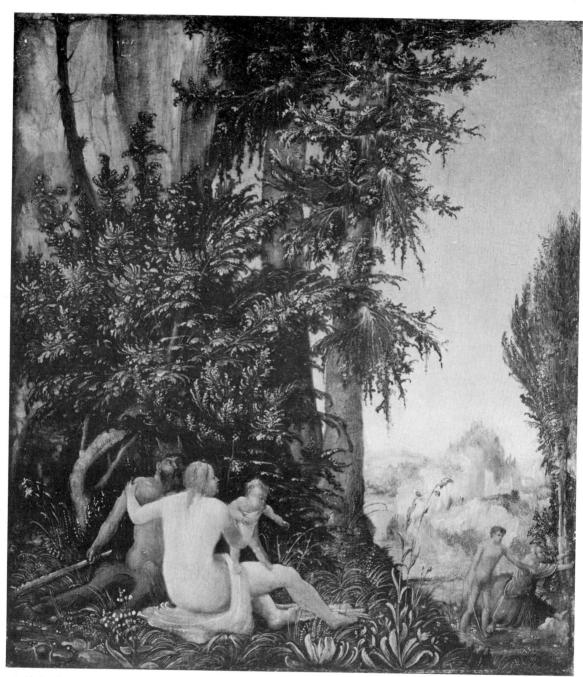

46 Altdorfer, Satyr Family

LANDSCAPE OF FANTASY

Already in the fifteenth century artists began to feel that landscape had become too tame and domesticated, and they set about exploring the mysterious and the unsubdued. These artists came from and worked for an urban population which had long since learnt to control natural forces. They therefore could view the old menaces of flood and forest with a kind of detachment. They could use them consciously to excite a pleasing horror. To this extent they may justifiably be called romantic. But it would be a mistake to suppose that they were similar to the Gothic novelists or the men of 1830. Horace Walpole wrote from the absolute security of Twickenham; to Grünewald, Altdorfer and Bosch the menaces of life were still real. They had seen villages burnt by passing mercenaries, had experienced the barbarities of the Peasants' War and the subsequent wars of religion. They knew that the human mind was full of darkness, twisted and fiery, and they painted an aspect of nature which expressed these dark convolutions of the spirit, just as the backgrounds of Piero della Francesca had expressed the clarity of the intellect. In doing so they no doubt made a conscious use of certain disturbing shapes and symbols. They are what we now call 'expressionist' artists, a term which is not as worthless as it sounds, because, in fact, the symbols of expressionism are remarkably consistent, and we find in the work of these early sixteenth-century landscape painters not only the same spirit but the same shapes and iconographical motives which recur in the work of such recent expressionists as van Gogh, Max Ernst, Graham Sutherland and Walt Disney. Expressionist art is fundamentally a northern and an anti-classical form, and prolongs, both in its imagery and its complex rhythms the restless, organic art of the folk-wandering period. It is forest born, and even when it does not actually represent fir trees and undergrowth - as in German painting it almost invariably does – their gnarled and shaggy forms dominate the design. The last symbol of these old German obsessive fears, tamed and domesticated by a century of materialism, is the Christmas tree. The first, or one of the first, is to be found in *Beowulf*, in the passage describing Grendel's Mere, and it is worth quoting, as it contains almost all the elements of which the landscape of fantasy is composed.

In a doubtful land
Dwell they, wolf-shapes, windy nesses,
Fearsome fen-paths, where the force from the mountains
Under misty nesses netherwards floweth,
A flood under the fields. 'Tis not far from hence
As miles are marked that the mere standeth,
Above which hang rimy bowers;
A wood fast-rooted the water o'er-shadows.
There will, every night, a wonder be seen,
Fire in the flood. There is none found so wise
Of the sons of men, who has sounded those depths...

The two painters who expressed this attitude to nature in its purest form came from the forests which border the Rhine and the Danube. They are Grünewald and Altdorfer. Of the two Grünewald is the greater and the more disturbing, and his Isenheim altarpiece is perhaps, the most phenomenal picture ever painted. Like Bosch and Seghers, his life is almost entirely unknown to us. But we see from his works that he was profoundly affected by the mystical writings of his time, and by the forms of revivalism which preceded and accompanied Luther's reformation. As with all revivalist art, everything in his pictures is designed to have the most violent and immediate effect upon the emotions. The landscape behind the Virgin and Child in the Isenheim altar-piece consists of a snowy, precipitous Valhalla on which there falls a fiery avalanche of angels. There is Turner's delight in the contrast between warm and cool tones, and Turner's power of using his memories of natural phenomena in adventures of the imagination. But more extraordinary still are the landscapes on the outer wings of the altar [47], which show the visit of St. Anthony to the hermit Paul and St. Anthony attacked by demons. They are terrifying. The wilderness in which St. Paul has found release from the world is of a desolation never again attempted in painting, and Grünewald has discovered, in the ragged fingers of moss which drip from every leafless twig, a perfect symbol of decay. Their repeated verticals impose a ghastly stillness broken only by the fall of a rotten branch. The landscape behind St. Anthony's hideous ordeal is more supportable because it is really too extravagant. Grünewald, in his attempt to use all the machinery of horror has, like some of the minor Elizabethans, come near to the vulgarity which accompanies too-muchness. The fact that this amazing work was painted in about 1513, and is a historical curiosity of the highest order, should not induce us to suspend our critical faculties, and in looking at

some of the details we may feel that only Grünewald's distinction of style and colour prevents a comparison with Disney.

Altdorfer, though on a smaller scale than Grünewald, is more representative of the German spirit; in fact he is the most German of all painters, for although his eye penetrates deeply into the northern forest with its twisting tendrils and undergrowth, its pools and mosses glowing like enamel, he views them with a certain *gemütlichkeit*, a smugness, as though from the inside of a cottage window, whereas Grünewald walks abroad among his terrors with staring eyes.

Altdorfer's little picture of St. George [48], painted in 1511, is at the opposite pole to the great figure pieces which were being painted at this time in Italy. In it man, even though he be St. George, almost disappears in the luxuriance of the forest. Trees fill every inch of the picture, not the orderly, decorative trees of tapestry landscape, with their gifts of fruit and blossom, but menacing, organic growth, ready to smother and strangle any intruder. And who were the natural inhabitants of this primaeval forest? Altdorfer shows us in his picture of the Satyr family in the Berlin Gallery [46], a *fête champêtre* of almost the same date as the Giorgione in the Louvre, but of a very different character. Satyrs were not uncommon before this time: Dürer's engraving of a Satyr family dates from 1505; but it is clearly influenced by his stay in Venice, and the classical proportions of his Satyress are not those of primitive life. Altdorfer's family are far more in harmony with their shaggy setting, and have less to do with the classical satyr than with that favourite figure of late mediaeval imagery, the wild man or woodhouse. Was there in his mind the unorthodox notion that our life began in some such wild surroundings and not in the Golden Age or the Garden of Eden? Although they would not have dared to formulate it, some of the more perceptive spirits of the time had already found that the story of Eden satisfied neither their imaginations nor their scientific curiosity. Some strange intuition of primaeval slime seems to have impelled Grünewald. We are surprised to find that his two holy hermits are not accompanied by a dinosaur. And in Altdorfer's landscapes we have the same feeling that the world has been newly created. In his drawing of Sarmingstein the mountains seem to have shot up from a volcanic centre as they do in Disney's illustration to Stravinsky's Sacre du Printemps: in the background of the two St. Johns in the museum of Regenstein we feel that the mists and bubbles of creation still hang over the simmering earth.

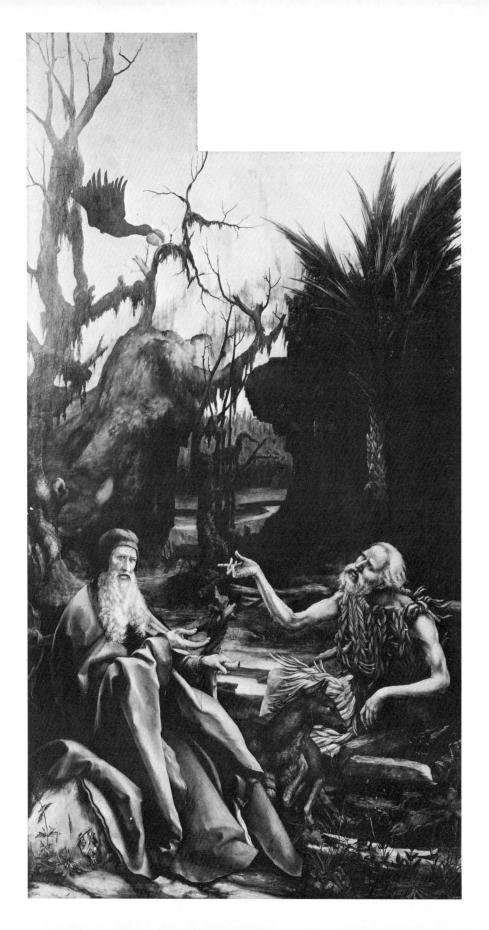

This interest in the origins of man was not confined to the North. Its sources were in the literature of classical antiquity, in Lucretius and Vitruvius¹ and a woodcut in the Como Vitruvius of 1521 shows a scientific attempt to illustrate this theme. Groups of naked people are huddled together for warmth, unable to profit by the fire which has broken out in the background. The theory also owes something to the reports of travellers, like Leonardo's friend, Andrea Corsali, who had recently brought back information about primitive peoples; and we are reminded of the fact that it was a Florentine who gave his name to the New World. It was also a Florentine, Piero di Cosimo, who made the most imaginative interpretation of primitive life, in a series of decorative panels, one of which, The Forest Fire in the Ashmolean Museum, Oxford, is the first landscape in Italian painting in which man is of no importance [49]. The conflagration which has broken out in the forest is that described in the fifth book of Lucretius where he attributes the discovery of fire to the accidental rubbing together of branches. Among the animals escaping from the flames are two with human faces, which exemplify the theory of Democritus that in the early days of creation nature had not decided how the various features of the animal world should be allotted. In this series the recipe for the representation of trees and hills is taken from Flemish models; but the lonely and neurasthenic Piero di Cosimo, though in moments of depression he affected an extreme conventionality, was capable of turning these formulae into personal symbols. He was obsessed by pendant cliffs and bulbous trees which are an unusually direct and unconcealed expression of his unconscious mind and should make him a favourite with those who value such exhibitions.

Travel and exploration enlarged the world, and a few years later Copernicus was to enlarge the Universe, which has continued to expand ever since. The results may be seen in the fantastic panoramas which dominated land-scape painting throughout the sixteenth century. These were entirely different from the realistic panoramas of Pollaiuolo, for instead of being actual views of the Val d' Arno, which were familiar to everyone who climbed the surrounding hills, they seem to have been imaginary, and intended to excite emotion, rather than to satisfy curiosity. We have already seen an example in

¹The importance of this new curiosity about primitive life, and its realisation by Piero di Cosimo was first worked out by Panofsky in a brilliant essay, reprinted in *Studies in Iconology*. It omits, however, the influence of actual exploration. Before Piero di Cosimo painted his panels Columbus had returned from America.

Altdorfer's two St. Johns. An even more striking illustration is his *Battle of Alexander* in Munich [III] in which Altdorfer has symbolised the extent of Alexander's conquests, stretching far beyond the limits of previous human knowledge. No wonder the picture was a favourite with Napoleon, who had it taken from Munich and hung in his bathroom at St.-Cloud.

The *Battle of Alexander* also shows the consciously romantic character of this kind of landscape, for it expresses the artificial and quasi-antiquarian chivalry of the Field of the Cloth of Gold. But most significant of all are the extraordinary disturbances which are going on in the upper air, those fizzings and bubblings and convulsions of light which are entirely characteristic of the landscape of fantasy, particularly where they introduce into the sky an unearthly glow. Bellini had used sunset and sunrise to heighten the mood of his pictures, but not with the self-consciousness and violence of the northern expressionists. This is the supreme manifestation of untameable nature, and the crowning horror in the description of Grendel's Mere: fire in the flood. Throughout the landscape of fantasy it remains the painter's most powerful weapon, culminating in its glorious but extravagant use by Turner [108].

The emotive effect of flaming light, or actual flames, seems to have been discovered in the 1490s, and was part of the repertoire of Hieronymus Bosch. In this, as in so much else of his work, he may have been inspired by mediaeval miniatures, or, more probably, by the frequent representation of Hell in miracle plays. But I know of no examples earlier than his pictures in the Venice Academy and the Escorial, which date from about 1495. The aesthetic effectiveness of unexpected red and orange in a pool of darkness added to his popularity; and in the next thirty years Bosch's flames break out in almost every landscape. In particular the pictures which we group under the name of Patenier, and which constitute the first series of pure landscapes, rely on Bosch's fire to heighten their somewhat prosaic character. Once, indeed, it allows him to achieve true poetry, in the landscape [51] where Charon paddles his boat between heaven and hell, and the fires of the underworld are contrasted with the shining white lakes of the Elysian fields. The most fantastic of these fire pictures represent Lot and his daughters, and go back to a design by Lucas van Leyden. An example in the Louvre, though perhaps not by Lucas himself, will serve as an example of the fashion for this unedifying subject [54]; and suggests that its popularity was due to the opportunity it gave for violent effects of light. This is one of many instances

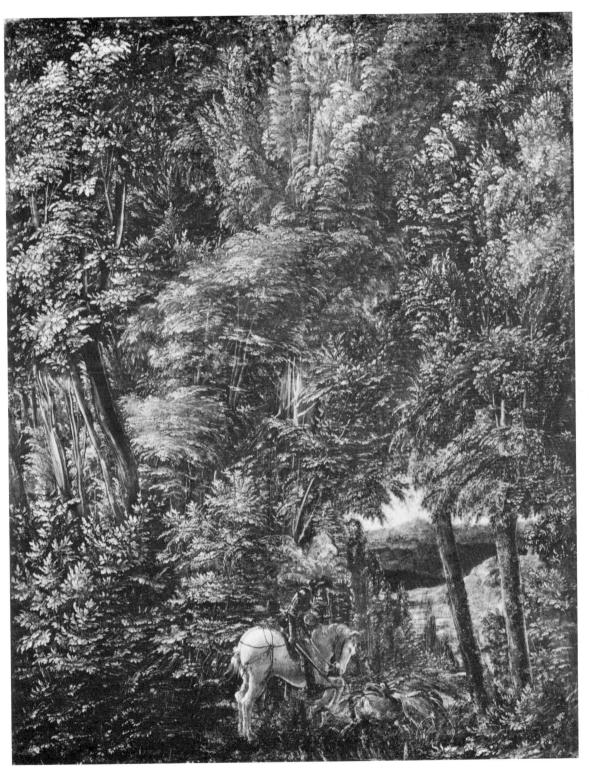

48 Altdorfer, St George

of aesthetic interests creating iconography rather than the reverse process, and should be remembered at a time when iconological study is almost as fashionable, though not as profitable, as connoisseurship was forty years ago.

The fire spread at an early date to Italy. Leonardo in his treatise on painting describes with obvious pleasure how one should paint a night-piece: 'The figures which are seen against the fire look dark in the glare of the firelight; and those who stand at the side are half dark and half red, while those who are visible beyond the edges of the flames will be feebly lighted by the ruddy glow against a black background. As to their gestures, make those which are near it screen themselves with their hands and cloaks, to ward off the intense heat, and some with their faces turned away as if drawing back. Of those further off, represent some of them with their hands raised to screen their eyes 'hurt by the intolerable splendour of the flames'. Here, as is usual in Leonardo, his love of fantastic effects is united with a scientific desire to describe accurately an actual scene. But in most cases the appearance of fire in Italian painting was due to the direct influence of Bosch. We know that a number of his pictures were in Italian collections, particularly in that of Cardinal Grimani, in Venice. There they were seen by the ardent young romantic, Giorgione. Immediately fire breaks out in his backgrounds, and he chooses subjects which give an excuse for it. The story of Orpheus and Eurydice, with its suggestion of those magic powers which preceded the more rational divinities of antiquity, had the added advantage of introducing the mouth of Hell. We see, in the copy of a lost Giorgione at Bergamo [50], how he has pictured it as a blast furnace, using, as the highest imaginations so often do, a perfectly concrete impression as part of a poetical idea.

Another Giorgione design which shows very precisely the influence of Bosch, survives only in an engraving by Marc Antonio. It is the sinister work which used to be known as 'Raphael's Dream'. Two naked women, of full

¹The connection of 'Raphael's Dream' with a lost design by Giorgione has been generally accepted since Wickhoff. The figures recur in engravings by Giulio and Domenico Campagnola who used Giorgione's designs. Several attempts have been made to explain the scene by reference to classical literature, but it is more probably a free fantasy, like the *Tempesta*. Among the Bosches in the Grimani collection was *una tela dei sogni*. Raphael was himself much excited by the fiery backgrounds of Bosch, and brought them into one of his earliest pictures, the *St Michael* in the Louvre. He later used them with splendid effect in the background of the *Attila* in the Stanza.

50 After Giorgione, Orpheus and Eurydice

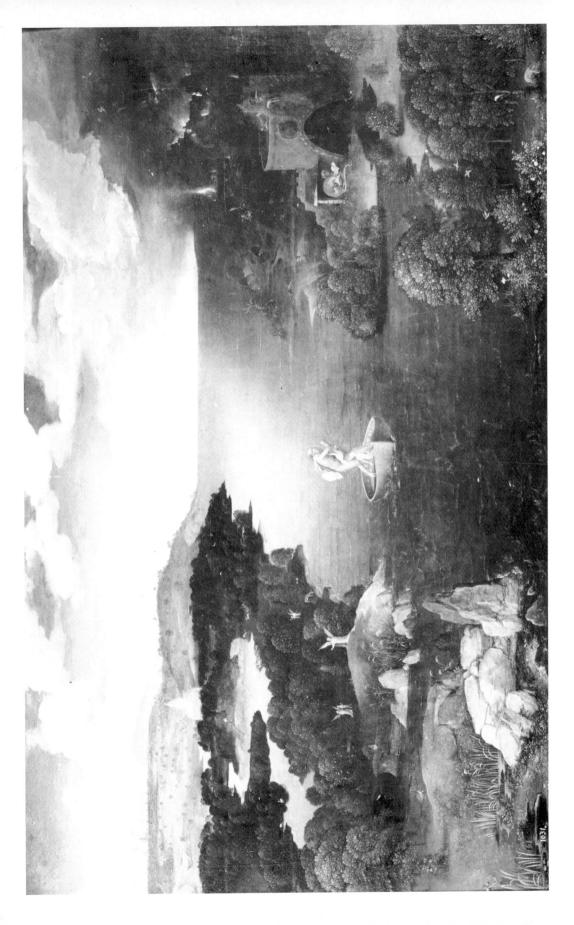

Venetian sensuality, lie sleeping on the edge of a lake. Beyond them the sky is menacing and a castle has broken out in flames. The sleepers are undisturbed, but they are soon to be the victims of four disgusting monsters, which advance towards them along the bank. Here the supreme interpreter of harmony between man and nature reminds us of those mysterious and malevolent forces, which, in our minds no less than in nature itself, are always lying in wait to poison our dreams of epicurean tranquillity. The largest of all Giorgione's responses to this kind of romanticism, a work so strange that art historians have tried to ignore it, is the Shipwreck in the Scuola di S. Marco. It has come down to us as a dark, damaged picture, made up of bits sewn together, and painted by different hands. But the evidence leads us to believe that the whole design and part of the execution is due to Giorgione; and, as with Hubert van Eyck, we are dumbfounded by the prophetic power of genius, for here is a work which anticipates and transcends all romanticism of the sixteenth century and points directly to Géricault and Turner. I say 'anticipates', for I think the Giorgione must have inspired those mannerist romantics like Lorenzo Lotto, Dosso Dossi and even Beccafumi who played with fire from 1520 to 1550. But there is no doubt that Lotto was directly in touch with German painters. In his earliest painting, the Maiden's Dream in the National Gallery, Washington, which dates from about 1498, the trees and their relation to the distant landscape show unmistakably the influence of Dürer, who was in Venice in 1494-95, and foreshadow the forest landscapes which, in the next five years were to excite the imaginations of Altdorfer and Cranach. The St. Jerome in the Louvre, dated 1500 [52], contains rocks and trees remarkably similar to the drawings which Dürer did on his journey home from Italy in 1495.1 From these two early works we may suppose that Lotto could have become one of the great landscape painters of the sixteenth century. But his moody, unstable character and his genius for portraiture kept him tied to his commissions, and his landscapes appear only accidentally, like the wide prospect which forms the lower half of his St. Nicholas altarpiece in the Carmine.

In the revived classicism of the late sixteenth century these fiery disturbances are suppressed. As before, Breughel is the only exception. He could

¹That there was also some connection between Lotto and Grünewald will be evident to anyone who compares Lotto's early altarpieces with the St. Sebastian in the Isenheim altarpiece. Lotto was evidently in touch with the Protestant reformers, for he did portraits of Luther.

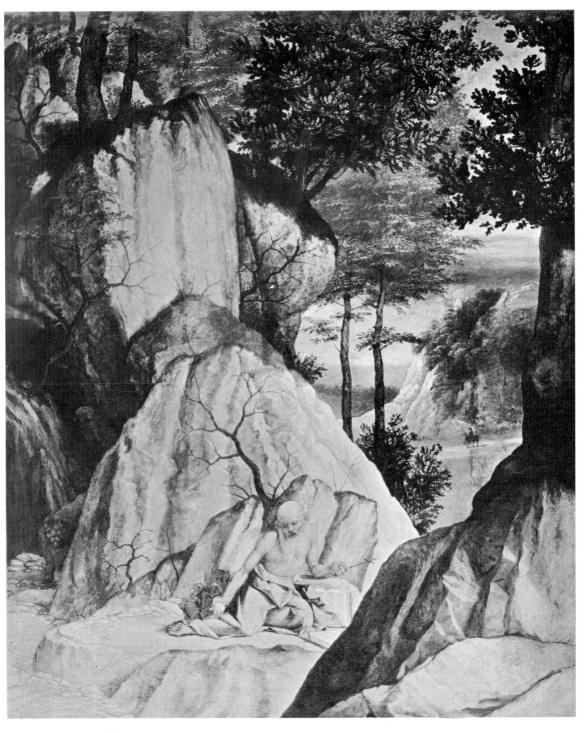

52 Lorenzo Lotto, St Jerome

not take so much from Bosch, and omit his fires: and by placing them in a field of snow, he gains a new sharpness of contrast both in colour and in the imagined opposition of heat and cold. In his *Fall of Icarus* in the Brussels gallery [53] he is even more archaistic, going back to such curiosities of fifteenth-century illumination as the *Livre de Cœur d'Amours Epris*. The result is a marvel of poetry, in which light, like the music of words, heightens our emotion and makes us more receptive of the image.

From fantastic light we may turn to fantastic form. Whereas in the North it was dominated by the knotted shapes of trees, in Mediterranean art a similar formal impulse was expressed through the old Byzantine tradition of jagged rocks. The crazy Gothic mountains of Broederlam and Lorenzo Monaco continue far into the Quattrocento. Giovanni di Paolo's St. John steps out into a wilderness which is the Sinai of Byzantine iconography carved into Gothic sharpness. In its decadence this tradition achieved a point of unreality which has not been equalled since. Salvador Dali might envy the dreamlike freedom with which Jacopo da Valencia's rocky mise en scène defies the law of gravity and vanishes into space [55]. Such an irresponsible convention could not satisfy a serious-minded artist like Mantegna, and so we have in his Virgin of the Quarries [56] one of the earliest attempts to retain and justify the iconographic motive of fantastic rocks by a show of science and reason. The culmination of this union of science and fantasy is to be found in the work of Dürer and Leonardo da Vinci.

In studying Leonardo it is often difficult to say whether his eye was controlled by his scientific curiosity or by his sense of form. He loved certain forms, he wanted to draw them, and while drawing them he began to ask questions: why were they that shape and what were the laws of their growth? This is true of his interest in fantastic rocks. He began (in the Uffizi *Amunciation* and the Benois *Madonna*) by accepting the rocks of convention. In one of his earliest dated drawings (1473) he had already shown himself an observer of rock formations, but the drawing [57] is in no way scientific: the trees, for example, are impressionist scribbles.

In 1483 his love of fantastic rocks leads him to that peculiar freak of iconography, the *Virgin of the Rocks*. It may be that the cave illustrates some apocryphal legend, although Leonardo's copious writings on art do not suggest that this was the way in which his mind worked. It is more likely that the Gothic element in his character was excited by the prospect from one of the quarry caves in Monte Ceceri, and he resolved to make it the basis

54 School of Lucas van Leyden, Lot and his Daughters

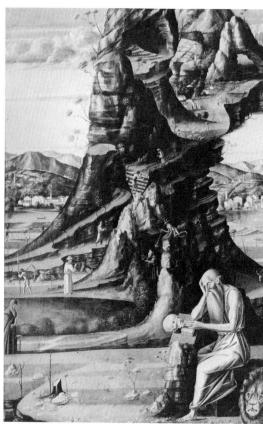

55 Jacopo da Valencia, St Jerome

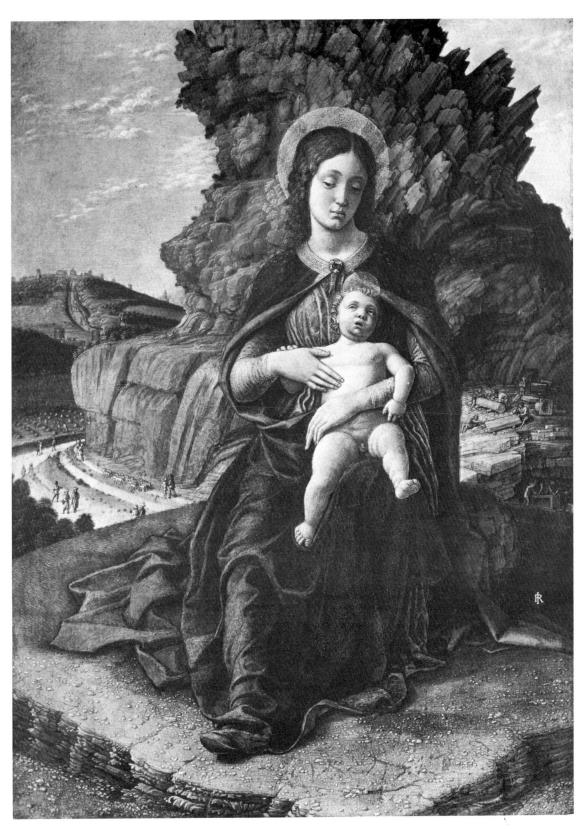

56 Mantegna, Virgin of the Quarries

of his design. At that date he had no particular interest in science: his first scientific entries in his note-books date from a few years later. But as time went on his insatiable curiosity prompted him to ask more and more questions about the character and origins of rocks until finally his researches into geology led to the most original of all his scientific speculations. If Petrarch was the first man to climb a mountain, Leonardo was the first to make a close scientific study of one. His accounts of climbing are romanticised, as is usual in his literary compositions; but his drawings of distant ranges are the result of a scrutiny which is both sensitive and scientific; and his studies of geological strata show a real understanding of the forces which lead to their structure.

All this knowledge is implicit in his later landscapes, but it is used in the service of his imagination. How highly Leonardo valued a free play of the imagination is shown in the most famous passage in his Treatise on Painting, where he says that he will not refrain 'from including among these precepts a new and speculative idea, which although it may seem trivial and almost laughable, is none the less of great value in quickening the spirit of the invention. It is this: that you should look at certain walls stained with damp or at stones of uneven colour. If you have to invent some setting you will be able to see in these the likeness of divine landscapes, adorned with mountains, ruins, rocks, woods, great plains, hills and valleys in great variety; and then again you will see there battles and strange figures in violent action, expressions of faces and clothes and an infinity of things which you will be able to reduce to their complete and proper forms. In such walls the same thing happens as in the sound of bells, in whose strokes you may find every word which you can imagine.' Later he repeats this suggestion in slightly different form, advising the painter to study not only marks on walls, but also 'the embers of the fire, or clouds or mud, or other similar objects from which you will find most admirable ideas . . . because from a confusion of shapes the spirit is quickened to new inventions. But', he adds, 'first be sure you know all the members of all the things you wish to depict, both the members of animals and the members of landscapes, that is to say, rocks, plants and so forth.' I have quoted this passage at length, familiar as it is, because it illustrates an important element in the landscape of fantasy, the manner in which it evolves out of a chaos of forms, out of the undergrowth, the firelight or the clouds, through an interplay of the conscious and the unconscious mind. No doubt Leonardo sought for the extraordinary in nature,

58 Leonardo da Vinci, The Virgin and Child with St Anne (detail)

just as he did in the human face. 'On one occasion above Milan,' he records in the Leicester notebook, 'over in the direction of Lake Maggiore, I saw a cloud, shaped like a huge mountain, made up of banks of fire, because the rays of the sun, which was then setting on the horizon, dyed it with their colour. The great cloud drew to itself all the little clouds that were round about it. And the great cloud remained stationary, and retained the light of the sun on its apex for an hour and a half after sunset.' This is a phenomenon, but not a fantasy, any more than is the famous drawing [57] which is often connected with it. The backgrounds of the Mona Lisa and the St. Anne [58] express the moods in which these pictures were conceived; yet we can find mountainous rocks, like those that encircle the Mona Lisa, in the foothills of the Alps, and thirty miles further north we come on the lunar silence and sterility that lie behind the St. Anne. Leonardo had made drawings of Alpine ranges in 1511 and, although he transforms them in his imagination, as Turner was to do, we still feel sure that he 'knew the numbers of all the things he wanted to depict'.

One could almost say the same of the drawings of Deluges which seem at first sight to be pure works of the imagination. As we know from a recent experience, Florence is subject to storms of rain so violent that even modern technology cannot control them. One of the most famous of deluges (1456) is described by Machiavelli; another (1514) is recorded by Landucci, and Leonardo himself, in the Madrid M.S., records a storm which damaged his cartoon of the Battle of Anghiari. So the emotions aroused by a 'deluge' were the result of real experiences. And the actual structure of moving water was observed and recorded by him in hundreds of drawings. It became an obsession. But if the series of Deluge drawings at Windsor take their point of departure in experience and observation, they soon change their intention. They record one of Leonardo's deepest intuitions, that the forces of nature are totally out of our control, and may easily destroy our fragile civilisation. The landscape of fantasy is no longer nature before man has tamed it, but the forces of nature rising in revolt against man with his absurd pretence to ignore them, or use them for his advantage. Fifty years ago the significance of these drawings would have been lost on us. Now we can understand them only too well. We know that Leonardo was influenced by the apocalyptic speculations which were current round about the year 1500, and which led Dürer to dream of a similar cosmic disaster and record his dream in a drawing dated 1525. But Leonardo's scientific knowledge of nature, and his even more extraordinary intuitions as to the hidden potentialities of matter, have enabled him to pass into a different world from the old mediaeval Apocalypse with its confused oriental symbolism, and to arrive at a vision of destruction in which symbol and reality seem to be at one.

Twenty years later Leonardo's profound intuition received grotesque expression from Giulio Romano in his frescoes in the Palazzo del Tè [59]. Religious and scientific speculation reverts to classical myth, the Apocalypse becomes the fall of the giants; and the fury of the elements, which Leonardo concentrated into a few square inches, is inflated into a large decoration. Giulio's invention is powerful and exciting, especially in those panels where the forms of the giants become merged in the rocks, with an effect like the double images of Tchelitchew. But already the feeling for the independent life of nature which was the mainspring of Leonardo, has been lost in mannerism.

It is time to examine this word, which, for twenty years, succeeded Baroque as the 'open Sesame' of art historians. Without attempting a full

definition, we may say that sixteenth-century mannerism employs the exciting elements of picture-making irrespective of their truth or relevance; and that although it uses, as far as possible, the forms of classicism, it reveals, in accent and rhythm, the great deposit of Gothicism which the Renaissance had not strained out of Italian art. It was characteristic of the mannerists that they should take pleasure in the fantastic rocks of Gothic painting, but should justify this taste by using forms derived from the decorative landscapes of antiquity. Far more of these landscapes, in what is known as the Hellenistic style, were visible in the Renaissance than have survived today, and I believe that from them was derived the compositional scheme of mannerist landscape with its high point of view, its distant prospect of mountains and hills running down one side of the picture, and a sea coast or estuary on the other. It is a scheme which we have already seen foreshadowed in Altdorfer's two St. Johns (Gothic and Mannerist, as usual, joining hands), and it is present in the antiquarian decorations of Polidoro Caravaggio in S. Silvestro al Quirinale [65]. I repeat the usual epithet antiquarian, but Polidoro's landscapes do not resemble any surviving piece of antique painting that is known to me. On the contrary, these landscapes done before the year 1530 anticipate in an almost incredible manner the mature style of Claude and Gaspard. They have Claude's luminous distances and his way of uniting his figures with the trees that surround them; but the general effect is more that of Gaspard. Their free handling was totally invisible before they were cleaned. Polidoro's contemporary reputation was based entirely on painting the façades of buildings. But he must have painted other landscapes. What has happened to them?

To see the pure mannerist landscape, with its complete repertoire of tricks and a minimum of first-hand observation, we may turn to Niccolò dell' Abate. His landscape in the National Gallery, illustrating the Fourth Georgic [59], must date from about 1550, some years before the landscapes of Tintoretto and Paul Veronese; and already everything is subordinated to an ideal of elegant picture-making, in which the painter skates over all his difficulties with ravishing skill. Naturally this decorative style was at its best when used for its original purpose of interior decoration; and nowhere

¹This statement is repeated in all books on mannerist landscape but seems to me (1976) to have no foundation. The Vatican Odysseus series are almost the only antique landscapes that justify it. In the Naples museum the only landscape with a high viewpoint is the harbour scene from Stabia.

is it more charming than in the room of landscapes which Paul Veronese painted, in about 1560, in Palladio's villa at Maser. In most of them he has followed the antique model, with its elaborate architecture, bridges and jetties, and dark foreground tree: but he has allowed himself the large Venetian skies which irradiate all his work. He was later to paint a calm poetic sunset, before which St. Anthony of Padua preaches to the fishes, the whales and porpoises in the background still lit by the evening sky, the little fishes in the foreground almost invisible in the darkness [61].

This decorative use of landscape is the most harmless form of wall painting ever devised, and continued to be fashionable till the middle of the nineteenth century. But it is an approach to the subject at the furthest remove from that of Bellini, Constable, Cézanne and the other patient quarriers of natural appearances. In fact, only two of the great mannerists produced landscapes of any significance. They are Tintoretto and El Greco. With Tintoretto nature was caught up in the rushing wind of his genius and made to serve the purpose of his colossal invention. The background of the *Flight into Egypt* is a drama of light and shade as exciting as an Altdorfer; the desert landscapes in which are seated the two St. Marys [60] are made up of tangled, twisting forms, which communicate his own creative energy through the representation of organic life. Switch off this current of energy, leave only the nervous gestures, and we have those minor picturesque landscape painters – Mola, Testa and Magnasco – whose caves, ravines and bristling beaches are found diverting in an age of decadence.

El Greco has left us one unforgettable landscape, his *View of Toledo* in the Metropolitan Museum, New York [64]. It is a true expressionist work, a picture of Greco's own mood, which by the time this picture was painted, had become so much involved with the character of his adopted town, that we can understand how, for M. Barrès, it seemed to represent the spirit of Toledo; although we know that an artist of different temperament and equally strong vision might have persuaded us to accept as true a Toledo of an entirely different character. This extraordinary work is an exception to all rules, far removed from the spirit of Mediterranean art and from the rest of seventeenth-century landscape painting. It has more the character of nineteenth-century romanticism, though Turner is less morbid, and van Gogh less full of artifice; and to find analogies we must look to Romantic music, to Liszt and Berlioz. Yet in his landscapes, as in all his work, Greco is compounded of Byzantine traditions and the machinery of mannerism. One

60 Tintoretto, St Mary of Egypt

61 Veronese, St Anthony Preaching to the Fishes

of his very earliest pictures (c. 1570) is a landscape, in which he makes direct use of the stylised rocks of Byzantine iconography [63]. And one of his last (c. 1610) is a panorama of Toledo, in the Casa Greco, which is typical of the romantic cartography of mannerism, even down to the river god and the map; though he has given it an all-pervading rhythmic life, very different from the hack topographers of the time.

The compositional scheme of mannerism also provided a scaffolding for one of the greatest of all landscape painters, Peter Paul Rubens. He cannot, of course, be classed with the painters we have just been considering. Tintoretto probably never paused to draw the correct form of a single leaf, whereas Rubens' drawings from nature are amongst the most sensitive and observant ever made. A bramble covering a dead tree stump, with all its intricacy of detail, an osier hedge with its innumerable changes of plane, flowed from his pencil true in every particular and in the general rhythm of their growth. And there are Rubens drawings which for delicacy of atmosphere might stand with Turners, Monets and the paintings of the Sung dynasty, and differ only in the hint of greater buoyancy which underlies them. But although this prodigious power of recording natural details was often transferred to his pictures, Rubens cannot be called a painter of fact. Certainly his landscapes do not come under Fuseli's condemnation of the 'tame delineation of a given spot'. Nor have they the literary character and the backward glance to a golden age which I have called Virgilian. So they must appear in this chapter, although the word fantasy is altogether too weak to describe their imaginative richness and warmth.

Just as Shakespeare reworked the stock themes and situations of Elizabethan drama, so Rubens, by the heat of his imagination, his unfailing vitality and the richness of his pictorial language, has forced the worn-out scheme of mannerist landscape to yield a new splendour. His earlier landscapes, such as the *Shipwreck of Aeneas*, in Berlin, or the *Philemon and Baucis*, in Vienna [62], conform superficially to the pattern, which we find, for example, in Breughel's engravings, but it has grown more complex and more dynamic. The mannerist desire to keep all forms in a perpetual flux of movement has never been more marvellously realised in landscape than in the *Philemon and Baucis*. But the arcs and spirals which leave us breathless are based on a series of horizontals, calculated with a classic sense of interval.

The *Watering Place* in the National Gallery introduces a different scheme of composition. It is seen from a low point of view, and the structure of the

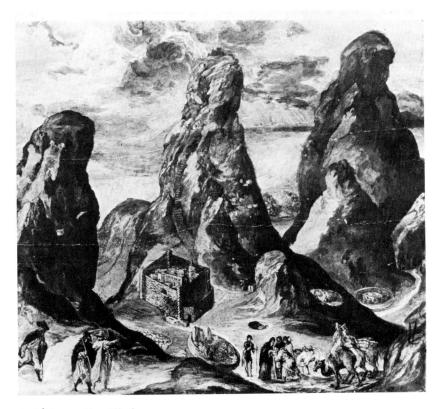

63 El Greco, Mount Sinai

towering central mass is a perfect example of the Baroque. It has the large swinging movement, the twist and counter twist, which are the essence of Baroque architecture, and give it a unity and power which transcends the perverse rhythms of the preceding style. But as a reading of nature it still belongs to the romantic tradition of the North. The trees and undergrowth are of an overwhelming luxuriance. They writhe and surge like monsters; they are part of the primaeval forest. Rubens himself recognised the character of his romanticism, and expressed it in the picture of a *Tournament before a Castle*, now in the Louvre [67]. Like Altdorfer, he saw the connection between the landscape of fantasy and the Gothic past, and filled the foreground of his picture with knights in armour. As before one of Wren's Gothic churches we may think of it either as the end of the chivalrous tradition – the poetic spirit of Ariosto – or as the first example of the Gothic Revival; its remarkable similarity to Bonington and Delacroix

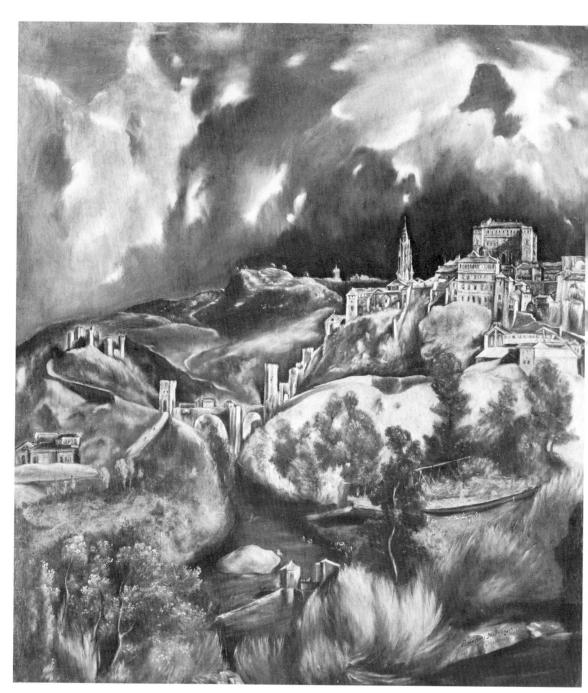

64 El Greco, View of Toledo

suggests that the second reading is correct. Beyond the castle, hanging low over the landscape, is one of those large red suns of which Rubens, in his later work, is so prodigal. No one, before Turner, has painted richer and more various sunsets, ranging from fiery orange to the mysterious milky sun of the *Birdcatcher* in the Louvre. He was also a great master of enraged skies. In the *Philemon and Baucis* the clouds are driving up for a deluge; in the *Shipwreck of Aeneas* their darkness is made more lurid by a flaming beacon on the distant promontory; most violent of all is the storm in a picture in the Neuerberg Collection¹ where the dark landscape is lit only by terrific flashes of lightning. Here, and in the moonlight landscape in the Seilern Collection, he returns to those night scenes which had stirred the imaginations of Altdorfer, Leonardo and Giorgione.

Night is not a subject for naturalistic painting: 'Mr. Whistler's picture', said Burne-Jones, in the Ruskin trial, 'is only one of the thousand failures to paint night'. A large area of dark paint cannot be made to look convincing by optical processes alone; it must have been transmuted into the medium of the poetic imagination. It happened that in about the year 1600 there appeared in Rome a landscape painter with a queer, concentrated gift of poetry, the Frankfurt-born Adam Elsheimer. He was one of those artists like Edgar Allan Poe, whose influence was beyond his achievement. Rubens, Rembrandt and Claude each took from him something decisive in their development, and, what is more extraordinary, each took something different. Elsheimer died in Rome in 1610, after having worked there for ten years. He therefore used the current Roman landscape style, the style of Brill and Domenichino, but his spirit is that of Altdorfer. He paints classical scenery, but with a strangeness and intensity of light, an enamelled quality which is entirely German and takes us back beyond Altdorfer to Lucas Moser of Tiefenbronn. It was Elsheimer who brought to a new stage of realisation the nocturnal fantasies of a hundred years earlier. In his picture of the Flight into Egypt in Munich [67], he carried them as near to the limits of truth as such subjects can go without entirely sacrificing the element of decoration which must exist in any picture. No student of English poetry need be reminded that in the early seventeenth century men were enchanted by the beauty of night. Romeo and Juliet, A Midsummer Night's Dream, even The

¹I have not seen the original, and cannot be sure from the coloured reproduction in Gluck, *Die Landschaften von P.P.R.*, plate 17, that it is authentic. The trees look too reminiscent of Salvator Rosa.

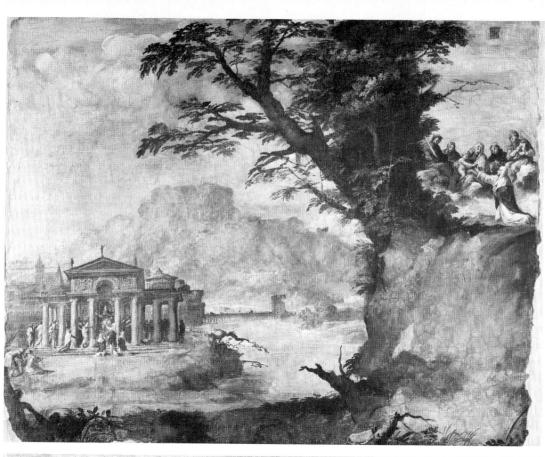

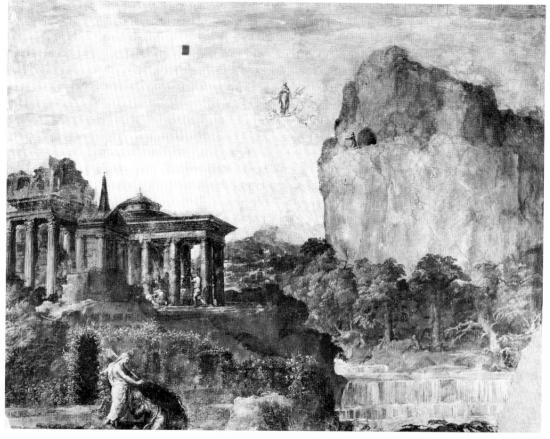

66 Inigo Jones, Night scene, for Luminalia

Merchant of Venice, contain those poetic scenes which the Venetian artists used to call un notte, in the same way that Herrick and other lyricists used the expression 'a night piece' in description of a poetic subject. There is a link with these nocturnal lyrics and Elsheimer in the scenery which Inigo Jones designed for Sir William Davenant's Luminalia or the Festival of Light, performed before Charles I in February 1638. His drawings for it are at Chatsworth, and one of them represents a night scene [66] which writers on Inigo Jones have usually connected with Rubens's visit to London in 1629. At that time Rubens's landscapes were still in a sharp, clear mannerist style and there can be no doubt that it reflects the influence of Elsheimer, whose pictures, etchings and drawings were already in the cabinets of English collectors.

Just as, in the eighteenth century, that winter of the imagination, the landscape of fact degenerated into topography, so the landscape of fantasy degenerated into the picturesque, more particularly into that branch of the picturesque which derived from Salvator Rosa. In his best works Salvator was master of a stylish romanticism, which later purveyors of the genre, from Magnasco to Fuseli, never surpassed. His landscapes opened a new vein of sentiment, and discovered the rhetorical form in which it could be

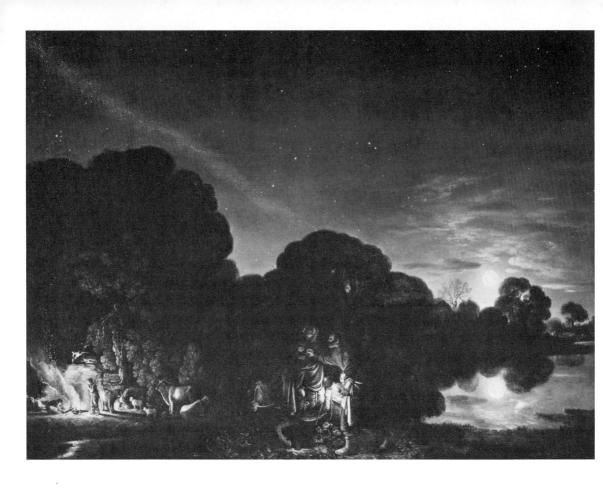

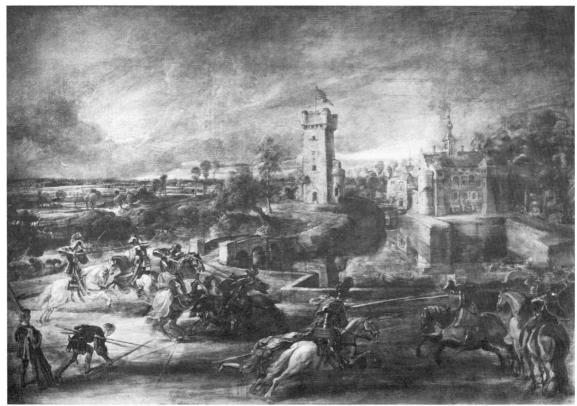

conveyed. That his sentiments were exaggerated and his means of expressing them often commonplace was a factor in his popularity. The artist who invents stage properties which can be borrowed with effect, is sure of success, and the minor painters of the eighteenth century came to rely on Salvator's *banditti* and fir trees as their successors of the 1930s relied on Picasso's harlequins and guitars. Neither would have obtained currency had they not also fulfilled some half-realised dream of the period. As Charles II said of a popular preacher, 'His nonsense suited their nonsense'. The nonsense which the eighteenth century required was some escape from its own oppressive rationalism.

'Precipices, mountains, torrents, wolves, rumblings – Salvator Rosa.' It is the young Horace Walpole, in a letter describing his crossing of the Alps, often quoted as one of the opening bars of the Romantic Movement; justifiably so, for, although Salvator was the source of much picturesque nonsense, he was also the inspiration of genuine poetry. Without him Alexander Cozens would have had no style in which to depict the grandeur of wild nature, in those strange drawings which remind us both of Hercules Seghers and of Southern Sung. Alexander Cozens was the mentor of that quintessential Romantic, William Beckford, and his son, John Robert, was for a time Beckford's private painter. Now it was John Robert's water-colours of Switzerland which introduced Turner to alpine scenery. Through Cozens he painted ravines, glaciers, avalanches and snowy peaks long before he had seen them. So the greatest master of untamed landscape is linked with the romantic mannerists of the sixteenth century, and completes the cycle which Altdorfer and Grünewald had begun.

IDEAL LANDSCAPE

Before landscape painting could be made an end in itself it had to be fitted into the ideal concept to which every artist and writer on art subscribed for three hundred years after the Renaissance. The delight in imitation, which had satisfied Alberti and Bellini was not enough for Lomazzo and the Carracci. Both in content and design landscape must aspire to those higher kinds of painting which illustrate a theme, religious, historical or poetic. And this cannot be done simply by introducing a small group of figures enacting the Flight into Egypt or the Story of Eurydice, but by the mood and character of the whole scene. The features of which it is composed must be chosen from nature, as poetic diction is chosen from ordinary speech, for their elegance, their ancient associations and their faculty of harmonious combination. *Ut pictura poesis*.

Two poets of antiquity, Ovid and Virgil, furnished the imaginations of Renaissance artists. Of these the first, with his clear and detailed descriptions of the fabulous, was the favourite with figure painters; but Virgil was the inspiration of landscape. The reason lies not only in the delicate suggestions of scenery which occur in the Aeneid, but also in the myth of ideal rusticity of which he was the master. His works show a first-hand knowledge of the country, and many a good humanist, from Petrarch onwards, managed his estates on the advice of the Georgics. But this element of realism is combined with the most enchanting dream which has ever consoled mankind, the myth of a Golden Age in which man lived on the fruits of the earth, peacefully, piously and with primitive simplicity. This conception of the early history of mankind is the exact opposite to that which produced the landscape of fantasy, and is, I believe, known by sociologists as 'soft primitivism' as opposed to 'hard primitivism'. We might be tempted to call it poetic as opposed to scientific truth, were it not that the evolutionary conception of our origins had inspired Lucretius's poetry and Altdorfer's painting.

Although this dream of the Golden Age was filled with the forms and images of classical antiquity, it was not unconnected with the dreams of the later Gothic period. Virgil, after all, had been the guide of Dante. If someone

69 Giovanni Bellini, Allegory of the Progress of the Soul

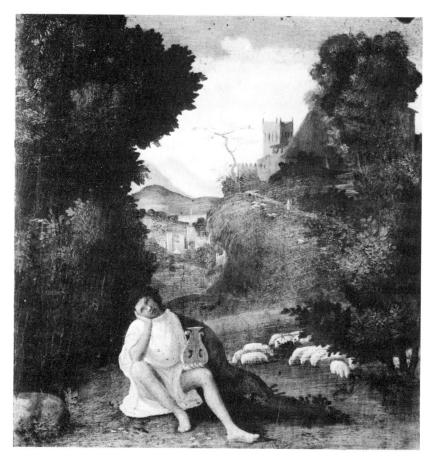

71 School of Giorgione, Scenes illustrating an Eclogue by Tebaldeo

who had never seen the original were to read a description of the *Paradise Garden* at Frankfurt [11], with its figures sitting on the grass, its flowers, its women bending to draw water from the well, and its evocative suggestion of music, he might well suppose he was about to look at Giorgione and Titian's *Fête Champêtre* [68]. The immense, the almost shocking, difference between them is a measure of change in the sense of form which has taken place in less than a hundred years; and it shows the indissoluble connection between form and content, for the study of antique sculpture, to which these new rhythms are due, has changed the sentiment, we may say, even, the philosophy, of the whole work.

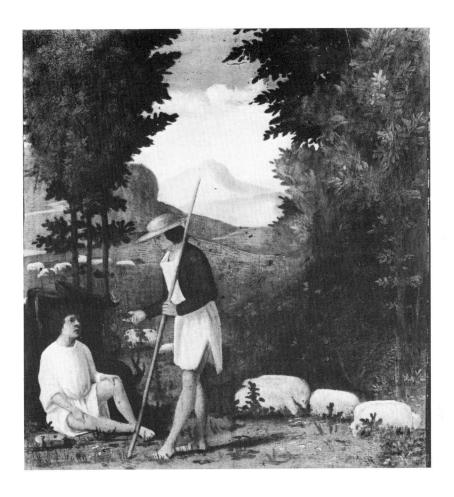

So Virgilian landscape is essentially an evocation of the antique world, with all its fullness of life and its confidence in the body, but also with some qualities which the ancient world lacked, some half-lights, some backward glances. Foreshadowing this new prospect is the beautiful *Allegory* by Giovanni Bellini [69], a descendant of the paradise garden, but a palpable one in which the figures breathe the air of a warm summer evening. The foreground is occupied with saints, but cupids (however Christianised) play around the tree of life, and in the landscape, one of the most beautiful of the Quattrocento, a centaur is lurking near the Cross. In spite of its sacred theme, this is really the first example of that kind of painting which the

Venetians called *poesie*, and pictures of this kind must have been a formative influence on the youthful Giorgione.

In the epoch of high materialism, the type of art historian who said that Hubert van Eyck had never lived, said the same of Giorgione. It was a scholarly-looking way in which common sense might safely deny the existence of inspiration. Even his earliest landscapes [70], backgrounds of religious paintings painted when he can have been no more than a boy, show astonishing skill. The eye is led into the distance firmly, smoothly, but with some complexity. Natural objects, leaves and stones are rendered precisely, and there is Bellini's sense of precious light. But already they are removed from the landscape of fact. The scenery, as Pater said, 'is such as in England we call "park scenery", with some elusive refinement felt about the rustic buildings, the choice grass, the grouped trees, the undulations deftly economised for graceful effect. Only, in Italy all natural things are as it were woven through and through with gold thread, even the cypress revealing it among the folds of its blackness.' It is this golden light and flowing rhythm in the line of trees and contours which make Giorgione's earliest landscapes poetical, and his natural lyricism was developed by association with the group of poets of the so-called Arcadian movement at the court of Caterina Cornaro in Asolo, near to his native Castelfranco, and in particular with that arbiter of classic elegance, Pietro Bembo. An arcadian spirit is present in Italian poetry as early as Boccaccio, but its great popularity was due to Sannazzaro, whose Arcadia appeared in the 1490s. Apart from the general charm of its subject matter to a landscape painter, the Arcadia is full of pictures. Here, for example, on the entrance to the temple of Pales, is one of those compositions with which, fifteen years later, Giorgione and Titian were to decorate the walls of Venetian palaces. 'We found', says Sannazzaro, 'painted above the doorway certain woods and hills of the most delightful beauty, full of leafy trees and of a thousand sorts of flowers, among the which were seen many herds at pasture, wending at pleasure through green fields, with peradventure ten dogs to guard them, the footsteps of which were traced upon the dust most natural to the view. Of the shepherds, some were milking, some shearing wool, others playing on pipes, and there were there a few, who, as it seemed, were singing and endeavouring to keep in tune with them. But that which pleased me to regard with most attention were certain naked Nymphs, standing halfhidden behind a chestnut bole, laughing at a ram, who, in his eagerness to

gnaw a wreath of oak that hung before his eyes, forgot to feed upon the grass around him. At that moment come four Satyrs, with horns upon their heads and goats' feet, stealing through a shrubbery of lentisks, softly, softly, to take the maidens by surprise.' This is the kind of subject which will delight the painters of Venice during the next fifty years. And Sannazzaro anticipates the very colour of Venetian painting. 'It was the hour', he writes, 'when sunset had embroidered all the West with a thousand variety of clouds; some violet, some darkly blue and a certain crimson; others between yellow and black, and a few so burning with fire of backward-beaten rays that they seemed as though of polished and finest gold.'

There survives a direct connection with this circle of poets in four little scenes illustrating an Eclogue by the Ferrarese Tebaldeo, painted under the direct inspiration of Giorgione. Tebaldeo was a close friend of Bembo and in the Veneto his work rivalled that of Sannazzaro in popularity. This Eclogue tells the traditional story of Damon's unrequited love for Amaryllis, and the painter has rendered it with a poignant naïveté and concentration. The glow of Giorgione's personality has so illuminated a craftsman that he has decorated the doors of a small cupboard with the purest images of pastoral poetry [71]. These scenes also show in simplified form the structure of the new Arcadian landscape. On either side are dark masses of tree and rock, like wings of a theatrical scene, which leave the centre of the picture free. Even the figures, which are completely one with the landscape, are sometimes placed at the side; sky and distance take the principal place. It is the composition which, with every refinement of variation, was to form the basis of Claude. We know that it occurred in one of the earliest Giorgiones, the lost Finding of Paris, and it also underlies the one essential and indubitable Giorgione, that quintessence of poetic landscape, the Tempesta [72].

The *Tempesta* is one of those works of art before which the scholar had best remain silent. No one knows what it represents; even Michiel, writing almost in Giorgione's day, could offer no better title than 'a soldier and a gypsy', and I think there is little doubt that it is a free fantasy¹, a sort of Kubla Khan, which grew as Giorgione painted it – for X-rays have shown us that Giorgione was an improviser, who changed his pictures as he went along, and that this composition originally contained another

¹I now (1976) accept unreservedly Edgar Wind's theory that the man in the *Tempesta* represents *fortitudo* and the woman *caritas*, and that they are united by *fortuna*, an archaic Italian word for a storm.

naked woman, bathing her feet in the stream. This improvisation, which was so much at variance with the studio practice of preceding painters, was characteristic of an art which was akin to lyric poetry. If we cannot say what the Tempesta means, still less can we say how it achieves its magical power over our minds. Its sequences of association and felicities of composition are extremely recondite, and can only be felt by those who are prepared to surrender themselves to its mood. To a common-sense approach it will yield as many faults as did *Endymion* to the Scottish reviewer; but, of course, part of its incantatory power lies in its defiance of logic, in the strange detachment of the figures, who seem unaware of each other's existence, of the approaching storm or of the inexplicable character of the ruins in the middle distance, which can never have formed part of a real building. These are the inconsistencies of a dream, and if we ask why we do not reject them with our waking minds, the answer must be very largely that the thundery light of the landscape has put us into that state of heightened emotion in which we can accept anything. Giorgione was quite consciously and deliberately working a spell. We can see from the painting of his circle that his mind was much occupied with that traditional magic which played such a curious part in the later Quattrocento, the pagan magic of the Golden Ass or of that crazy antiquarian dream, the Poliphilo. This fact does not invalidate my epithet Virgilian, for Virgil was not averse from a spot of sorcery, and in the Renaissance still retained some of his mediaeval status as the prime magician. Perhaps without this consciousness of danger Giorgione could never have given such poignancy to his vision of perfect harmony with nature, the Fête Champêtre in the Louvre [68]. It is the supreme expression of a most precious moment in the history of the European spirit, a moment fortunately interpreted for us in a masterpiece of criticism, Pater's essay on the School of Giorgione. To quote from it does violence to the beauty of its texture, but I must recall with what a sure intuition Pater associates Giorgione with the rise of Italian music, and points out how many pictures of his school have musical themes; 'music at the pool-side while people fish, or mingled with the sound of the pitcher in the well, or heard across running water, or among the flocks; the tuning of instruments; people with intent faces, as if listening, like those described by Plato in an

¹Cf. *The Horoscope* at Dresden, *The Astrologer* engraved by Giulio Campagnola, and *The Dream*, already referred to. Giorgione's own *Three Philosophers* at Vienna probably has a magical significance.

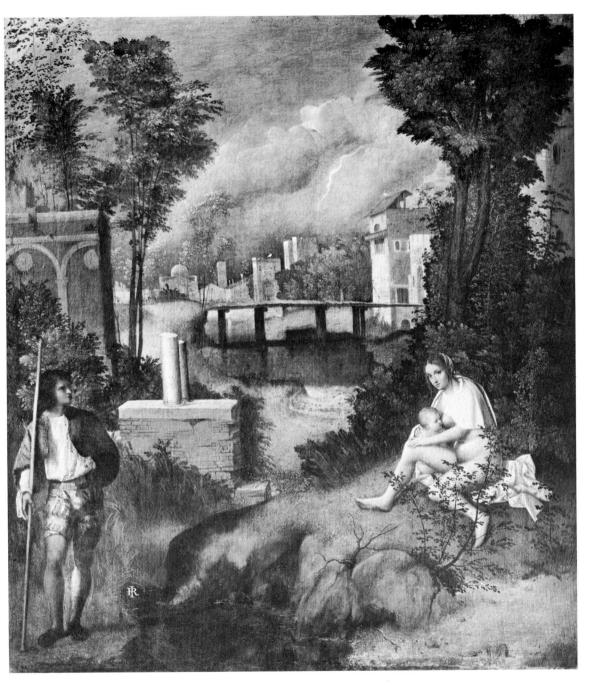

72 Giorgione, La Tempesta

ingenious passage of the *Republic*, to detect the smallest interval of musical sound, the smallest undulation in the air, or feeling for music in thought on a stringless instrument, ear and finger refining themselves infinitely, in the appetite for sweet sound; a momentary touch of an instrument in the twilight, as one passes through some unfamiliar room, in a chance company'.

To my mind it is precisely this musical quality, this feeling, as Pater says, that 'life itself is conceived as a sort of listening' which distinguishes Giorgione from his younger contemporary, Titian. In his youth, under the fascination of Giorgione, Titian attempted his mood, and painted an Eclogue of great beauty, the *Three Ages of Man* in the Ellesmere Collection. The rapt expression with which the girl regards her swain has an echo of Giorgionesque music which at first deludes us. But comparison with the *Fête Champêtre* is unavoidable, and at once reveals the more explicit and material character of Titian's sensuality.

The most complete and satisfying of Titian's early landscapes are those which lie either side of the Sacred and Profane Love [73]. But in the heads of the twin Venuses (for that is what they are) we see a proud, sensual look entirely different from the pure, gentle, abstracted expression of the Giorgione. This is already the work of an ambitious man of action, a Prince of Painters, as the old critics rightly called him. The appeal of this picture to our emotions is due very largely to the mood of the landscape, achieved by the beauty of the evening light. How far this landscape mood dominates the painting of the time is shown by the fact that the group of buildings that lies behind the earthly Venus appears reserved in two Giorgionesque pictures painted a few years earlier. One of these is the Sleeping Venus by Giorgione at Dresden, which must have been one of the most beautiful pictures in the world, but was damaged in a fire, and has been much restored. The other, perfectly preserved, is the Noli me Tangere in the National Gallery. I hold the heretical opinion that this is one of the pictures begun by Giorgione and finished by Titian after his death; I cannot dissociate the landscape from that of Fête Champêtre, and the whole picture has a tenderness which I do not find in Titian. It is characteristic of the neo-Platonic doctrines of the time, that the landscape, which gives the picture its spirit, is transferred without alteration from a pagan to a sacred theme.1

¹In the original sketch of this picture, as revealed by X-ray, the Christ was standing in a pose taken direct from the antique figure of Amor, now in the Venice Museum, and in a Venetian Collection in Giorgione's day.

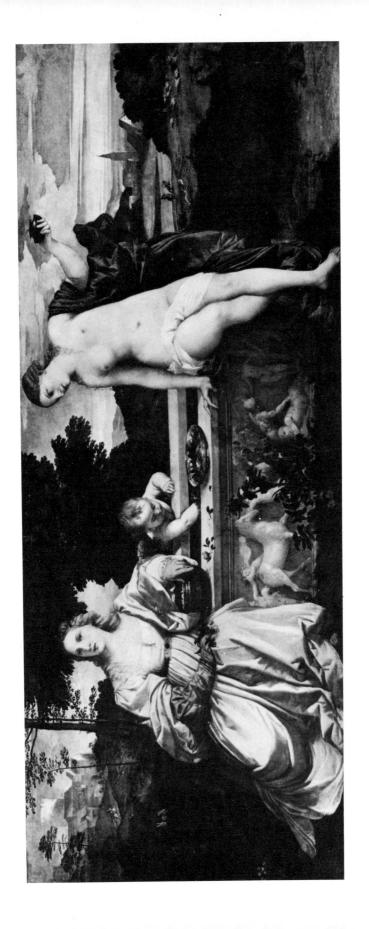

[By writing about Titian in the golden light of Giorgione's Arcadia (and incidentally it now seems to me probable that the buildings on the hillside behind the Sleeping Venus and the Noli me Tangere were added by Titian himself), I did a great injustice to his marvellous powers as a landscape painter. Titian had more perhaps than any painter Cézanne's sensation forte devant la nature. Anyone who has visited Cadore will have recognised that the memories of Titian's native place remained with him all his life. The rocky hills with their thick clusters of trees, the rushing streams and blue mountain distances, are remembered with passion and crowded into the small backgrounds of his portraits. There are also backgrounds in the religious pictures and the *poesie* where sky and distance play a decisive role. These are not ideal landscapes, but landscapes of heightened perception, raised to a new emotional temperature that increases the power of the main subject. Some of them still look back to the mountains of Cadore, like the sublime twilight landscape that surrounds the figure of Christ on the Cross in the Escorial; but others are of the lagune, like the view of the Ducal Palace in an altarpiece in Ancona, and, most astonishing of all, the sunset in the Prado St. Margaret, which looks as if the City of Venice were on fire. Before these evening skies we remember the famous letter addressed to Titian by his rascally, but loyal, friend Pietro Aretino, in which he describes at great length a spectacular sunset seen from his window, and asks 'Titian where are you now?' Titian must often have been there, for all his sunsets, painted from memory, have an astonishing intensity and truth [74].

Next to skies Titian loved trees, and had an unequalled grasp of powerful trunks and weighty foliage. These too he used as partners in the presentation of his great dramas, and nowhere more so than in that lost masterpiece, one of the most admired and influential works of high-Renaissance, the *Martyrdom of St. Peter Martyr*, destroyed by a fire in the church of SS. Giovanni e Paolo. One can see from numerous copies that the sweep and thrust of the tree trunks not only accentuates the violence of the murder, but helps the saint's soul to rise up to Heaven]

It was precisely Titian's sensation forte devant la nature that such an admirable composer of landscape as Domenichino lacked. Even the famous lunettes by Annibale Carracci and his disciples in the Doria Gallery look like pieces of picture making, although one must admit that in Annibale's Flight into Egypt the picture is remarkably well made; and in the Entombment

74 Titian, St. Margaret

there is a note of authentic poetry and a delicate pathos that the all-powerful chef d'école seldom permitted himself. But as a whole these eclectic landscapes fall into the category of art historian's art. All the unjust criticisms which Ruskin, in his weaker moments, levelled at Claude, can be applied to the academic landscapes of the seventeenth century Bolognese. They are without joy in the perception of fact, or an imaginative sense of the force and mystery of nature, and above all, they lack feeling for the unifying element of light; and without these life-giving qualities no amount of idealisation will justify landscape painting as an art form. It is by these qualities, no less than by his sense of Arcadian poetry, that Claude can make the formal language of his predecessors still fresh and vivid to us.

Claude Gellée, the true heir to the poetry of Giorgione, was fully appreciated in his own lifetime, and has been the object of much devotion ever since; but he does not offer an easy target for the critic, and no great artist has inspired so little literature. Roger Fry, whose essay on Claude in *Vision and Design* remains the best criticism of his painting since Hazlitt, regarded him as a sort of simpleton who arrived at his felicities by accident, and this view would probably have been corroborated by Poussin, who lived in Rome at the same time as Claude for almost forty years and never mentions him, although we know from Sandrart that they went painting together. But the inspired-idiot theory of a great artist is practically never correct; and when we look at the enormous range of Claude's drawings and the quantity of delicately observed fact which they contain, and then consider that he was able to use all this material in subordination to a poetic conception of landscape almost as ideal in its own way as Poussin's, we realise that Claude, however inarticulate, was not lacking in intelligence.

He was born in 1600 in Lorraine, and went to Rome as pastry cook. We know he was assistant to a painter called Tassi in 1619. After one short and unsuccessful journey back to France he returned to Rome and lived there uninterruptedly till his death in 1682. He has the same claim to be considered a French painter as Sisley has to be an English one. Unlike Poussin we know very little about his life or the dates of his early paintings, but we have a short biographical note by a fellow painter, Sandrart, who accompanied him on his early painting expeditions. He tells us that at the time Claude's study of nature was limited to contemplation, particularly of sunrise and sunset. 'He first met me', he adds, 'amid the rocks at Tivoli, my brush in hand. Seeing that I worked from nature he began to do the same

himself, and in the end achieved works of great value.' Later Sandrart makes it clear that Claude not only drew but painted from nature, especially his distances. This is contrary to anything one is told about the landscapes of the old masters, and is not suggested by a first impression of the paintings themselves, although careful scrutiny of Claude shows effects which could hardly have been carried in the memory.

No great painter ever lived so completely within his resources as Claude. Unlike such splendid prodigals as Rubens, his pictures always suggest a tactful and far-sighted economy. At first sight their extreme simplicity may suggest a certain lack of resource, and it is only when we become familiar with them, and compare them with the work of imitators, that we realise how rich is the observation which Claude has put into every branch, how subtle the tonality of his foregrounds, and how delicately drawn the waves and ripples which catch the light of his golden skies. Behind these simpleseeming pictures there was an immense amount of preparation. First came the sketches from nature. These are the works of Claude in which we may see most clearly the gulf which separates him from the Carracci, for they show a visual responsiveness hardly different from that of the impressionists. Sometimes they are careful studies of detail, sometimes they are entirely impressionist in their sense of light; sometimes they have a Chinese delicacy of accent [75]. In all of them the large disposition of area is masterly, and no one will deny their ravishing beauty, freshness and variety. Claude never thought of these sketches as ends in themselves. His mind was always looking forward to their use as parts of a whole composition, and parallel with these studies from observation he made sketches of ideas which could be used as the basis for pictures. This is the type of Claude drawing which was admired and imitated by the early English water-colourists, especially by Alexander Cozens and by Gainsborough, much as the poets of the eighteenth century turned to Horace for models of the ode, or musicians to Bach to discover the possible variations of the fugue. Then came the actual studies for pictures carried far towards the final composition, and sometimes, as in the example in the Ashmolean of Ascanius and the Stag, done when Claude was 82 [75], setting it down exactly. These are the drawings that Claude himself valued and those which were collected by his contemporaries; and if we study them with something of the patience which went to their composition, we gradually come to inhabit a world of pre-ordained harmony.

Finally we come to the pictures, about which there is little to say because

77 Claude Lorrain, Landscape with Acis and Galatea

78 Claude Lorrain, Landscape with the Flight into Egypt

anyone who looks at them in a receptive frame of mind must surely be touched by their exquisite poetry. They are a perfect example of what old writers on art used to call Keeping. Everything is in Keeping: there is never a false note. Claude could subordinate all his powers of perception and knowledge of natural appearances to the poetic feeling of the whole. The world of his imagination is so clear and consistent that nothing obtrudes, nothing is commonplace, nothing, least of all, is done for effect. As with Racine's plays, which give the same feeling of devotion to an ideal whole, this is not so much the result of self-discipline—an act of will – as of a natural habit of mind. Just as Racine conformed to the Unities and to the exacting prosody of the Alexandrine, so Claude nearly always conformed to an underlying scheme of composition. This involved [76] a dark coulisse on one side (hardly ever on two), the shadow of which extended across the first plane of the foreground, a middle plane with a large central feature, usually a group of trees, and finally two planes, one behind the other, the second being that luminous distance for which he has always been famous, and which, as we have seen, he painted direct from nature. Much art was necessary to lead the eye from one plane to the next, and Claude employed bridges, rivers, cattle fording a stream and similar devices; but these are less important than his sure sense of tone, which allowed him to achieve an effect of recession even in pictures where every plane is parallel. He used many variants of this compositional scheme. Often he dispensed with the central feature, as in that enchanting work, which, by its title alone evokes the spirit of Claude, the Decline of the Roman Empire. More rarely he dispensed with the coulisse, as in the Morning of the Hermitage, or Jacob and Laban at Dulwich. This method of designing by successive planes which sometimes, at first sight, seem little more than silhouettes, gave to the shape of his dark masses a role of unusual importance. The discovery of graceful and characteristic silhouettes was, as I have said, one of the chief aims of his drawings from nature, and however refined and carefully balanced in the final pictures are the shapes of his trees and rocks, they always retain their character. In spite of his extreme formality, nothing in Claude is a formula.

My comparison of Claude's scheme of composition with the Ode or the Unities is in one respect misleading, for it implies that he was adopting a current classic mode, whereas in fact it grew up in his mind parallel with the gradual expansion of his poetic sense. Only when he was past middle age do spirit and design attain their full expression. His greatest poems – the *Times*

of the Day in the Hermitage, or the Acis and Galatea of Dresden [77] – were painted when he was over sixty. It is these later works which, whatever their ostensible subject, are fullest of the Virgilian spirit. His seaports, painted in the '40s, may remind us of that moment when Aeneas leaves the grandeur and certainty of Carthage for a shining unknown distance. But the Virgilian element in Claude is, above all, his sense of a Golden Age, of grazing flocks, unruffled waters and a calm, luminous sky, images of perfect harmony between man and nature, but touched, as he combines them, with a Mozartian wistfulness, as if he knew that this perfection could last no longer than the moment in which it takes possession of our minds [78].

The great figures in history have a curious way of appearing in complementary pairs. The complement to the gentle, inarticulate Claude, was the stern, Cartesian, Poussin. Unlike Claude, we know a great deal about him, more perhaps than we do about any painter who preceded him, except Michelangelo; and everything we know proves that the intellectual content of his pictures cannot be exaggerated. Every incident, no less than the disposition of every form, is the result of deep thought and meditation. Nothing could be further from the inspired improvisation and lyric flow of Giorgione. Yet the early Poussin landscapes, the backgrounds of his Bacchanals, go back to Titian's Mythologies in the palace of Ferrara, which he is said to have copied. Poussin did not paint pure landscapes till about 1648 when he was fifty-four, and we may wonder why, holding the opinions he did about the inherently moral character of painting, he should have attempted the subject at all. But in spite of his theories, Poussin had an immense appetite for nature; and we may also guess that he was ambitious of achieving a fresh conquest for the intellect, by giving logical form even to the disorder of natural scenery.

It is worth analysing a few of the means by which he solved this problem as they were to influence all of those later painters who have tried to give to landscape an air of order and permanence [82]. Without some knowledge of them we cannot understand Cézanne and Seurat. Poussin conceived that the basis of landscape painting lay in the harmonious balance of the horizontal and vertical elements in his design. He recognised that the spacing of these horizontals and verticals and their rhythmic relation to one another could have an effect exactly like the rhythmic travée or other harmonic devices of architecture; and in fact he often disposed them according to the so-called golden section. The chief difficulty

of imposing this geometric scheme on nature lies, of course, in the absence of verticals. Landscape is essentially horizontal, and such verticals as exist are not always at right angles to the ground. To meet this difficulty Poussin, in his more schematic compositions, was fond of introducing architecture, which also assisted his secondary purpose of giving an antique air to his subjects. His groups of buildings are of great importance as providing a modulus, or key, to the scheme of proportion on which the design is constructed, and sometimes, by means of blocks of masonry from a ruined temple, he is able to carry this pure geometry right through the composition. It was essential to Poussin's design that his verticals and horizontals should meet at right angles: in fact if any upright line inclines slightly from the vertical, we may be sure to find another slightly off the horizontal which is at right angles to it. This insistance on the right angle is only possible when the main axis of the composition is parallel to the picture plane, and it thus accounts for the frontality of Poussin's landscape, a condition equally at variance from our ordinary vision, and from the serpentine recessions of Rubens. But since penetration into space is an essential part of landscape painting, Poussin had to devise means of leading our eye back into the distance. No doubt the way most congenial to his mathematical mind was the central point of perspective, but he saw that this was too rigid and artificial to be anything more than occasional solution. He therefore fitted into his scaffolding of horizontals a subsidiary scheme of diagonals which would conduct the eye smoothly and rhythmically to the background, and he was particularly fond of a diagonal path which turned back on itself after about two thirds of its journey.

We are naturally led to speculate how far this remarkable concept of Pythagorean landscape was Poussin's own invention. It owes nothing to Titian and Giorgione (who influenced him so greatly in other respects) and little enough to Domenichino; and I believe that the true precursor of Poussin in the construction of landscape was Giovanni Bellini. Although he does not mention Bellini, he made a full-size copy of Bellini's Feast of the Gods, which has long been recognised as one of the foundations of his style. And it is worth turning back to Bellini's Resurrection [34] to see how it is built up on the geometric principles I have just described. We are immediately struck

¹In pure landscape he seems to have used it only once, in the so-called *Landscape with* the Roman Road, of which the best replica is at Dulwich, but he uses it frequently in the backgrounds of his figure-pieces, e.g. The Rape of the Sabines.

by the grandiose rectangle of the tomb, its proportions between void and solid controlled by the golden section; and by the rhythmic progression of the horizontals. More important still is the angle formed by the staff of Christ's banner as it crosses the band of cloud, and we notice how the line of the staff is continued down through the sleeping soldier till it meets the fallen door of the tomb. We are so much accustomed to thinking that Bellini addressed himself to the heart and eye rather than the head, that these exercises of the intellect come as a surprise. Yet we have only to turn to the background of the *Madonna of the Meadow* [I] or even the Uffizi *Allegory* to find them confirmed.

The paintings of Poussin in which these principles are most explicitly worked out are the heroic landscapes of 1648 that illustrate the story of Phocion. They show the intimate connection, in ideal landscape, between form and content, for the stern Plutarchian fable has produced the most rigorous of all Poussin's compositions [83]. They are intended to symbolise the dangerous fickleness of the mob, which had condemned to death a great leader simply because he had not courted their favours and had the irritating faculty of being right; and Poussin conceived that the setting of this story must be of the utmost austerity. No beauties of light or charming distances, but a full, closely knit design, presented with uncompromising frontality. The firmness of these great masses and the certainty with which the eye is led back into the distance until it is arrested by the Euclidian finality of the Temple, combine to give an impression of irresistible logic. But in the great myths which Poussin painted between 1658 and 1665 this extreme geometrical ardour was relaxed or at least concealed. They are still in the fullest sense ideal landscape: as Hazlitt puts it 'they denote a foregone conclusion. He applies nature to his own purposes, works out her images according to standards of his own thoughts . . . and the first conception being given, all the rest seems to grow out of, and be assimilated to it, by the unfailing process of a studious imagination.' But in the same passage he says with great truth that Poussin 'could give to the scenery of his heroic fables that unimpaired look of original nature, full, solid, large, luxuriant, teeming with life and power'.

It is this sensuous grasp of organic as well as abstract form which makes Poussin's later landscapes so inexhaustibly satisfying. In such a picture as the *Diogenes* [80] in the Louvre the rigour of the Phocion pictures is relaxed, and in its place is an almost romantic response to nature. The trees and

79 Nicolas Poussin, The Deluge

80 Nicolas Poussin, Landscape with Diogenes

bushes on the bank, the pebbles in the stream and the shining bend of the river are observed with a solemn joy, and we can believe Hazlitt when he tells us that Poussin was Wordsworth's favourite painter.

Although the subjects of Poussin's landscapes are often drawn from the myths of antiquity – Orpheus and Eurydice, Polyphemus, the giant Orion – and were no doubt inspired by fervid reading of the classics, they do not, to my mind, at all suggest the imaginative worlds of Ovid and Virgil. They are too grave, too weighted down with thought and stoicism. The Saturnian reign is over; and one cannot look at these valleys, with their overhanging forests and voiceless streams, 'far from the fiery noon', without being reminded of the opening of Hyperion, and remembering that Keats, who normally drew his inspiration from works of art, was certain to have been familiar with the late landscapes of Poussin so much admired by his friends. Hyperion is the last and greatest of Miltonics; and in contemplating the work of Poussin it is Milton who comes most often to mind. For although Milton lacked Poussin's extreme rationalism, we find in both the same early delight in pagan richness of colour and imagery, the same strenuous and didactic middle period, and the same old age of renunciation and remoteness, giving a new depth of poetic vision.

The most Miltonic of Poussin's landscapes are the *Four Seasons* painted for the Duke of Richelieu during the years of the composition of *Paradise Lost*. Brienne has left us an account of their first reception: 'Nous fûmes une assemblée chez le duc de Richelieu où se trouvèrent tous les principaux curieux qui furent à Paris. La conférence fut longue et savante.... Je parlai aussi et je me déclarai pour le *Déluge* [79]. M. Passart fut de mon sentiment. M. Le Brun, qui n'estimait guère le *Printemps* et l' *Automne*, donna de grands éloges à l'*Eté*. Mais pour Bourdon, il estimait le *Paradis terrestre* et n'en démordit point.'

These noble compositions are still the subject of admiring debate among those who love painting, and I find myself in the same state of uncertainty as were their original admirers. Sometimes, like Bourdon, I am firm for the *Spring*, that perfect illustration to *Paradise Lost*, in which, by the art of design, our first parents are given their true place in nature. And sometimes, like Le Brun, I feel that nothing can surpass the *Summer* [81], in which the mood of the *Georgics* is raised to a kind of sacramental gravity; and here I believe I should have had the support of Cézanne whose compositions were much influenced by the parallelism of the *Cornfield*, and by the large tree filling the

82 Nicolas Poussin, St John on Patmos

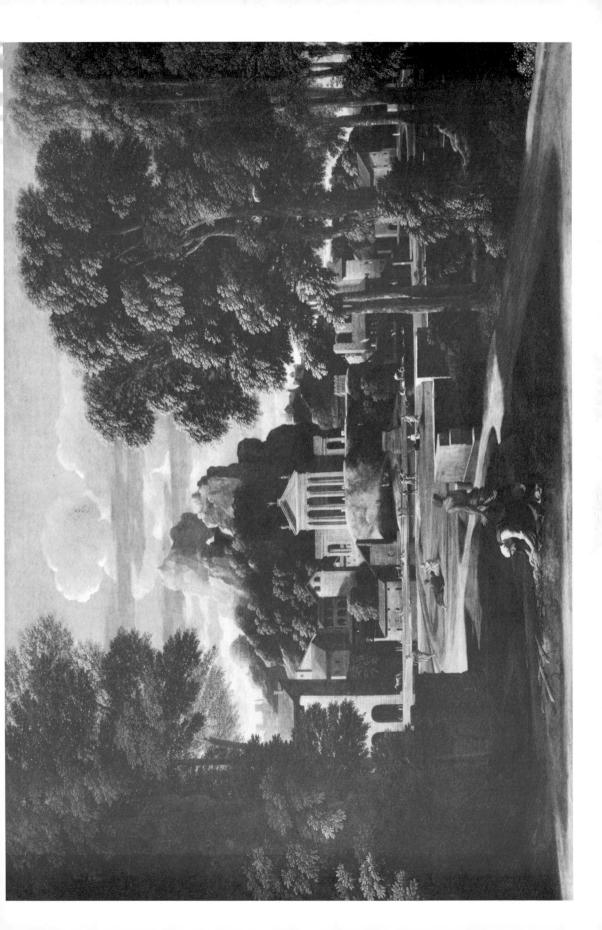

left-hand side. But, in the end, perhaps the most astonishing proof of Poussin's powers is to be found in the *Winter*, where he has given a romantic subject the logic and consistency of his great classic designs without sacrificing its dramatic force.

Poussin is one of those rare artists whose influence was wholly beneficial. This is not a common attribute of greatness, for artists like Michelangelo and Raphael usually exhaust the possibilities of their chosen style; nor is it necessarily the mark of a classical artist, for the influence of Ingres was, on the whole, destructive, whereas Rembrandt's pupils painted pictures which are almost indistinguishable from their master's. Poussin's influence was good because he combined in such full measure the ideal and the real. His scrupulous sense of design was nourished on observation; his most exalted visions remain concrete. Without his sense of truth Bourdon would have become a mere picture-maker; without his sense of form Gaspard would have become a sort of Charles Jacques. As it is, they both produced fine landscapes; indeed Gaspard, in authentic work like the Palazzo Colonna frescoes or the landscape in the National Gallery [84], was, till recently, one of the most underrated artists in the history of painting. He had a gift of straightforward naturalism, which makes him the true precursor of the Barbizon school, but Rousseau never achieved his clarity of composition. Even the romantic side of Poussin was perpetuated in the work of Francisque Millet, whose Destruction of Sodom [85] contains the sort of alpine panorama which Ruskin believed to have been the discovery of Turner. That Poussin's influence should have declined in the Rococo period was inevitable, but in the more heroic age of classicism it was revived. Through Pierre Henri Valenciennes it dominated the early work of Corot, and although Corot himself was to discover that his true affinities were with Claude, the shadow of Poussin still falls across the landscapes of Millet and Pissarro, long before Cézanne made a more spectacular return to his principles.

The idea that an appreciation of nature can be combined with a desire for intellectual order has never been acceptable in England. In spite of Hazlitt's eloquence, Poussin has had few followers among English painters. Turner thought his *Winter* a tame performance, and only Constable attempted to profit by his discoveries. Claude, on the other hand, gave to English painting a simpler scaffolding on which the native school could build. There was something in Claude's gentle poetry, in his wistful glances at a vanished civilisation and in his feeling that all nature could be laid out for man's

delight, like a gentleman's park, which appealed particularly to the English connoisseurs of the eighteenth century. Sometimes his principles of composition, with their wings and stage trees, offered too easy a formula; but Wilson, at his best, understood the two chief lessons of Claude, that the centre of a landscape is an area of light, and that everything must be subordinate to a single mood. As a result, although by no means a skilful artist, Wilson is a true minor poet, a sort of William Collins, writing his 'Ode to Evening' in classic metre and with fresh perception.

John Robert Cozens is slighter, but more original. He is an entirely English artist. He painted only in the native medium of water-colour, and his work belongs to that kind of painted poetry which the French find trivial. But we should not let ourselves be bullied out of enjoying these nostalgic visions which distil all that we have read or dreamt of Italy from the time of Virgil to that of Shelley and Keats. In his water-colours of Albano, Castel Gandolfo or the Euganean hills [86] he gives that feeling of romantic piety which ranks high among civilised pleasures. Here and here, we feel, have lived the men through whose greatness of spirit our own lives have received some occasional lustre. The pale, lunar tones of Cozens's water-colours are the true reflection of morning light, not perhaps the first light of the Golden Age which Virgil sang, but of its rediscovery in the seventeenth century.

I began by saying that ideal landscape was closely connected with the landscape of symbols. Both were inspired by a dream of the earthly paradise, both sought to create a harmony between man and nature. The landscape of symbols begins with Simone Martini's frontispiece to Petrarch's Virgil; ideal landscape may fitly end with Blake's illustrations to Dr. Thornton's edition of the Ecloques. It was a very humble edition, intended to teach the young by means of numerous illustrations, amongst which Dr. Thornton included, with some misgiving, for he felt that 'they displayed less of art than genius', seventeen woodcuts by 'the famous Blake'. These smudgy little images prove once more the character of inspiration, for they focus within a few inches a poetry which is still radio-active today. The first man to feel these rays was that strange genius whose work, rediscovered for this generation like the poetry of Hölderlin, has had almost too pervasive an influence on recent English painting, Samuel Palmer. Much beside Blake went to the formation of his style; Dürer, Breughel, Elsheimer and Claude are all perceptible. But it was Blake who gave him the courage to express his

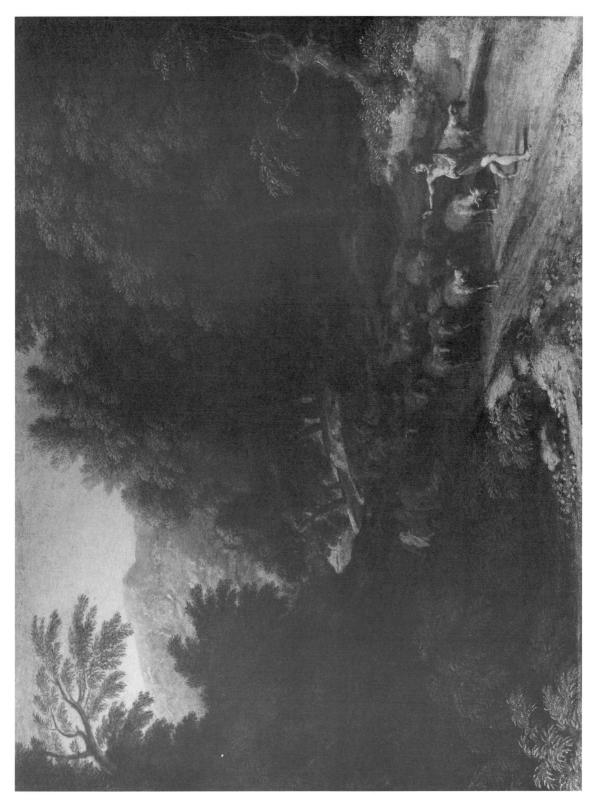

84 Gaspard Poussin, A Road near Albano

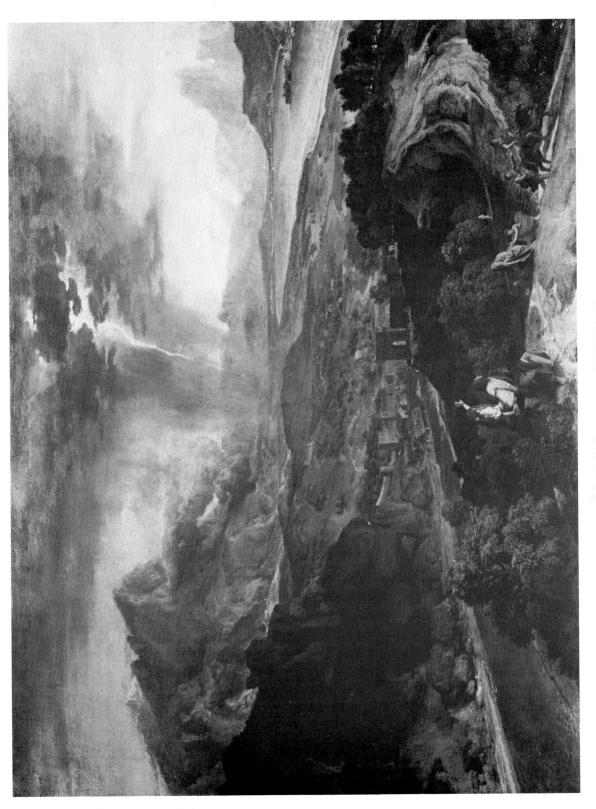

 $85\ \ {\rm Francisque\,Millet}, {\it Destruction\,of\,Sodom}$

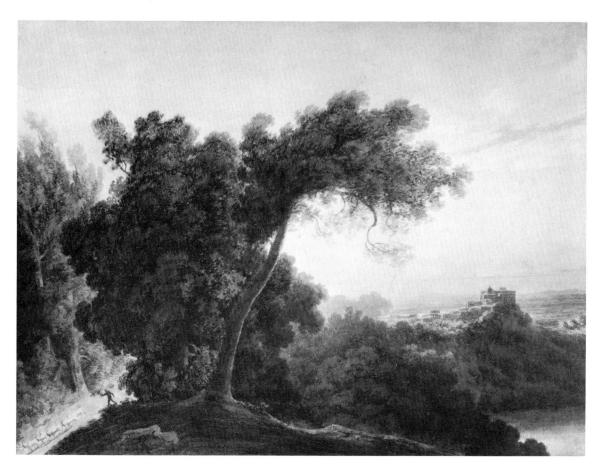

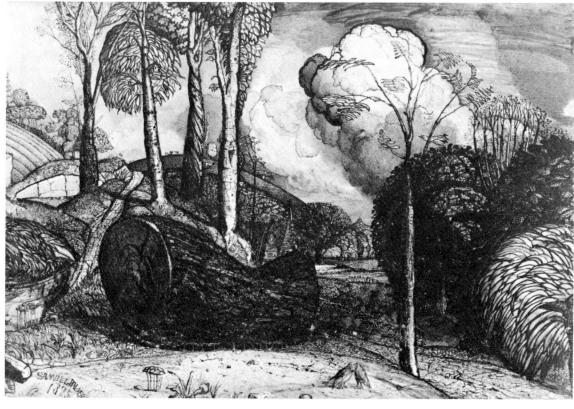

vision in a symbolic language more uncompromising than any of these. In the landscapes done between 1825 and 1830 this vision is so intense as to have the character of hallucination. These were the years when Palmer was living in Shoreham with a few friends remote from the world, reading Virgil and Milton, Fletcher's Faithful Shepherdess and Flavel's Husbandry Spiritualized. No less than Wordsworth, Palmer invested nature with a spiritual quality; but whereas Wordsworth took his point of departure in the senses, and deduced God in nature from what he had perceived, Palmer, as the disciple of Blake, saw first with the spiritual eye, and in so doing found every blade of grass and leaf and cloud was designed according to God's pattern. It was the vision of the middle ages, and thus created a style very close to the landscape of symbols [86]. But, unlike other nineteenth-century escapes to the past, this style has no antiquarian flavour. An artist can seldom swim against the current of his times without artiness and affectation, and perhaps this feat can only be achieved by those who do not simply look back to the past, but have some prophetic notion of the needs of the future. If in some of his drawings Palmer's use of decorative symbols reminds us of a Verdure tapestry, in others the freedom of his means anticipate van Gogh. In these ways he is closer to contemporary feeling than another romantic landscape painter whose brooding on nature is in some respects similar to his, Caspar David Friedrich; for Friedrich worked out his intense visions in the frigid technique of his times. But, although he is not so acceptable to English taste, I think we must concede that Friedrich was the greater artist, with a far more extended range than Palmer. No one has expressed more poignantly the gloom of solitude and the sadness of unfulfilled expectation [87].

Palmer remains the last painter of Virgilian landscape. His flocks and sheaves of corn, his harvest moons and trees weighed down with fruit, symbolise a passionate conviction that the good life can only be lived in terms of pastoral simplicity. With the passing of the Reform Bill (which he bitterly opposed) and with the rising fog of the nineteenth century, he gradually lost heart. Virgil remained his source of inspiration, but his images grew fainter and his style more commonplace. And with him there ended that beautiful episode in European art, which from Giorgione's day till the nineteenth century had been a source of enchantment and consolation. Since the Renaissance I do not suppose that many people had believed very seriously in the facts of a Golden Age or the perfection of a pastoral life; but these had remained, within the scope of the imagination,

87 Caspar David Friedrich, Woman in front of the Setting Sun

Rubens, Landscape with Rainbow

concrete enough to produce art and poetry. By 1850 Malthus and Darwin had made them into moonshine. And with this annihilation of an ideal past there vanished the concept of ideal landscape. The principles of composition with which Poussin had embodied his high fictions were, it is true, to be valued again. But the feeling that 'some God is in this place' and has given to nature an unusual perfection, was bundled away, together with less agreeable attributes of classic painting, and can never be revived.

THE NATURAL VISION

Early in the nineteenth century it was recognised that the status of land-scape painting was changing. This change happened quite quickly. The fabulous successes of Turner took place only thirty years after the failure of Wilson; and in the course of the century landscapes which at least purported to be close imitations of nature, came to hold a more secure place in popular affection than any other form of art. A peaceful scene, with water in the foreground reflecting a luminous sky and set off by dark trees, was something which everyone agreed was beautiful, just as, in previous ages, they had agreed about a naked athlete or a saint with hands crossed on her bosom. As for an extensive view: a great change has taken place since Petrarch's ascent of Mount Ventoux, and, with the exception of love, there is perhaps nothing else by which people of all kinds are more united than by their pleasure in a good view.

It is generally true that all changes or expansions of popular taste have their origins in the vision of some great artist or group of artists, which sometimes rapidly, sometimes gradually, and always unconsciously, is accepted by the uninterested man. The popular appreciation of landscape arose from complex causes, and was accompanied by the successful endeavours of many second-rate painters. Purely as popular imagery the paintings of Callcott, Collins, Pickersgill and other mediocrities, remained for long as important as those of Constable. Yet in the end it is the genius of Constable which first discovered and still justifies the art of unquestioning naturalism. In contrast with Gainsborough's statement that no landscape was worth painting outside Italy, he said that his art could be found under every hedge. It was an aim as revolutionary as that of Wordsworth.

No artist, of course, is entirely original. When Constable was still a student Girtin had painted Wordsworthian landscapes which influenced such works as *Malvern Hall*. And, as a native of East Anglia, Constable had certainly seen Dutch landscapes in the local collections. His feeling for moving light, shadows cast by clouds in a large windy sky, must have been derived from Ruisdael, as well as from his own observations; for Constable, like all revolutionaries, was an eager student of tradition. He had the

capacity, found only in great artists, of entering into a way of painting apparently alien from his own, and drawing from it those elements which are eternally nourishing. He could absorb without imitating. His letters are full of understanding comments on Titian, Claude, Wilson and Gaspard, and quite late in life he would give up any commission in order to copy a Poussin or a Claude. A well-known passage in Leslie describes how as a boy he was introduced to Sir George Beaumont, who showed him his favourite Claude, the Hagar and Ishmael, now in the National Gallery. Constable, says Leslie, 'looked back on this exquisite work as an important epoch in his life'. We can feel the half conscious memory of this picture in the first dated oil painting in which Constable is recognisably himself, the Dedham Vale of 1802. And it is proof of how deeply embedded this design was in his mind that he used the same composition as late as 1828 in the picture now in the National Gallery of Scotland. By this time the distance from Claude is very great. The background contains a quantity of direct observation which Claude could not have assimilated into his ideal scheme. But it is worth insisting on the origin of the composition, because there is no doubt that this deep understanding of the tradition of European landscape was one of the reasons why Constable was able to present such a quantity of normal observation without the painful banality of later realists.

Another reason was the importance which he attached to what he called 'the chiaroscuro of nature'. The phrase occurs repeatedly in his letters, and it is evident from the contexts that he uses it to describe two rather different effects. First he meant the sparkle of light, 'the dews - breezes - bloom and freshness, not one of which has yet been perfected on the canvas of any painter in the world'. This was the aspect of his work which is usually considered most original, and the technical devices by which it was achieved, the broken touches and flicks of pure white with a palette knife were a decisive influence on French painting. But by 'chiaroscuro of nature' Constable also meant that some drama of light and shade must underlie all landscape compositions, and give the keynote of feeling in which the scene was painted. Of a fashionable landscape painter named Lee, he writes: 'I did not think his things were quite so bad. They pretend to nothing but imitation of nature, but that is of the coldest and meanest kind. All is utterly heartless.' It is this sense of dramatic unity, as much as his feeling for the freshness of nature, which distinguishes Constable from his contemporaries. He recognised a work of art must be based on a single dominating idea

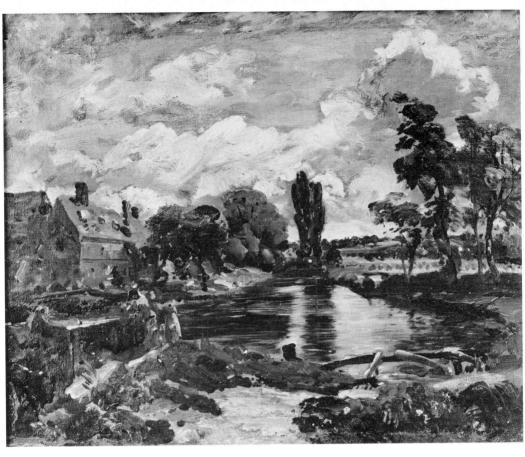

and that the test of an artist is his ability to carry this idea through, to enrich it, to expand it, but never to lose sight of it, and never to include any incidents, however seductive in themselves, which are not ultimately subordinate to the first main conception. Such an aim was relatively simple in classic landscape painting where ideal forms could be used to prevent the multiplication of distracting details. But it is exceedingly difficult in the naturalistic landscape, which was his discovery, where the impressions received from actual objects are the essential point of departure; and where the means of simplification have not been already shaped by generations of taste and style. Perhaps no other painter (except Rubens) has succeeded, as Constable did, in subordinating the infinite visual data of landscape to a single pictorial idea. Later painters have either killed the idea by enriching it, or offered the first sensation without daring to build upon it. The second course, though it produced much of the finest painting of the nineteenth century, restricts both scale and sense of permanence.

Constable has left us a full record of his sensations in oil sketches, which are nowadays the most admired part of his work [88]. But the struggle came, as he well knew, when these first impressions had to be turned into large pictures. Of this process we have, for several of his compositions, evidence at every stage: we have first pencil drawings in tiny notebooks; then small oils which state the theme of the pictures in terms of light and shade, the pencil studies which begin the definition of form, the detailed drawings from nature, the larger oil sketches. And then Constable takes his six-foot canvas. But the picture he paints on it is not the one which he is going to exhibit. To proceed straight from his own way of feeling, from sensations expressed in colour, to the conventional notion of finish - that is to say a series of observations each described separately - would have been too sharp a transition. He must first of all paint a large picture in his own language. This is the origin of those so-called 'full-size sketches' which are Constable's supreme achievement. How far he thought of them in this light it is hard to say. At first he may well have considered them as being no more than preparations for his exhibited pictures; and he undoubtedly valued the amount of additional fact which, by greater definition, he was able to include in the final version. We know this not only from his letters, but from smaller pictures such as the Willows by a Stream [89] or the Trees at Hampstead which show the most complete acceptance of the facts of vision which has ever been made art. It is significant that the former was actually rejected by the Royal

Academy in the year that the *Hay Wain* was accepted, because it was 'too tame a delineation of a given spot'. Of all Constable's works it would have been the most certain to be accepted between 1900 and 1950.

Among Constable's great pictures the closest to the common vision is the *Hay Wain*. Its leading motives have been the inspiration of a hundred thousand calendars, but personally I find that it has survived this destructive popularity and remains an eternally moving expression of serenity and optimism. There are occasions when even Constable's passion for nature cannot animate such a quantity of ordinary observations; as in the *Cornfield*, the picture chosen after his death to represent him in the National Gallery. But he is a bore only in his finished pictures. In his sketches the force of sensation is always strong enough to lift them above the commonplace. In the 'full-size sketch' for the *Hay Wain* his excitement has led him to a free, painter-like handling, which in turn has modified his vision. And in his greatest work naturalism is raised to a higher mode by his belief that since nature was the clearest revelation of God's will, the painting of landscape, conceived in the spirit of humble truth, could be a means of conveying moral ideas.

We have reached the final stage in the development of man's relations with nature, which began with the timid confidence of the middle ages; and just as the last chapter might have been called Virgilian landscape so might this have been called Wordsworthian, although Constable alone was a conscious exponent of the poet's beliefs. Both poet and painter found nature transformed by the philosophy of the eighteenth century into a mechanical universe working under the dictates of common sense; and both believed that there was something in trees, flowers, meadows and mountains which was so full of the divine that if it were contemplated with sufficient devotion it would reveal a moral and spiritual quality of its own. In both, this belief was based on 'a passion and an appetite', which Wordsworth, with a desire for dogma that has done much to alienate readers of his poetry, elaborated as a philosophy. Yet wearisome and logically unsound as some of Wordsworth's theories are, how completely his preface to the 1802 edition of Lyrical Ballads expresses the beliefs which underlie Constable's painting. Take, for example, Constable's dislike of park scenery, and his love of painting rustic life because, to quote from Wordsworth, 'in that condition our elementary feelings co-exist in a state of greater simplicity, and consequently may be more accurately contemplated and more forcibly communicated'.

Or take Wordsworth's other reason for writing of humble themes – that in them 'the passions of men are incorporated with the beautiful and permanent forms of nature'. It is a perfect comment on Constable's great landscapes of the Stour [89].

The poet and painter had this, too, in common, that both drew practically the whole of their emotive power from the scenes of their boyhood. Constable felt, and we may agree with him, that his paintings of Dedham, the Stour and the surrounding country reach a higher emotional temperature than his other work. Salisbury and Hampstead inspired some of his most popular pictures; and there are many sparkling coast scenes [90] which are the most 'impressionist' of his works, and anticipate most clearly Manet, Whistler and Wilson Steer. But they are not created with his whole being, as are the scenes on the Stour. Constable himself writes of his coast scenes almost with contempt; they do not involve the passions; they have, as he would say, no morality, by which he meant no sense of human drama. On the other hand he writes of the Stour, in one of the most famous of his letters: 'The sound of water escaping from mill-dams, willows, old rotten planks, slimy posts, and brickwork, I love such things. These scenes made me a painter, and I am grateful.'

Above all, Wordsworth and Constable were united by their rapture in all created things. 'I never saw', said Constable, 'an ugly thing in my life.' In such sayings, and in Leslie's description of his ecstatic love of trees, we are reminded of the passage in Traherne, often quoted, but indestructible: 'You never enjoy the world aright, till the sea itself floweth in your veins, till you are clothed with the heavens, and crowned with the stars . . . yet further, and you never enjoy the world aright, till you so love the beauty of enjoying it that you are covetous and earnest to persuade others to enjoy it'.

Such is the rapture through which Wordsworth is able to persuade us to enjoy such humble spectacles as daisies and glow-worms, and Constable such almost childishly obvious scenes as the *Willows by a Stream* [89], or the *Cottage in a Cornfield* [90]. That these songs of innocence should turn to the twisted, storm-shattered songs of experience of his later work was perhaps inevitable. Intensity of joy involves a great expenditure of nervous energy, and in all but the most robust is balanced by equally great despair. Constable was not robust. He did not lose the sentiment of nature, as Coleridge had done, or smother it with orthodoxy, like Wordsworth. But he did come to impose on nature so much of the darkness of his own feelings

that he ended as far from the normal, factual vision of the *Hay Wain* as van Gogh at Auvers, or Cézanne at Bibémus.

Although a Wordsworthian attitude to nature lies at the root of Constable's greatness, we must remember that his immediate importance was due to pictorial rather than philosophic causes. His influence in England, the country of philosophical naturalism, was practically nil; whereas in France, as we all know, it was immense. It did not induce Delacroix to paint willows and cottages but to repaint his *Massacre of Skios* in a freer and more colouristic technique. Contemporary critics speak of his influence on a school of French landscape painters, but of this little evidence survives until the rise of the Barbizon school in the late 'thirties. Perhaps the landscapes à la Constable, deplored by Delécluze in 1826, lie mouldering in French provincial galleries, dons de l'État: but I have never seen one. There is, however, no doubt at all of Constable's influence on Théodore Rousseau, who had seen the Hay Wain and several other Constables in the house of his friend M. Boursault.

Rousseau's aim was fundamentally the same as Constable's. He wished to make great compositions out of observed facts, and said: 'l'entends par composition ce qui est en nous, entrant le plus possible dans la réalité extérieure des choses'. His responses to nature, however, were very different: it was the static and not the dynamic that appealed to him, and his most genuine emotions were aroused by the torrid stillness of mid-day or the frozen stillness of a winter evening. This immobility he rendered with a kind of archaic rectitude, applying, for example, to a row of cottages the strict frontal perspective that Poussin had used in his landscape with a Roman road [91]. His work has to be looked at slowly, and as a result recent critics have failed to recognise its merits. By his exhibited works, which are sometimes too reminiscent of the studio and the museum, he created the academism of naturalistic landscape painting, which, as the romanticism of Turner declined, became the standard style for serious exhibition pieces. All the honourable, second-rate Royal Academy landscape painters of the late nineteenth century go back to Rousseau rather than to Constable - and some of the dishonourable ones too. His small studies from nature, which French amateurs keep in their private collections, have a lovable simplicity. But they lack the limpid purity of tone which was the peculiar gift of Corot.

[In my eagerness to come to Corot I almost entirely omitted one of the key figures in the history of landscape painting, Pierre Henri Valenciennes. He

91 Théodore Rousseau, Village of Becquigny and A Summer Day

entered the Academy in 1787, and it was largely through his gifts both as a painter and a writer that landscape became an accepted academic subject. A Prix de Rome landscape competition was established in 1817. Although Valenciennes' large 'heroic' landscapes are somewhat dry, his sketches [92] show a feeling for nature not dissimilar from the early Constable. He said that 'the painter must observe an expanse of country dominated by an area of sky and seen in the light that falls on it at the exact moment when the painter sets out to capture the scene'. Constable, or Monet! Under his influence painters like Michallon and Granet did remarkable studies from nature, and it may still be felt in early Daubigny. By the middle of the century landscape had become such a popular form that in 1863 the Count of Nieuwerkerke, for whom the word popular was anathema (see below), eliminated it by Decree from the Prix de Rome.]

Corot went to Rome as a student in 1825, the year after Constable's triumph at the Salon. He does not seem to have participated in the general excitement, and never in his recorded sayings refers to Constable.1 Indeed we can be sure that he would have been rather shocked by them, for he confessed that it was only late in life that he could swallow Delacroix. His tastes were entirely classic, and he went to Rome with the intention of following in the footsteps of Poussin and Valenciennes. The sketches he made from nature were undertaken simply as material for later compositions. We must remember that all the classic landscape painters of the time made such studies - those of Valenciennes himself are of considerable beauty - but they were not considered of more than private or professional interest, and were generally destroyed. Some of the studies made by Michallon, Corot's model in Rome, have survived and show the extent to which Corot was using a current form. But from the first he brought to it certain qualities which his fellow-students lacked. He had a natural gift of simplification which prevented his studies from ever becoming mere topography. He aided his powers of selection, as Claude had done, by the simple means of choosing as his main motive quite distant objects. But this would have produced feeble results if it had not been supported by a perfectly true sense of tone. Like a sense of absolute pitch in singing, a sense of tone in painting is almost a physical attribute, and is by no means always an indication of other

¹A few sketches, however, seem to show the influence of Constable, *e.g.* Robaut, 40, dated *c.* 1825. And in one finished painting, *The Ford*, exhibited in 1833, he combines a reminiscence of Constable with that of the Dutch.

qualities, moral or intellectual. With Corot, however, it is hard to believe that the truth of tone in his pictures does not genuinely reflect his own candid and ingenuous nature, the more so since it is inseparable from an equally true sense of design. On his first visit to Rome, the forms and colours of classic landscape had thrown him into a state of passionate receptivity, and he had been able to absorb the principles of composition, which lasted him all his life. The sketches made on this first journey are, in some ways, the most remarkable he ever did, for his excitement shook him into a freedom of handling which he did not allow himself again till his last years; in subsequent visits, although he was able to give a greater measure of observed fact, his touch was more discreet and his colour less resonant. Perhaps the grey and silver tones of his French studies were fixed on his palette and only a visit to Venice could dispel them.

Looking at these crystalline visions it is hard to believe that they were scarcely ever seen in Corot's lifetime, and were intended only as material for large compositions, which - by an irony of history - are never seen, and almost untraceable, today. Corot's studies are in many respects more complete than Constable's. Being fundamentally a classic artist, he had, at the back of his mind, a feeling of generalised form which allowed him to compose his sketches in larger and simpler units. But he seldom succeeded, as Constable had done, in making them into exhibition pictures. His large compositions bear no relation to his sketches. The example usually given (chiefly because it is one of the few of the exhibited pictures which have been photographed) is the Bridge of Narni. The study in the Louvre is as free as the most vigorous Constable; the finished picture in Ottawa is tamer than the tamest imitation of Claude. Even more surprising are pictures like the Quais Marchands à Rouen (Salon, 1831) where Corot has not taken refuge in classical imagery, but has painted from his own vision. Yet the fact that he has had to paint on a large scale and with the accepted degree of finish has proved so inhibiting that the picture lacks his two essential virtues - truth of tone and stability of composition. The objects, wholly unrelated to each other, swim about in cotton wool as if in a badly arranged shop window. Such a picture cannot but increase our respect for Constable. Only one of Corot's Italian pictures, the View near Volterra in the National Gallery, Washington [92], retains the virtues of his studies; but in France, particularly in the pictures painted in the Morvan [94], he arrived at a satisfactory compromise pictures of a moderate size, firmly constructed, and seen with an absolute

93 Corot, Le Vallon and View of St-Lô

naturalness, which makes almost every landscape, painted before or since, look slightly artificial.

In the 1840s Corot gradually evolved a means of making his Salon pictures more his own. In Le Vallon (1855) [93] he has discovered a composition that allows him to combine his experiences in a flowing, poetic whole. At the same time there begins the series of nymphs dancing among feathery trees which was to increase so disastrously the number of his admirers. We cannot blame Corot for adopting a genre which pleased both fashionable and critical opinion. In 1855 Paul de Saint-Victor wrote: 'We prefer the sacred grove where fauns make their way, to the forest in which woodcutters are working; the green springs in which nymphs are bathing, to the Flemish pond in which ducks are paddling'. And Corot's own tastes inclined him in the same direction. Since his youth he had been a great admirer of the theatre. We know from his sketch-books that the fanciful figures in his pictures were taken from studies of ballet dancers, and there is no doubt that in later life stage décor replaced memories of Claude and Poussin as his ideal of what a picture should be. It is entirely appropriate that a work by Corot should have inspired the *décor* of *Sylphides*. Some of his poeticising pictures are extremely beautiful. Souvenir de Mortefontaine (1864) is a masterpiece, which rises out of popular painting as the lyrics of Burns or Heine rise out of popular songs. In such a picture as The Lake [95] in the Frick Collection he created his own kind of ideal landscape and is the true heir to Claude. But he is more limited. From all his great range of delicate visual experiences Corot came to be satisfied with one - shimmery light reflected from water, and passing through the delicate leaves of birches and willows. He concentrated on it because he loved it, and he thereby proved once more his extreme simplicity of character. For he had revealed one of the eternally popular effects of nature, one which is still quoted by simple people as a standard of visual beauty.

But although he had discovered a formula which satisfied both himself and his public, Corot continued to paint from his natural vision and knew that it was the essence of his art. He even managed to introduce some of these pictures into the Salon by cataloguing them as *études*, perhaps encouraged by the example of Chopin. A note which he made in a sketch-book of 1856 advises the student above all to trust his first sensation: 'N'abandonnons jamais cela et, en cherchant la vérité et l'exactitude, n'oublions jamais de lui donner cette enveloppe qui nous a frappés.

N'importe quelle site, quel objet; soumettons-nous à l'impression première. Si nous avons été réellement touchés, la sincérité de notre émotion passera chez les autres.'

It is interesting to find that Corot, whose mind was anything but philosophic, has instinctively absorbed the aesthetic philosophy of his time, and assumes that art consists in conveying a sensation, not in persuading us to accept a truth. He is of course far nearer to pure aestheticism than Constable. Constable chose his subjects with a sense of their moral grandeur, and worked on them to make them nobler and more dramatic. Corot had no such protestant preoccupation with morals, but was confident that if he submitted with sincere humility to his sensations, *le bon Dieu* would do the rest. The point which unites them is the unquestioning belief in the natural vision as the basis of art.

By the middle of the century this belief had evidently become widespread. Baudelaire, in his criticism of the Salon of 1859, says that 'le credo actuel des gens du monde est celui-ci: Je crois à la nature et je ne crois qu'à la nature. Je crois que l'art est, et ne peut être, que la reproduction exacte de la nature'. No doubt Baudelaire, with his usual contemptuous pessimism, was exaggerating what he considered a contemptible state of opinion; at least a blind belief in nature was not reflected in the Salon. But at this time it did have the backing of a born populariser in the person of Courbet.

Courbet's opinions on art are supposed to be exceptionally foolish; but those which have been preserved do not seem to me stupider than anyone else's. He was a provocative personality, and a great deal of nonsense was talked for and about him. In the 1850s the word realist, like impressionist, futurist and surrealist in later ages, became a mere term of alarm, an expression of popular resentment against art. It was even applied to Wagner, much as, twenty years ago, old-fashioned people used to speak of Picasso as an impressionist. Courbet always said that the term had been forced on him. 'Faire de l'art vivant; tel est mon but.' In 1861, however, he did give a statement of his aims, and put as well as anyone the aesthetic of the nineteenth century, the attitude to nature which we find in Constable's letters and in Ruskin's advice to the Pre-Raphaelites. It is particularly valuable in disposing of an abstract notion of 'the beautiful', which whether or not it is valid philosophically, had become a source of error. 'Le beau est dans la nature, et s'y rencontre dans la réalité sous les formes les plus diverses. Dès qu'on l'y trouve, il appartient à l'art, ou plutôt à l'artiste qui sait l'y voir. Dès que le

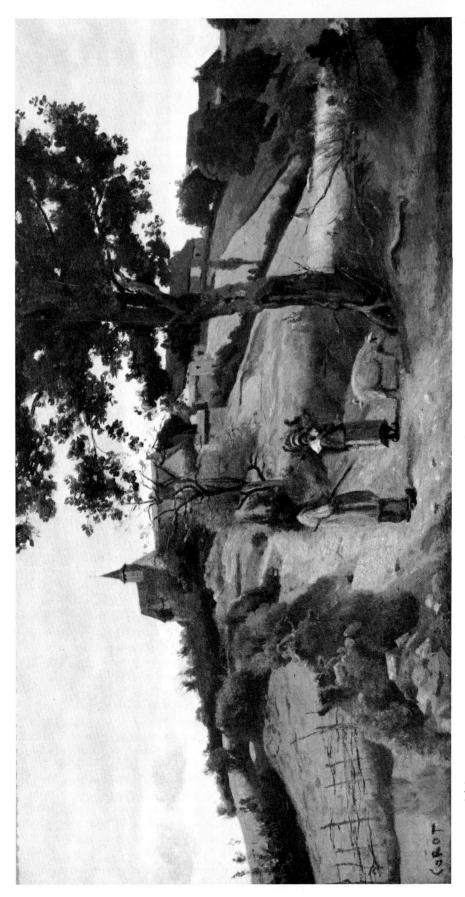

94 Corot, St-André-du-Morvan

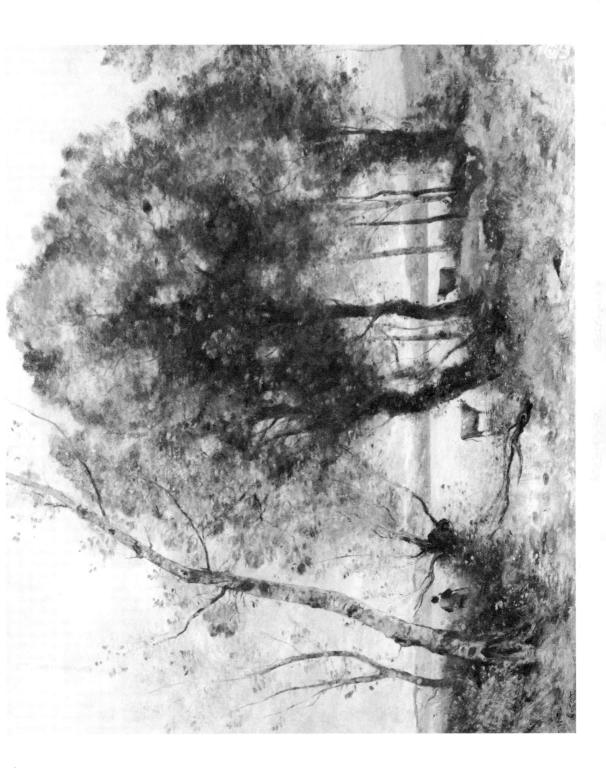

LANDSCAPE INTO ART

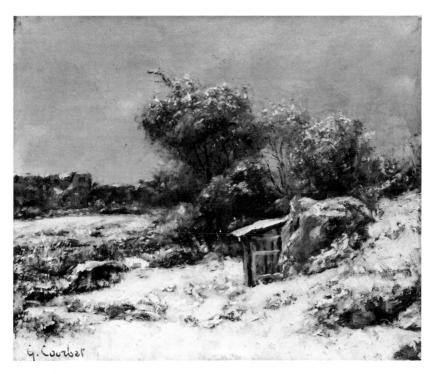

96 Courbet, Snow Scene

beau est réel et visible, il a en lui-même son expression artistique. Mais l'artiste n'a pas le droit d'amplifier cette expression. Il ne peut y toucher qu'en risquant de la dénaturer, et par suite de l'affaiblir. Le beau donné par la nature est supérieur à toutes les conventions de l'artiste.' It is an amplification of Constable's 'I never saw an ugly thing in my life'!

These statements became the stock-in-trade of art teaching for sixty years. But in 1860 the Salon and all the famous schools were entirely committed to a debased form of academic art, of which the first rule was that nature must be improved in the interest of the ideal. To draw or paint what one saw was vulgar.

The widespread use of this word shows that the conflict between realism and academism, like most conflicts in the nineteenth century, had a social basis. The Count of Nieuwerkerke, the head of all official patronage of art during the Second Empire, said of the Barbizon painters: 'This is the painting of democrats, of those who don't change their linen, and who want to put themselves above men of the world. This art displeases and disgusts me.'

Ingres has left us, in one of his least attractive drawings, a likeness of the Count, which supports and even amplifies this famous judgment; but while relishing his air of ineffable conceit, we must remember that this monster was responsible for the semi-starvation of practically all the greatest artists of his day. This excuses the arrogance and toughness of Courbet, whose check shirt and stubby pipe were the only possible answer to the Count of Nieuwerkerke's frock-coat, cameo tie-pin and exquisitely pomaded beard.

Courbet's answer to rejection by the Salon was his gigantic one-man show of 1855. It contained fourteen landscapes, the earliest of which was dated 1841. They are truly popular painting. We do not feel behind them, as with Constable, the study of landscape tradition; still less do we feel the admiration for Claude with which Corot gives a classic accent to his Second Empire reveries. Courbet chose subjects with an immediate appeal and dwelt on them with relish; the grass is very green – greener than it has ever been in good painting before or since – the sunset skies are very pink, the sea is very blue. There is a peculiar relation of tone between sea, sky and rock which anticipates in an incomprehensible way the coloured post-card [97], (and at this point I ought to admit that coloured postcards of land-scapes often give me a pleasure that I can only suppose to be aesthetic).

At their best Courbet's landscapes are great painting, not only because his skill and productive power are exhilarating, but because the sea of faith in nature is still at the full. We are watching the creation of popular imagery which is to serve for almost a hundred years. When Courbet is true to his manifesto, as in some of his smaller snow scenes [96], when he does not amplify the expression, he remains a great landscape painter. But sometimes he is seduced by nature's more extravagant effects, when only understatement could carry conviction; and sometimes, as in the embarrassing series of dying stags in the snow, he entirely forgets his principles in his satisfaction at having produced an emotional effect. Before such pictures we find ourselves joining the Count of Nieuwerkerke. They are inescapably vulgar. We must pause to ask what, in relation to landscape, this word means.

All forms of expression have within them the seeds of their own destruction, and just as classicism tends to emptiness and lack of vitality, so naturalism tends to vulgarity. It is the popular style, the style that can be understood without effort or education. Any art of recognition saves the effort of concentrating on formal relationships; but quite soon recognition itself becomes an effort, and the popular taste demands ready-made

equivalents for its favourite themes. Corot's studies from nature are never vulgar because every transition of tone is sincere and precise. But Courbet, though he could use his eyes to great effect, was sometimes prouder of his productive powers than of his perception. At such times he cheerfully substituted a false sensation for a real one, and the remarkable thing is that his false sensations are exactly those which have satisfied the popular eye ever since.

This leads us to another curious fact which I have already touched on when speaking of Corot's later work. There seem to be certain effects of nature which produce an immediate response in the Western European mind. They appear in the first landscapes of Hubert van Eyck, and may sometimes be associated with simple biological needs; the colours of Spring, for example, which remind us of rebirth and hope, or the evening sky which we associate with the end of labour. But in general popular landscapes are those in which the lazy or uninterested eye is suddenly jerked into responsiveness by an unusually resonant contrast of tone or colour. This is true of the example I gave earlier, the stretch of water lit by evening skies, set off by dark trees; or of the evening sun shedding an orange light on the hill-tops. These violent effects are the legitimate material of those landscape painters whom I described as painters of fantasy. But from their very crudity it is difficult for a naturalistic landscape painter to make true works of art from such effects. They give no opportunity for the delicacy of perception, the act of love, which justifies the landscape of fact. Moreover tones which are very close together have a peculiar beauty - they are like the faintly-shadowed vowel sounds which are so often a source of magic in verse. 'La vérité est dans une nuance.' Courbet could swallow, and make us swallow, almost anything - though even he flinched from bluebells and autumn tints; but to an artist with a less disciplined appetite the popular effect can be dangerous. Take the case of Daubigny.

Historically, Daubigny is a very important artist. He began exhibiting in the Salon in 1838 and was almost the first man to devote his whole life to the natural vision in landscape. He did not turn it into a vehicle of self-expression as Constable did, or divide his time between it and poetic fancies, like Corot. He was, I believe, the first artist whose work was criticised as being mere 'impressions' – by no less a person than Théophile Gautier; and he was an immense, a decisive, influence on Monet. So he has a high claim to be the grandfather of impressionism. Yet his pictures were accepted in the Salon,

and were popular [98]. And that is exactly what is wrong with them; for with Daubigny, gifted and honourable painter though he was, the natural vision is too often the common vision. Subject, composition, tonal relationships were all those which the popular eye accepted without effort or surprise; and has continued to accept ever since.¹

To realise how such ready-made naturalism corrupts the eye, we need only remember the early reception of the impressionists. Up to 1869, they were simple naturalistic painters [100]. Sisley and Pissarro were devoted followers of Corot – the real Corot, of course, not the Salon substitute; and Monet, as I have said, was inspired by Daubigny, though he had first of all felt the more refreshing influence of Boudin. Looking at the early work of these fine artists it seems inconceivable that they should have been thought offensive. One might, of course, question the whole principle on which their work was painted. But after giving a gold medal to Constable thirty years earlier, it is strange that the Salon should have rejected them consistently; and after Baudelaire's complaint about the popularity of nature it is stranger still that the ordinary man should not have recognised that these were just the pictures he wanted. But bourgeois taste was already so debauched by pseudo-naturalism, that the fresh vision of Monet and Pissarro was an unpleasant shock.

How far was the freshness, and the shock, due to the fact that these painters worked in the open air? On this point opinion has fluctuated. At one time it was usual to say that all landscape must be painted in the open air; then in reaction, Sickert, and other recent writers on art, have tried to maintain that serious work can be done only in the studio. The fact is that when an artist has evolved a consistent personal style it is difficult to know when he has painted direct from nature. Obviously Corot's and Constable's studies were done on the spot, and it is no surprise to learn that Daubigny painted from a specially constructed boat. But we also have first-hand evidence that Claude painted out of doors, and we know that the latest and most abstract Cézannes were painted sur le motif. So it was a mode of vision and not the physical fact of being out of doors which made the impressionist scale of tones seem so startling.

¹In fairness, Daubigny's work holds many surprises. In particular he was capable of a dark vehemence like early van Gogh, of which he himself seems to have been afraid.

98 Daubigny, Étretat and The Quarry

There is no doubt that in the '60s the impressionists achieved a truth of tone which is usually described as photographic. Recent historians of art have taken photographs of many subjects painted by Monet and Pissarro which prove the accuracy with which they were able to record optical sensations. But how far they were actually influenced by photography it is difficult to say. Early landscape photographs, with their long exposures, produced a scale of tones very different from the snapshot, and more like Madox Brown than Monet. Instantaneous landscape photography only became common in the '60s, and it is uncertain how much of it the impressionists had seen: perhaps enough to strengthen their belief in an impartial eye, though not enough to have created their style. But to the contemporary public this confirmation of their truth would have carried no weight, for at all times 'artistic' photography has been falsified to flatter the popular taste, and in the 1870s the tones of landscape photographs were smoothed and softened so that they might resemble late Corot, Daubigny or even more innocuous favourites of the Salon.

Monet, Sisley and Pissarro, during the '60s and even up to 1874, achieved the most complete naturalism which has ever been made into art. I doubt if a picture could be much truer to a visual impression, with all its implications of light and tone, than the Sisley paintings of Hampton Court, or Pissarro's of Norwood [99], and it is worth comparing them with such a picture as B. W. Leader's February Fill Dyke [99], long accepted by the public as a paragon of perfect truth to nature, in order to see the difference between true and false naturalism. The real contrast would be perceptible only in the originals, for it is above all the colour of the Leader which is false and degraded. Photography flatters it, but even in reproduction we see that there is none of that unity of atmosphere, that general envelope of light (to use Corot's word), which is the essence of true naturalism. But then there is no unity of any kind. Nature has not been perceived as a whole but described piece by piece. Leader still thinks of the world as made up of a number of 'things' which have to be treated separately. This was a perfectly reputable way of composing a landscape in an age which expressed itself through symbols; it was also a possible point of departure for a great pictorial architect like Poussin. It was not a possible procedure in a landscape which was supposed to render the truth of a visual impression. Leader's contemporaries believed that his landscapes were as true as photographs. How unjustifiable was even this squalid claim is apparent if we compare February

to such a picture as Corot's study of Geneva which dates from 1841, before the date of landscape photography.

The perfect moment of impressionism which produced Sisley's *Hampton* Court, like all other points of balance in the history of art, could not be maintained for long. After about ten years the impressionists reached the crisis of the natural vision, the point at which it either relapses into the commonplace or ceases to satisfy the creative needs of the artist. Constable had provided a classic example of this crisis. His own naturalism, which depended on his personal tranquillity, lasted for ten years: from his marriage to his wife's illness. Before his marriage his response to nature was weakened by a sense of frustration; after her death a black restlessness descended on his spirit and his pictures became less a mirror of nature and more an expression of his distress, until they were almost as tortured and mannered as those of van Gogh. But, leaving aside such personal misfortunes, we can say that to go on producing clear, objective transcripts of natural appearance without loss of freshness, requires very rare gifts of simple-heartedness and calm; indeed we may ask if any artist of the first rank, except Corot, has succeeded in doing so. Realistic landscape, which the ignorant believe to be one of the easiest forms of painting, is actually one of the most inaccessible, one in which success is rarest and most precarious. Even such a beautifully endowed painter as Sisley suffered a gradual decline in sensibility and conviction. Monet and Pissarro, being more conscious of their dilemma, took a different course. They forced themselves to see in nature what the average eye cannot see, or at any rate cannot analyse, the web of pure colour of which light is composed. Theoretically, they were maintaining the principle of naturalism or even carrying it a stage further; but actually they were rejecting the limitations of the natural vision in favour of a transposition which should allow them greater creative freedom.

The stages in this development are clearly marked. It begins in 1869 with the closer friendship of Monet and Renoir, one of those conjunctions, like that of Coleridge and Wordsworth, from which new movements in the history of art are often born. Monet had always been the member of the group who trusted most unreservedly to visual sensations, and with whom the traditions of European painting carried least weight. Whereas his companions were devoted students of the old masters – Manet and Cézanne both made admirable copies and Degas was perhaps the finest copyist who has ever lived – Monet could find nothing to interest him in the Louvre.

He was taken there forcibly by Renoir, who himself saw no reason why he should not continue the tradition of Watteau and Fragonard, given sufficient skill and application. Renoir had very great skill, as we can see from his early portraits, and his apprenticeship as a china painter had taught him a fresh and brilliant technique. No muddy colours, no dark shadows, no rich impasto were possible on porcelain. Renoir was at first too intent on the eighteenth century to join in the unquestioning approach to nature. His early landscapes are more like Diaz than Daubigny. But in 1869 he began to work with Monet on the same motive, and from this union impressionism was born. Monet contributed his complete confidence in nature as perceived through the eye and his remarkable grasp of tone; while Renoir contributed his brilliant handling and rainbow palette. The subject which united them was the sparkle and reflection of light on water. The riverside café of La Grenouillère is the birthplace of impressionism.

In 1870 the Franco-Prussian war temporarily broke up this partnership. Monet, Pissarro and Sisley took refuge in England; Renoir joined the militia, and remained in France.

It was in England, as we have seen, that Pissarro and Sisley painted their most completely 'natural' pictures, but this is mere coincidence. The war and the Commune coincided with the naturalistic stage of their development, and England, as Monet afterwards realised, is the setting for romantic rather than realistic painting. They do not seem to have been interested in Constable, whose work was then disregarded, and whose sketches were not yet visible. We know from Pissarro's letters that they were impressed by Turner. But here again, we must remember that they saw only Turner's big machines, and many of the pictures which we value most highly, like the Evening Star, were only brought up from the cellars of the National Gallery in 1906. When Monet returned to France in 1871 and once more began painting with Renoir, his palette grew more brilliant; but so did that of Renoir. A comparison of the pictures they painted together at Argenteuil shows that Monet still renders sparkle by contrasts of light and dark; whereas Renoir dissolves the whole scene in broken touches of pure colour, and in consequence loses some of the certainty of tone in which Monet excelled. Now Renoir had not seen Turner or Constable; and so I am inclined to think that this crucial phase of impressionism was independent of English influence. But such questions are highly speculative and perhaps, in the end, artificial, for ideas are like those minute particles of seed which

100 Monet, The Beach at Sainte-Adresse

101 Monet, Antibes. Trees near the Mediterranean

are wafted across the Pacific Ocean, and plant themselves in the most unpredictable soil.

In the pictures of Argenteuil by Monet and Renoir, done between 1871 and 1874, the painting of sensation yielded its most perfect fruits. They show an unquestioning joy in the visible world, and an unquestioning belief that the new technique alone can convey it. This balance between subject, vision and technique was so complete that it not only captivated sympathetic spirits like Sisley and Pissarro, but imposed itself on painters to whom it was quite alien. Manet, for example, whose own range of responsiveness to tone and colour was similar to that of Goya – or even darker – was bewitched into trying his hand at an Argenteuil picture. Even Gauguin and van Gogh, who were to destroy impressionism, painted some of their most beautiful pictures in this style.

There are few things more refreshing in art than the sense of delight in a newly acquired mastery. The excitement with which the impressionists conquered the representation of light by the rainbow palette, is like the excitement with which the Florentines of the fifteenth century conquered the representation of movement by the flowing plastic line. But art which depends too much on the joy of discovery inevitably declines when mastery is assured. In the lifetime - in the work - of Filippino Lippi the Quattrocento style degenerated into mannerism. By the middle of the 1880s the great impressionist moment had passed. At first Renoir and Monet tried to keep up their excitement by choosing more and more brilliant subjects. Renoir painted gardens which gave him the added problem of bright local colours, and Monet painted coast scenes which have the most intense light that can be put on canvas. Later he moved to the French Riviera, and there, in the garish sunshine of that hitherto unpaintable region, not only forms but tones are dissolved in incandescence [101]. It was the crisis of sensational painting and each member of the group responded in a different manner. Renoir, with his fundamentally classical outlook, was inspired by the antique painting at Naples and Raphael's frescoes in the Vatican to recapture the firm outline; and thenceforward gave up naturalistic landscape painting entirely. Pissarro, who had always taken more interest than the others in the architectural composition of his pictures, joined in the return to order, which is the subject of a later chapter. Sisley, who had always been the least intellectual and self-critical of the group, went on painting in the same way with declining confidence. His last

pictures are a warning that simple perception of nature is not enough. It was Monet, the real inventor of impressionism, who alone had the courage to push its doctrines through to their conclusion. Not content with the sparkle of his Riviera scenes he undertook to prove that the object painted was of no importance, the sensation of light was the only true subject. He said to an American pupil that 'he wished he had been born blind and then had suddenly gained his sight so that he would have begun to paint without knowing what the objects were that he saw before him'. It is the most extreme, and most absurd, statement of the sensational aesthetic. Actually Monet's technique made him particularly dependent on the nature of his subjects; and they were limited. Only sun on water and sun on snow could give full play to the prismatic vision and the sparkling touch [VII]. In such pictures Monet has remained without an equal. But in order to prove his point he chose for the subjects of his experiments, Cathedrals and Haystacks. No doubt he did so intentionally in order to show that the most articulate works of man, and the most formless, were pictorially of equal importance to the painter of light. But the choice, especially that of cathedrals, was disastrous, because grey Gothic façades do not sparkle. In an attempt to make them vehicles of light Monet painted them now pink, now mauve, now orange; and it is evident that even he, with his marvellous capacity for seeing the complementary colours of a shadow, did not really believe that cathedrals looked like melting ice-creams. In these obstinate pictures impressionism has departed altogether from the natural vision from which it sprang, and has become as much an abstraction as Gilpin's picturesque. The arbitrary colour of the cathedrals is much less beautiful than the truly perceived colour of the Argenteuil pictures; and the dialectical basis on which they are painted has prevented Monet from abandoning himself, like Turner, to poetic fantasies or musical harmonies of colour like the Interior at Petworth. If decadence in all the arts manifests itself by the means becoming the end, then the cathedrals of Monet could be cited as text-book examples. But, by a miracle, Monet recovered. The waterlilies in his garden moved him to a fresh and passionate response to nature; and he transposed it, without any loss of truth, into sweeps and scrawls and blots of paint that express his deepest emotions. Impressionism is a short and limited episode in the history of art, and has long ago ceased to bear any relation to the creative spirit of the time. We may therefore survey, with some detachment, the gains and losses of the movement.

There was the gain of the light key. Ever since Leonardo attempted scientifically to achieve relief by dark shadows, pictures have tended to be dark spots on the wall. Those who have visited the Naples Gallery will remember with what relief, after wading through three centuries and about thirty rooms of black pictures, one comes on the rooms of antique painting, still fresh and gay in tone. They are only journeyman's work, far poorer in execution than the great canvases of Ribera and Stanzione, but they are a delight to the eye. The impressionists recaptured this tone. 2 We are grateful that the pictures on our walls (and that, of course, is where pictures should be, not on the walls of galleries) are not only a pleasure to look into but also a pleasure to look at. This rise in tone was connected with the final liberation of colour. To read what was said of colour by Ingres, Gleyre, Gérome and the other great teachers of the nineteenth century, one would suppose that it was some particularly dangerous and disreputable form of vice. This was a rearguard action of idealist philosophy which had maintained that form was a function of the intellect, colour of the senses. The belief was philosophically unsound, and had proved an obstacle to free and sincere expression for centuries. Its removal gained a new liberty for the human spirit.

Impressionism gave us something which has always been one of the great attainments of art: it enlarged our range of vision. We owe much of our pleasure in looking at the world to the great artists who have looked at it before us. In the eighteenth century, gentlemen carried a device called a Claude glass in order that they might see the landscape with the golden tone of a Claude – or rather of the varnish on a Claude. The impressionists did the exact reverse. They taught us to see the colour in shadows. Every day we pause with joy before some effect of light which we should otherwise have passed without notice. Impressionism achieved something more than a technical advance. It expressed a real and valuable ethical position. As the Count of Nieuwerkerke correctly observed, it was the painting of democrats. Impressionism is the perfect expression of democratic humanism, of the good life which was, till recently, thought to be within the reach of all. It is a belief of which Bonnard's pictures and René Clair's early films were

¹Now in a different gallery so that this life-enforcing experience involves a very long drive.

²Strictly speaking, it was Turner who first recaptured the light key (see p. 183). But his followers misunderstood it, and, as I have said, it is hard to say whether he influenced the impressionists.

perhaps the last exponents. What pleasures could be simpler or more eternal than those portrayed in Renoir's *Déjeuner des Canotiers*; what images of an earthly paradise more persuasive than the white sails in Monet's estuaries, or the roses in Renoir's garden? These pictures prove that what matters in art is an all-pervading belief and not the circumstances of the individual artist. The men who painted them were miserably poor, and their letters show us that they often did not know where to turn for the next meal. Yet their painting is full of a complete confidence in nature and in human nature. Everything they see exists for their delight, even floods and fog.

Looking back over sixty years, it may seem that this confidence in the physical world was a fundamental weakness. Art is concerned with our whole being – our knowledge, our memories, our associations. To confine painting to purely visual sensations is to touch only the surface of our spirits. Perhaps, in the end, the idealist doctrine is right, we are more impressed by concepts than by sensations, as any child's drawing will show. The supreme creation of art is the compelling image. An image is a 'thing', and impressionism aimed at abolishing things. And in painting, the simplest and most enduring images are things with lines round them; and impressionism abolished line.

This is only a way of saying in pictorial terms that impressionism did not address itself to the imagination. We cannot call it the art of materialism, for that word carries too gross an implication; but we cannot (as many critics have done) call it pagan, for paganism involves the idea of remote country superstition, spring festivals and Dionysiac rites. Paganism has precisely that element of magic which impressionism excludes. That is the price we must pay for the happiness of here and now on which it is founded.

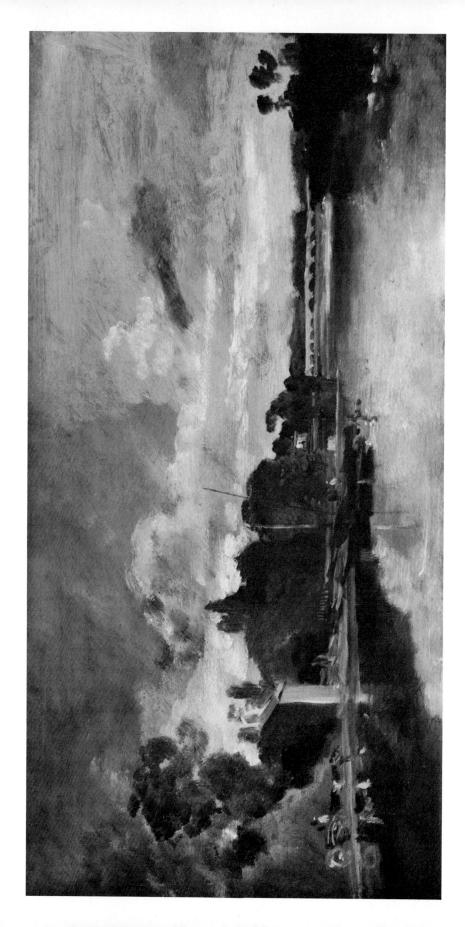

THE NORTHERN LIGHTS

The splendid procession of naturalistic painters which passes through the nineteenth century from Constable to Pissarro, may lead us to believe that, for a hundred years, landscape painting took no other form. But in fact two artists of genius, one at the beginning, and one at the end of the century, show that the landscape of heightened emotion was still a valid and potent means of expression. They are Turner and van Gogh. Both are fundamentally northern artists – painters of the midnight sun and the aurora borealis. Yet both were inspired by the landscape of Mediterranean countries, because only in these could they find that delirium of light which was to release their emotions.

It is through this passion for light that the landscape of fantasy is linked with the history of nineteenth-century painting. The imaginative painters of the early sixteenth century had made effects of flame and sunset the chief weapons in their assault on our emotions, and, with great powers of observation and memory, had rendered effects of light which could never have been achieved by a purely factual approach. So it is not surprising that in the pursuit of light which was to culminate in impressionism it was a master of imaginative landscape, a romantic and not a realist, who made the decisive step. It was Turner who raised the whole key of colour so that his pictures not only represented light, but were symbolical of its nature. This was the one, among his many achievements, that associates him with the painters who succeeded him, and which alone is enough to refute the belief, once widely held in France, that he is a freak painter of purely local interest.

Turner is one of those rare cases of a great artist whose early work gives no indication of the character of his genius (here we may notice a similarity with Wagner which is occasionally in our minds when looking at his pictures). He was amazingly precocious, and already in the 1790s he made his name by adapting the style of other famous landscape painters to the romantic tastes of the time. For twenty years he continued to produce versions of Claude, of Wilson, of van de Velde, of Cuyp, of Teniers, all done with heightened dramatic effect. He had no sympathy with the classical style and his imitations of Claude are vulgarisation in the bad sense. But

when he felt strong enough to depart further from his original models, as he does in *Crossing the Brook* and *A Frosty Morning*, he produced genuine popular painting which delighted his contemporaries and will continue to please those who can look at pictures without prejudice.

Except in so far as they introduce a certain democratic obviousness, these works do not add very much to the history of landscape painting. But at the same time Turner was painting scenes of catastrophe that came from the depths of his troubled imagination. The series opened in 1802 by *The Tenth Plague of Egypt*, to be followed by *The Destruction of Sodom*, and culminated (1812) in *Hannibal Crossing the Alps*, which is an unquestionable masterpiece of romantic painting. It also marked a crisis in the development of his character, and is the first of his pictures to be accompanied in the catalogue entry by a quotation from a sequence of poetical fragments which became the record of his ever increasing pessimism, the *Fallacies of Hope*.

The great sweep of imagination in the *Hamibal* is expressed in a design that splendidly rejects the traditional uniform which Turner had worn so uneasily. As in almost all his finest work it is based on a vortex and parabola, with shifting, overlapping curves and sharp diagonals. This system of design, which runs counter to the static intervals of classicism, he had developed in a series of reconstructions of storms at sea. It begins with *Calais Pier* (1802), is fully established in the fearful diagonals of *The Shipwreck* (1806), and achieves a frenzied violence in the *Wreck of a Transport Ship* (c. 1810). These are the thrusts and conflicts of the Gothic North.

While working on these large, dark dramas Turner was also painting oil sketches from nature which, in their direct and vivid rendering of the thing seen, anticipate Constable by almost ten years [102]. These were chiefly done in the Thames Valley, and, like the landscapes of Daubigny and Monet, they were painted from a boat. As with Constable, light is still rendered by contrast, sparkling meadows set off by dark green bushes, trees silhouetted against the sky. But they have an elegance and artifice which Constable lacked, and we recognise that they are the work of a painter who is used to relying on his memory and to finding graphic equivalents for every phenomenon. And at the same time his sketches show the influence on his colour and tonality of the sea. Ruskin rightly emphasised the fact that the mouth of the Thames provided Turner with the earliest experience of landscape which entered deeply into his system. While the young Constable was gazing at the oaks and elms of East Bergholt, Turner spent his time in 'the

mysterious forest below London Bridge', the forest of masts and flapping sails, inhabited by 'glorious creatures, red-faced sailors appearing over the gunwales – the most angelic beings in the whole compass of the London world'. And in addition to filling his imagination, the sea provided him with a subject in which, pictorially, the whole motive was colour and movement and light.

Turner by upbringing and by predilection was a painter in water-colours. This is one of the many things about him which alienate continental opinion, for the classic tradition has never considered water-colour a medium of serious painting. Turner himself, in the period of his great successes, concentrated on the mastery of oils, but he never ceased to use water-colour, both as an aid to his retentive memory and for the numerous illustrations to engraved books on which he was always at work. Now water-colour, if properly used, involves a light tonality, and there is no doubt that as time went on Turner, like Cézanne, was influenced in his oil technique by his experience of water-colour. In many of his later pictures the oil medium is used so exactly like water-colour that in reproduction it is impossible to tell which is which. In the originals these light pictures are richer than any water-colour could be, for a marvellous film of mother-ofpearl paint has been floated over what would, in a drawing, have been white paper. But it was years of experiment with white paper which allowed Turner to paint in these tones at all.

From 1815 to 1818 Turner exhibited at the Academy much less than his usual quota. The epoch of his great imitations, his Napoleonic victories over the most famous landscape painters of the past, was over and he was clearly entering the dreaded 'middle period', when the old accomplishments had ceased to satisfy him, and the new vision was not yet in focus. It is possible that his struggles were concerned with the transference of the heightened colour, which he had already achieved in his sketches, to his exhibited pictures. At this point, in the autumn of 1819, he visited Italy for the first time.

He had been painting supposed views of Italy for twenty years, but these had all been copies from the drawings of Cozens or pastiches based on Claude. When he saw Italy with his own eyes he might have said, as did Manet when he went to Spain, 'Comme ils m'ont trompé!' As if in reaction against the formal twilight vision of his predecessors he was conscious chiefly of the heat, glitter and profusion. He made a large number of detailed

103 Turner, Rain, Steam, Speed

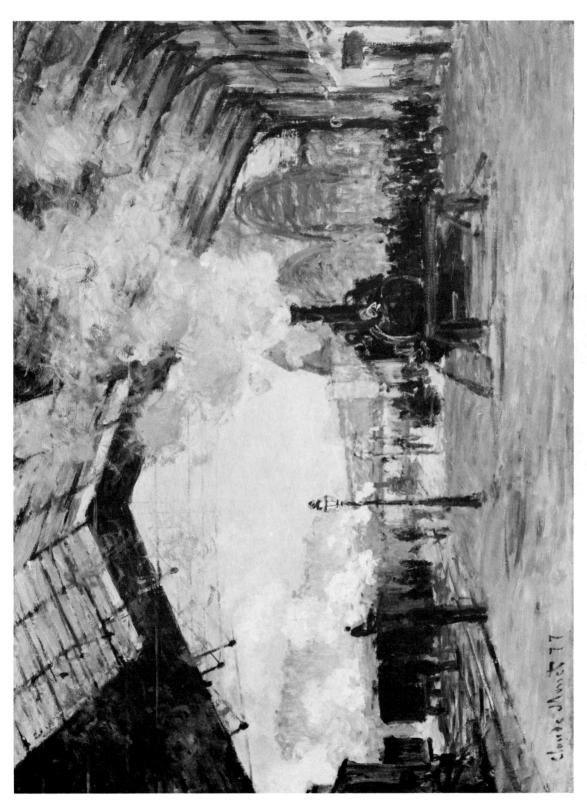

104 Monet, Old St-Lazare Station

drawings and water-colours – in Rome alone he made one thousand five hundred in three months – in which he was content to record his pleasure in the classic landscape with almost the simplicity of Corot. But when he came home again and began to re-create his impressions in his studio, the memories of Italy were like fumes of wine in his mind, and the landscape seemed to swim before his eyes in a sea of light. Shadows became scarlet and yellow, distances mother-of-pearl, trees lapis-lazuli blue, and figures floated in the heat-engendered haze, like diaphanous tropical fish. Turner's professional admirers have usually treated these Italian landscapes as an aberration, and even Ruskin habitually referred to them as 'nonsense pictures'. Judged from the standpoint of naturalism, to which, unfortunately, Ruskin was committed, they *are* nonsense, just as, from the point of view of logic, Shelley's poetry is nonsense. But as expressions of Turner's peculiar vision they are superior to the pictures by which he had made his name: for they are entirely his own.

Turner's visit to Italy also had the paradoxical effect of intensifying the anti-classical element in his art. Thenceforward he does not attempt sham Claudes and Poussins, and his compositions give up all pretence of classical construction. They are based on an extension of the Mannerist scheme, rather similar to that evolved by Breughel, and often involve serpentine recession on an inner and outer circle, which, to the classically conditioned eye, give a slight feeling of *mal de mer*. They are also anti-classical in their staffage — monks, maidens, troubadours, balconies, guitars and other properties of the Keepsake style, reminding us that the antique landscape of Corot was also the Italy of *Childe Harold*. For this reason Turner was happiest not in classic lands of Naples and the Campagna, but in the wholly romantic setting of Venice.

Venice effected the final release of Turner's imagination. Nothing in *Modern Painters* is more penetrating than the famous chapter at the end of the fifth book in which Ruskin contrasts the upbringing of Turner with that of Giorgione, and, after an opulent description of the beauties of Venice in 1500, introduces Turner's home with these words: 'Near the south-west corner of Covent Garden, a square brick pit or well is formed by a close-set block of houses, to the back windows of which it admits a few rays of light. Access to the bottom of it is obtained out of Maiden Lane, through a low archway and an iron gate; and if you stand long enough under the archway to accustom your eyes to the darkness, you may see on the left hand a

narrow door, which formerly gave quiet access to a respectable barber's shop, of which the front window, looking into Maiden Lane, is still extant, filled in this year (1860) with a row of bottles, connected, in some defunct manner, with a brewer's business.' After being brought up in such surroundings, Venice was like the confirmation of all the sunset-cloud architecture which he had built in his mind's eye from the bottom of the square brick pit or well. In consequence he could paint it directly, without the rhetoric with which he felt bound to embellish less dreamlike subjects. Turner was only in Venice twice - it is hard to believe - and for quite short periods. As in Rome, he filled his sketch-books with accurate and very beautiful water-colours. All his pictures were painted on his return, and as long as the pink and white stone, the shadows full of light and the fantastic interplay of sky and water were fresh in his memory he could make anything carry conviction. We must also admit that some highly finished pictures of Venice, painted after too long an absence, are as embarrassing as an unsuccessful deception.

In Turner's painting the relation between experience and imagination is very delicate. If we compare one of Monet's versions of the Gare St-Lazare [104], painted in 1877, with Rain, Steam, Speed [103], painted in 1843, it is evident that the Monet is a great deal nearer to what we can all see. Indeed it makes the Turner look like a poetic fantasy, unrelated to experience. But against this we have the testimony of Mrs. Simon. She had been surprised when a kind-looking old gentleman, sitting opposite her in the train, had put his head out of the window during a torrential downpour, and kept it there for nearly nine minutes. He then withdrew it, streaming with water, and shut his eyes for a quarter of an hour. Meanwhile the young lady, filled with curiosity, put her head out of the window, was duly drenched, but had an unforgettable experience. Imagine her delight when in next year's Academy she was confronted with Rain, Steam, Speed and hearing someone, in a mawkish voice, say, 'Just like Turner, ain't it. Who ever saw such a ridiculous conglomeration?' was able to answer 'I did'. Of course she didn't as she was in the train and Turner has imagined the scene as if he were suspended in the air about fifty feet above the viaduct. The whole story has been doubted on chronological grounds but contains enough basic truth to be worth retelling. The evidence of anybody who had the misfortune to be caught in the same storm as Turner, is that his observation was extraordinarily accurate. But when he was confronted by the commonplace scenery of Deal or Margate, his impatience at their inadequacy led him, as Ruskin observed, to exaggerations which falsify the whole effect, and produce the redundancy of his *Southern Coast*.

It is hardly surprising that Turner's painting fell out of favour in the 1830s. On the contrary, the astonishing thing is that Turner's pictures were exhibited annually in the Royal Academy without causing those outbursts of virtuous indignation which in 1867 assailed the much more comprehensible productions of the impressionists. There was behind him the accumulated goodwill of his earlier pictures and the popularity of his engravings. And as an acknowledged romantic he might be expected to do anything; whereas the impressionists claimed to paint what everyone could see. It is another instance of 'what is too silly to be said may be sung'. Critics, of course, were shocked. They warned the public against the seductive influence of his colour, they called his pictures 'portraits of nothing and very like'; and Hazlitt, with his usual intelligence, invented the phrase 'tinted steam'. Turner does not seem to have been in the least disturbed. He had saved, from his time of success, a large fortune, and he still sold his work to a few old friends and patrons, for the most part as eccentric as himself. One of these, Lord Egremont, must be named, for it was while staying with him at Petworth in the early '30s, that Turner was most completely himself. The beauty of the park and house, the splendour of the collection, and the agreeable unconventionality which prevailed in this bachelor household, seem to have freed Turner's colour sense from its last restraints; and confirm the connection between colour and licence which so much troubled the more austere critics of the nineteenth century.

In the park and surrounding country he painted some of the most extreme and rapturous of all his sunsets; but even more extraordinary is the series of studies which he made inside the house, in which he recorded in a kind of shorthand every incident of those delightful days. They show the certainty with which, by this time, Turner could find a colour equivalent for every form. The culmination of these studies is the famous work known as the *Interior at Petworth* which, although it is not a landscape, may detain us for a minute, as it is the first attempt to make light and colour alone the basis of a design. In this respect it goes further than any of the impressionists, for while they took as their point of departure the natural vision, and are constantly referring back to it, Turner has retained only such elements of the scene as were necessary to his new creation.

I need not emphasise the courage and conviction which allowed Turner to paint such a picture as this in the 1830s; and it is not simply the result of irresponsibility – the work of that well-known nineteenth-century figure, the mad Englishman. In these pictures Turner knew very well what he was doing. The theory of colour had occupied his mind ever since he ceased to tint topographical views, and one of his first great pictures, the *Buttermere with a Rainbow* of 1797–98, is accompanied in the Academy Catalogue with a long quotation from Thomson's *Seasons* which specifically anticipates the theories of impressionism.

Meantime refracted from yon eastern cloud,
Bestriding earth, the grand ethereal bow
Shoots up immense; and every hue unfolds,
In fair proportion running from the red
To where the violet fades into the sky.
Here, awful Newton, the dissolving clouds
Form, fronting on the sun, thy showery prism;
And to the sage-instructed eye unfold
The various twine of light, by thee disclosed
From the white mingling maze.

Throughout his life Turner continued to study the subject with an application which shows that although he could not control words, his intellectual faculties (as Ruskin always said) were of a high order. His annotated copy of Goethe's treatise on colour exists, and his sketch-books are full of completely abstract colour combinations in which he puts his theories to the test. 'The art of the colourist', says Baudelaire in that crucial work of nineteenth-century art criticism, the essay on Delacroix, 'is evidently in some respects related to mathematics and music.'¹ This was the solitary path which he had set out to follow after 1822, and with this in mind we can understand much of his work which is otherwise mysterious.

Contemporary taste has judged Turner, like Corot, by the pictures which he did not exhibit. These are very numerous and are often brought to a high point of realisation; the word 'sketches' gives a false impression of them. It is true, of course, that many of them contain no definition of form, and sometimes no single recognisable object. 'Things' have completely disappeared,

¹It is a proof of how the same idea will grow up independently at the same time in different places, that the first systematic application of these theories, Chevreul's De la loi du contraste simultanè des couleurs, was written in 1838.

unless we can account as such, an occasional red sail, or those inexplicable concentrations of colour which cataloguers in despair have described as 'Sea Monsters' or 'Vessels in Distress'. But this does not mean that they are slight or unfinished; on the contrary, the paint which covers these large canvases has been applied and graded with the utmost care and delicacy. The transitions of colour in a late Turner are as considered and elaborate as the transitions of form in a Poussin and, like them, represent an alliance of thought, sensibility and imagination. But whereas Poussin's compositions of form were conceived with a high sense of literature, and were nominally subservient to some literary or didactic intention, Turner's compositions of colour existed for their own sakes. Not that Turner ignored poetry. On the contrary, he read too much. Thomson was his favourite (understandably as Thomson had a keen visual sense), but he was also influenced by Akenside and, after the appearance of Childe Harold, by Byron. Quotations from the poets accompany the titles of his pictures and when the right one could not be found he wrote it himself as part of his interminable epic, the Fallacies of Hope.

Because Turner's fragments of poetry are often ungrammatical and obscure, they used to be underrated in the study of his paintings. But they are actually the only written documents which give us an insight into that part of his character which his letters and conversation were designed to conceal. An example is the picture exhibited in 1843 (a vintage year for Turner's poetry) with the title Light and Colour (Goethe's Theory) – The Morning after the Deluge – Moses writing the Book of Genesis. With the following extract from the Fallacies of Hope:

The Ark stood firm on Ararat; the returning sun Exhaled earth's humid bubbles, and emulous of light Reflected her last forms, each in prismatic guise Hope's harbinger, ephemeral as the summer fly.

In spite of his lack of literary sense we can feel the immense symbolic and expressive importance of colour in his imagination. And how completely these lines might describe a picture by Altdorfer. But, alas, we know that compared to Altdorfer, Turner's figure of Moses (so surprisingly installed as the contemporary of Noah) will be as awkward as his versification.

Turner could not, or would not, draw the figure in a conventional

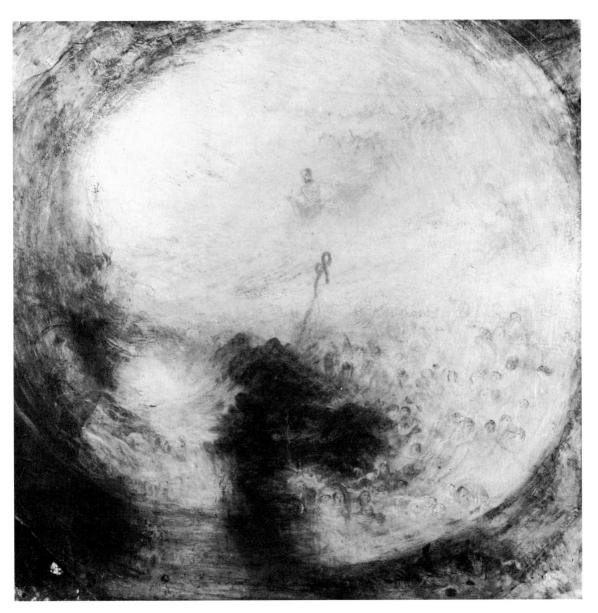

105 Turner, Light and Colour

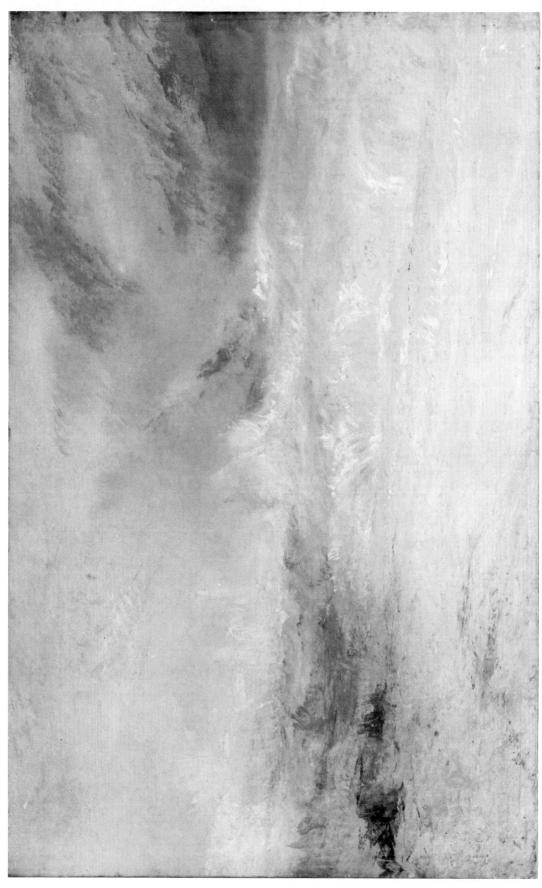

Turner, 106 (above) A Stormy Shore; 107 (below) Norham Castle

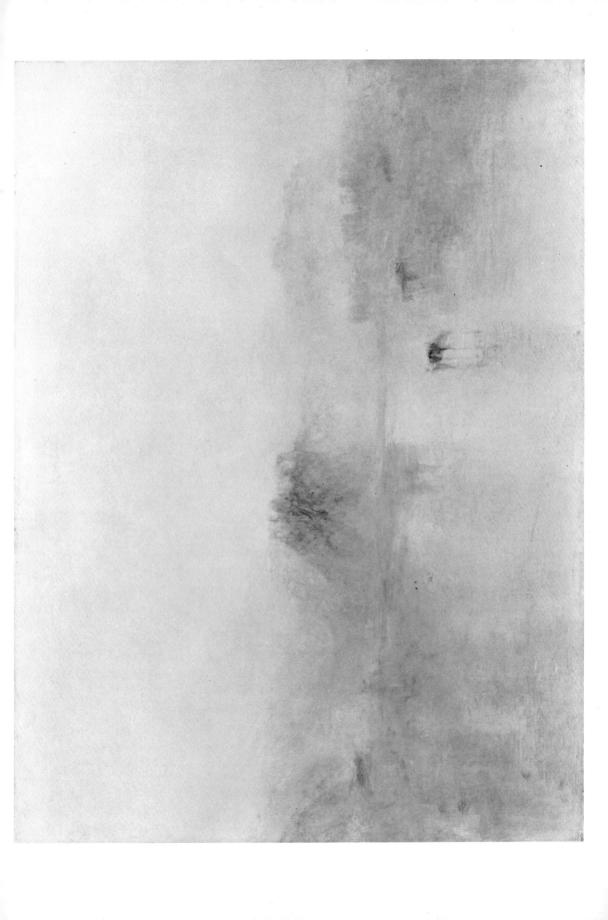

manner, and this makes his 'historical pictures' as hard to swallow as Cézanne's *Poésie*. Many of his forms are remarkably ugly in themselves, so that the old accusation that his pictures look like poached eggs and sausages is not without foundation. Ruskin, who recognised the ugliness of Turner's forms, attributed it to the extreme lack of grace of all the objects which surrounded him in early youth – excepting always the masts and rigging of ships on the Thames. This may well be true, for although Turner could imitate the elegant forms of trees and cirrus clouds, all his self-generated forms tend to resemble the sacks of potatoes, piles of baskets, barrows, buckets and other inelegant paraphernalia of Covent Garden.

As an example of the uncertainty of Turner's imaginative faculties in his later exhibited pictures, we may compare two more, painted as pendants to each other in 1842. One of these, known as *Peace: Burial at Sea* and supposed to represent the burial of Sir David Wilkie, is a popular picture but a beautiful one. The central feature, being the rigging of a ship, was something which had entered into Turner's system; and the contrast between the hot light of the fire and the cool light of the sky, no less than the black silhouette and the Gothic diagonal of the smoke, remind us not unworthily of Breughel. The pendant, known as *War: the Exile and the Rock Limpet* is a ludicrous picture. It represents a figure of Napoleon, pathetically ill-drawn, accompanied by an English sentry, standing before a sunset of awful red. Under the title Turner printed some lines from the *Fallacies of Hope*:

Ah! thy tent-formed shell is like A soldier's nightly bivouac, alone Amidst a sea of blood but you can join your comrades.

Yet when the human and historical elements were removed, Turner's imagination could distil from light and colour poetry as delicate as that of Shelley. Such are the pale, opalescent visions of rivers and estuaries of which perhaps the most beautiful are those which take their point of departure from Norham Castle [107]. To say that they represent Norham Castle is as misleading as to say that a picture by Braque represents a woman at a piano. The logical connection between what we should have seen if we had been there and the faint touches of pink, blue and yellow with which Turner has stained his canvas exists – it is the essence of their beauty – but is extremely complex, and could only be discovered by re-living Turner's

experience. And it is inseparable from the technique by which he floats on to the canvas the most delicate films and mists of colour, a technique which Turner, by elaborate precautions, kept a secret in his own day, and which has remained a secret ever since.

These landscapes are almost as abstract colouristically as a great piece of classic architecture is abstract formally. Yet, in some inexplicable way, they give a more vivid feeling of nature than do his earlier works in which the shapes and colours of nature are so minutely described. Just as the grammar of language always defeated Turner when he wrote, so the articulation of style seems to have hindered that pure synthesis which his later paintings achieve. Turner might have said like Cézanne in his last years: 'Je deviens, comme peintre, plus lucide devant la nature.' This applies particularly to the series of pictures of a stormy sea coast which he painted out of his lodging-house window in Margate [106]. Although not a single form is defined, they are extraordinarily true, and we recognise that, in the end, Ruskin was right: it was Turner's truth which was, above all, important, and which distinguishes him from his contemporaries.

Turner's later work made no immediate contribution to the development of art. The so-called sketches were unknown and remained so until a few were placed on exhibition in 1906. The exhibited pictures were too far removed from timid description to influence the English painting of their time; and too irrational to have an effect in France. Moreover, their grotesque subjects and ill-drawn figures were an offence to French taste. All that Voltaire said of Shakespeare – and more – might reasonably have been said of such a Turner as the Slave Ship, and men whose taste has been formed on classical models, from Sir George Beaumont to Roger Fry, have continued to find him vulgar and disorderly. In his own day his patrons, with one exception, were drawn from the new middle classes, not the traditional connoisseurs; and, through his engravings, he was more popular in the numerical sense, than any great painter before or since. Seventy years ago an engraving of a Turner, like a copy of Enoch Arden, was to be found in every lodging-house. But during that time the tide of creation was running in the opposite direction, and was preparing that predominance of French art, which was, until recently, accepted as absolute.

In the vast range of his work Turner fulfils practically every aim that the earlier romantics foreshadowed. He is penetrated by a sense of nature's unsubduable, destructive force. If, in front of his great machines, we are

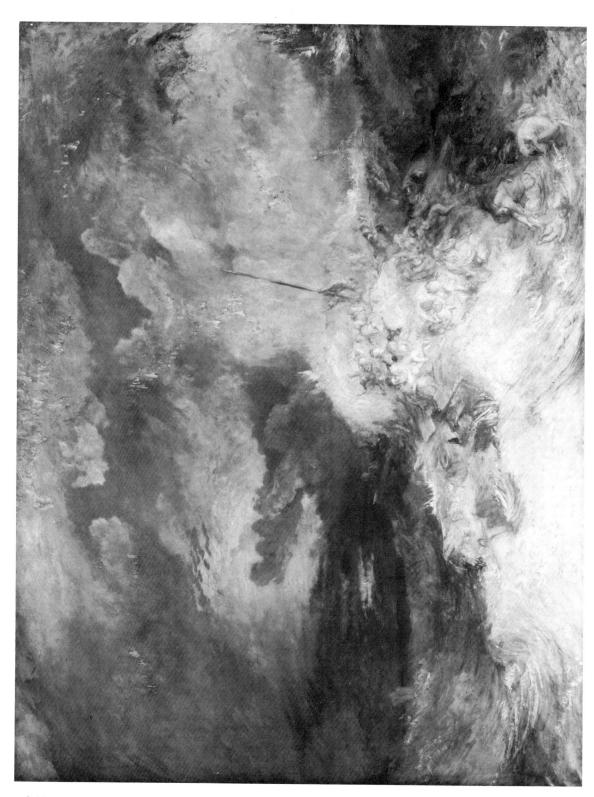

108 Turner, Fire at Sea

tempted to think that his whirlwinds and avalanches are mere rhetoric, later pictures like After the Deluge [105] and the Slave Ship prove that we were wrong: that Turner's deluges are as truly expressive of his spirit as are those of Leonardo. The immense pessimism which dictated, however inadequately, the Fallacies of Hope, was due to his feelings of man's impotence in front of these blindly hostile forces. He painted those elements of nature which supported this conviction, and which were, in fact, the same as those which had expressed the romantic fears of the sixteenth century, the crags and tempests and 'fire in the flood'. It is his devotion to this last motive which shows decisively his kinship with Grünewald, Altdorfer and Bosch. As early as 1814 he was moved to paint the Eruption of the Island of St. Vincent at Midnight, a fire in the flood to lick all rivals. And the subject of one of the greatest of his late, unexhibited pictures is a Fire at Sea [108], where, for once, even the group of figures is successful, and the drawing is fused with the colour by the heat of Turner's imagination. Nothing in romantic painting, it seems to me, is more breath-taking than the passage from the menacing leaden sky on the left to the shower of golden sparks on the right, which burst upon us like some glorious last movement, so that we want to stamp and clap our hands.

With the death of Turner it must have seemed that the romantic response to nature, the obsessive fears and the sudden glory, had vanished from landscape painting, and could not reappear in a material world. But when, towards the end of the century, the tide of naturalism began to turn, there emerged an artist who embodied all the impulses of Grünewald, Altdorfer and Huber. I applied to these painters the word 'expressionist', with some reluctance, as it has become a cant word, but also with some precision because there are so many elements in their work which are used, in almost identical form, by the painter for whom it was invented, van Gogh. Van Gogh was a truly northern artist. Throughout all his mature work runs a restless, flowing line, curling and uncurling in endless, agitated spirals, as it does in the earliest ornament of the folk-wandering period, or the convoluted draperies of German Gothic. This linear character is best seen in his landscape drawings where he uses the style of Altdorfer and Huber with added truth and richness [109, 110]. We are dazzled by the colour and saturation of light which he is able to convey by a sort of hailstorm of dots and dashes. As for particular images, we find in van Gogh the enormous suns, the gnarled and hollow trees, the pierced and twisted rocks; and since he was completely ignorant of the earlier expressionists,¹ and drew his inspiration from such utterly different sources as Millet and Hiroshige, we may assume that these images are really part of the permanent furniture of the unconscious. Above all, van Gogh, like Turner, had the northern sense of light as a source of magic.

He had begun as a dark painter, making much the same passionate travesties of Mauve and Israëls as Cézanne made of Delacroix. And he, too, was forced by his interest in light and colour to learn the language of impressionism, though his model seems to have been Renoir rather than Pissarro. The pictures he painted during his few months in Paris with their broken touches of lilac, prove both van Gogh's talent for painting and the adaptability, even as late as 1887, of the impressionist style. But impressionism could give him only a momentary satisfaction. It is true that van Gogh remained all his life a passionate lover of the thing seen. He said, 'Je mange de la nature', just as Ruskin, whom in some ways he so strangely resembles, said of a drawing he was doing, 'I should like to eat up this Verona, touch by touch'. His earlier pictures of Provence are rhapsodies in praise of light; and as with Turner he found himself driven to use lighter and lighter colours, ending almost in yellow monochrome. We can read in his letters what this colour meant to him, 'Un soleil, une lumière, que, faute de mieux, je ne peux appeler que jaune soufre pâle, citron pâle, or. Que c'est beau le jaune.' So we might soliloquise in front of a late Turner. And yet van Gogh's light is very different from the pearly radiance of Turner. It is fierce, fitful and distracting (once more we see the analogy between light and love); it beats upon the brain and can only be exorcised by the most violent symbols, wheels and whorls of fire, and by the brightest, crudest colours which can be squeezed with frenzied urgency from the tube. So in spite of his passion for nature, van Gogh was forced more and more to twist what he saw into an expression of his own despair.

I have said that impressionism was the painting of happiness. This, although one of its charms for us, is also one of its limitations, for the impressionists were thereby cut off from the deepest intuitions of the human spirit, and in particular from those which great artists achieve in the

¹He certainly did not know Altdorfer and Grünewald, and it is doubtful if he had seen any paintings by El Greco. Similarly Turner did not know the German landscape painters, and always expressed a dislike of Rubens. It seems that expressionist painters need some classic basis as their point of departure.

109 Van Gogh, Stone Seat, in the Hospital Garden, St-Remy

110 Van Gogh, Fading Daylight

last years of their lives. There used to be a comfortable belief that great artists grew old in a kind of haze of benevolence, but a theory which does not apply to Dante, Shakespeare, Milton, Tolstoi, Beethoven, Michelangelo and Rembrandt, is not really of much value; and the history of art shows that the minds which have not simply given up the struggle end in a kind of sublime despair at the spectacle of human destiny. Now expressionist art is essentially tragic; it was a sense of the misery and wastefulness of existence which gave an expressionist character to the late work of Constable and Cézanne – even to some of the late drawings of Degas. But in 1880 Cézanne and Degas were still classic painters, and the impressionists were all sunshine. It was van Gogh who brought back the sense of tragedy into modern art; and, like Nietzsche and Ruskin, found in madness the only escape from the materialism of the nineteenth century.

Cézanne, when shown one of van Gogh's pictures, said with characteristic brusqueness, 'Sincèrement, vous faites une peinture de fou'; and looking at the latest *Cypresses* [111] or the *Ravine* we must reluctantly agree with him. Expressionist art involves a dangerous tension of the spirit. We feel that

111 Van Gogh, Road with Cypresses

LANDSCAPE INTO ART

Grünewald cannot have been entirely sane. But the frenzied writhings, the Catherine-wheel convolutions of van Gogh are further out of control than anything in El Greco, and are in fact painfully similar to the paintings of actual madmen. Perhaps this is one reason why they have proved so popular. The assault they make on our feelings is so violent that people who are not normally moved recognise that something unusual is going on. Those to whom the rhythms of a Seurat would be as inaudible as the music of the spheres, cannot fail to hear the voice of van Gogh rising to a scream of rapture, pity or despair.

As a result, coloured reproductions of van Gogh's *Sunflowers* and *Cypresses* have been almost as widely diffused during the last twenty years as were formerly engravings of Turner's sunsets. And they have been responsible for an even greater quantity of bad painting. Devotion to the facts will always give the pleasures of recognition; adherence to the rules of design, the pleasures of order and certainty. Bad expressionist painting is merely embarrassing. But we should not therefore avert our eyes, in an agony of good taste, from the value of this style at the present time. In an age of violence and hysteria, an age in which standards and traditions are being consciously destroyed, an age, above all, in which we have lost all confidence in the natural order, this may be the only possible means by which the individual human soul can assert its consciousness.

112 Van Gogh, Cottage with Cypresses, near St-Remy

113 Camille Pissarro, Entrance to the Village of Voisins

THE RETURN TO ORDER

Impressionism, like all genuine art forms, created its own order by consistency of vision and texture. But it was the sensational unity of the glance or snapshot. One cannot reason with an impressionist picture, one cannot 'cut and come again'. The measured interplay of horizontals and verticals, the use of a house, a window, or a block of masonry as a modulus of proportion, the diagonal which turns back on itself after two-thirds of its journey, the arc whose ideated centre is a nodal point in the composition, all these devices which, as we saw, were brought to perfection by Poussin, were foreign to the impressionists, and may have seemed irreconcilable with their technique. As a result they could achieve neither the scale nor the air of permanence of their greatest predecessors. An exception must be made on behalf of Pissarro. As the pupil of Corot he had learnt the laws of classic landscape painting, and they are apparent in the village scenes which he painted before 1870. They are even perceptible in such a purely impressionist picture as the entrance to a village [113], dated 1872, and it is not surprising that when the group split up, Pissarro should have become an imitator of Seurat. Monet, on the other hand, was the pupil of two painters to whom the rules of construction meant little, Daubigny1 and Boudin; and it was Monet whose desire for total immersion in a bath of appearance led him to leave the firm ground of traditional design. Not that his compositions were feeble by English standards, but they were loose and hearty - there is a kind of Brahmsian heartiness about Monet - and by the '80s this occasionally degenerated into formlessness.

This is the point at which Seurat appeared. I mention Seurat first rather than Cézanne because, whereas Cézanne seems to belong to all time, independent of fashion and circumstance, Seurat is the answer to the tidyminded historian's prayer. He is one of those familiar historical characters whom, if they had not existed, it would have been necessary to invent. He concentrates in himself all the intellectual currents of the time: the belief in science, the interest in primitive and oriental art, even the beginnings of *art*

¹Cf. the interesting comparison of two pictures of Dunkirk by Corot and Daubigny painting side by side, reproduced in *Corot*, by Germain Bazin.

114 Seurat, Sketch for the Grande Jatte

115 Seurat, Entrance to the Harbour at Gravelines

LANDSCAPE INTO ART

nouveau. Cézanne and Seurat also represent the two traditions in nineteenthcentury French painting. Delacroix was Cézanne's god (literally: he tried for years to paint an Apotheosis of Delacroix), and his earliest works are grotesque imitations of Delacroix's manner; whereas Seurat's earliest paintings are wonderfully perceptive copies of Ingres. We see that what attracted him was the completeness of Ingres's design, and that care for the contrast of beautiful shapes in light and dark tone which gained for Ingres's early works the reputation of primitivism. The portrait of Granet at Aix is an ancestor of Seurat by the shape of the collar, no less than by the severe frontality of the landscape. After these classical exercises there comes a gap in Seurat's career while he did his military service. He was stationed at Brest where he spent the long hours of sentry duty gazing at the sea, and gained that intimate knowledge of its light and colour which was the basis of his finest landscapes. It is usual to say that on his return he was influenced by Delacroix, and we know from Seurat's notebooks that he studied Delacroix's painting in S. Sulpice and copied out theories of colour from Delacroix's journals. Nevertheless the influence of Delacroix has been much overrated. Nothing in Seurat's work recalls Delacroix's actual paintings, neither the technique nor the forms, nor even the colour. The pale tonality of the Baignade is as far removed from Delacroix's rich, resonant colour as are its calm, static forms from Delacroix's wild contortion of movement. The landscapes which Seurat did at this period show without question that he was influenced by the tonality of impressionism, and in particular of Pissarro. They show us that he was a man of delicate poetic sensibility, but with the French passion for intellectual tidiness of which the architecture of Cîteaux and the poetry of Malherbe are other manifestations. He must have turned with relief from the Hindu luxuriance of Ingres's later designs, to the severe frontality of fifteenth-century fresco painting, and although he does not seem to have mentioned the fact (he was the most secretive of men), he must have looked with attention at the Uccello battle-piece in the Louvre, feeling some instinctive sympathy with this earlier disciple of theory. He took from Uccello the idea¹ of arranging

¹For a perfect example of this in Quattrocento painting look at the hooves of the principal horse in Uccello's *Rout of San Romano*. In order that they should tell as design they have been placed on a sort of hearthrug. The fact that such arbitrary devices were foreign to the naturalistic convention of Seurat's time added greatly to his difficulties.

simple masses of light and dark so that one is always set off by, or even framed in, the other. This involved reducing the modelling of his figures to a minimum and placing them in profile so that they did not upset the stability of the design by moving from one plane to another. But these simplified elements were subject to the most complex laws of composition. Scurat was a great master of the mathematical laws of harmony by which all the greatest architects of the past, and some of the greatest painters, have secured their effects. That arsenal of geometry, of which the golden section was only one important weapon, was at Seurat's command, and perhaps no painter, except Poussin and Piero della Francesca, has used it with greater precision. He added, indeed, an occasional element of surprise, a geometric fantasy such as the placing of the post on the extreme right of the *Chenal de Gravelines* [115], which he must have learnt from Far Eastern art; and in his later work a certain number of mathematical squibs seem to go off for their own sakes, though on the whole these are confined to his figure compositions.

In all this we seem to have gone a long way from Corot's 'Soumettons-nous à l'impression première'; but in fact Seurat's finest work depends on his emotional response to what he has seen. He was particularly moved by the seaside, by the immense whiteness of water and sky, by the precision of seaside architecture, and by the interval of proportion between sky and jetty, or sea and distant sail. That space should be both uneventful yet full of movement, architectural yet tremulous with light, was the first necessity of his spirit, as we can see from his simplest drawings. In these seascapes Seurat has taken the archetypal impressionist subject, sailing-boats on sparkling water, and has used it for anti-impressionist ends, working out every millimetre of surface with the industry of a coral insect and the logic of a mathematician.

Patience, patience,
Patience dans l'azur!
Chaque atome de silence
Est la chance d'un fruit mûr!

In the pictures which Seurat painted at Honfleur, Grandcamp and Gravelines, his poetical sensibility and his need for intellectual order were at one, and we may be tempted to wish that he had been content to rest at this point of perfection. But true perfection is achieved only by those who are prepared to destroy it. It is a by-product of greatness. And Seurat's ambitions

were very great indeed. He wished not only to tidy up impressionism, but to employ its luminous technique and contemporary vision in the creation of pictures which should have the scale and timelessness of Renaissance frescoes. This aim involved a triple difficulty. There was the difficulty of style: the frescoes of the fourteenth and fifteenth centuries were based on the unquestioning acceptance of a conceptual and linear style, which was easily adapted to decorative treatment. There was the difficulty of scale: a way of painting evolved from the sketch and so suitable for small impressions had to be used to cover a large surface without trickery. And there was the difficulty of vision: ordinary, everyday people had somehow to be given the air of permanence, without looking self-conscious or stuffed, like the figures in official art. He succeeded at the first attempt, and the *Baignade* remains, among other things, a triumph of the will.

As with Constable, we know the steps by which his composition was achieved. First came the little paintings, sweet slices of impressionism, in which he established his tonality and sought for his motives, capturing first one, then another, till the whole scene was clear in his mind; and then the crayon studies, done in the studio, in which figures and objects are their final shapes - simple, certain, memorable and grand. Finally there emerged one of those great works which immediately convince us of their authority, and from which each succeeding age will draw its own conclusions. The first appreciation of the Baignade, written by Signac, dwells on 'the understanding of the laws of contrast, the methodical separation of elements – light, shade, local colour and the interaction of colours – and their proper balance and proportion, which give this canvas its perfect harmony'. A later generation may give more emphasis to the affinity which it shows with that massif central of European art, the Italian frescoes of the fifteenth century, and in particular with Piero della Francesca. The monumental figures in profile, simplified and immobile, the pale tonality in which dark truffles of form are placed with such certainty, and the mathematical dispositions of the forms against the horizontal background remind us of the frescoes of Arezzo. It has long been a puzzle how Seurat, who never went to Italy, could have come so close to these, then almost unknown, works. The answer is that copies of two of Piero's frescoes, by the painter Loyaux, hang in the Chapel of the Ecole des Beaux-Arts. They had been commissioned in the 1870s by the director, Charles Blanc, whose pages on the geometrical basis of design in his Grammaire des arts du dessin had also influenced Seurat profoundly: so

for once an art historian made a positive contribution to creative art.

The *Baignade* is painted in an extension of the impressionist technique, which Seurat called *balayé*, meaning touches of pure colour swept on by a broad brush.¹ But as the requirements of Seurat's sense of design became more exacting, he felt that the touches, in order to be more easily controlled, must be smaller. This coincided with the crystallisation in his mind of a pseudo-scientific theory of colour. Certain speculations in Delacroix's notebooks hint at such a theory, but Seurat, with his love of intellectual order, had worked it out according to the experiments of Maxwell, the measurements of Rood, and, above all, the theories of Chevreul; and from these he created a sort of dogma with which to support his faith. He thereby put himself in a false position, for his contemporaries thought of him not as a great designer, but as a man with a doctrine.

The theory of colour was applied in his next great picture, A Sunday Afternoon at the Grande Jatte, together with all the other principles of composition which went to make up the Baignade. Here the preparatory studies are even more numerous and elaborate, for in addition to drawings and small colour sketches, many of great beauty, he made a number of large preparatory paintings. One of these is the landscape - the stage, so to speak, in which this drama of shapes is to be set [114] - and it is a proof of how clearly Seurat worked out a composition in his mind, that, although the final picture was not finished for two years, the original landscape, with all its apparent accidents of light and shade, was left practically unchanged. The only difference is an absence of emphatic verticals because, of course, he foresaw that these would be supplied by the figures. The drawings and small studies are chiefly of his dramatis personae and show how, unlike the Baignade, where each figure had been drawn in the studio from an isolated model, the figures in the *Grande Fatte* are all studied in relation to the whole. His aim was to discover interesting silhouettes, but he tried by very subtle operation of tone to keep an effect of modelling while preserving the general unity of the plane. In this, too, he was following the practice of early Italian painting, and he was also influenced by the low reliefs of Egyptian sculpture. Finally Seurat carried out a large oil sketch of the whole, painted with a breadth and vigour which he usually repressed.

It is appropriate that the Grande Jatte should have been the chief exhibit

¹Like many of Seurat's early works, it is retouched in places, *e.g.* the hat of the 'echo' figure on the right, in a pointillist technique.

of the last impressionist exhibition of 1886, for nothing could mark more clearly the end of impressionist doctrines. The members of the group, already on bad terms, were still further disrupted by it. Pissarro became a whole-hearted admirer and imitator; and wrote contemptuously of Monet as a romantic impressionist, as opposed to the 'scientific' impressionism of Seurat. George Moore, the disciple of Manet, was completely bewildered, and has recorded, in his Confessions of a Young Man, that he at first suspected a hoax. Let me also confess that even after long familiarity with the original, I still find the Grande Fatte a disconcerting work. From the point of view of composition one must, of course, put impressionism out of one's head, and think more of Uccello's Rout of San Romano than of Renoir's Moulin de la Galette. But this does not dispose of my difficulties, because even the flattest fresco is thought of as form, whereas Seurat's means of expression are still light and colour. Seurat has tried to create large monumental shapes in colour by means of the silhouette, and this, in spite of all his skill in shallow, internal modelling, produces rather the effect of pasteboard figures in a toy theatre. The Baignade avoids this disturbing effect because the units of which it is composed are fewer and more monumental; and the contrasts of light on dark, dark on light, are less complex and artificial. And it is not so far removed from the impulse of the first impression. True, everything in the Grande Fatte was based on some visual experience, and Angrand has recorded that when the grass on the river bank grew so long as to upset certain proportions, Seurat's friends cut it for him. But here and there is a first hint of that decorative geometry which was to make Seurat's later work a source of art nouveau; it occurs, for example, in the monkey's tail which scandalised George Moore because it was too long, but worries me because the arc it describes is too regular. And in fact two studies for the monkey show that its tail either drooped or followed an entirely different curve.

Far more serious is the effect on the picture of Seurat's theory of colour. Anyone who knows the small sketches, with their marvellous truth and freshness of tone, must receive a shock when he sees, for the first time, the melancholy green and purple of the original; and comparison of the large study for the whole composition has rather the same effect as comparing Constable's full-size 'sketch' of the *Hay Wain* with the finished picture. The fact that this is perceptible even in black and white shows that it is partly a matter of tone, but the loss of fresh tonality was aggravated by the scientific employment of complementaries. To gain an idea of what this means we

must read the description of the grass in shadow in the foreground of the Grande Jatte by Seurat's friend and faithful admirer Félix Fénéon: 'Most of the strokes', he says, 'render the local value of the grass; others, orangetinted and thinly scattered, express the hardly-felt action of the sun; bits of purple introduce the complement to green; a cyanine blue, provoked by the proximity of a plot of grass in the sun, accumulates its siftings towards the line of demarcation, and at that point progressively rarefies them. Only two elements come together to produce this grass plot in the sun, green, and orange-tinted light, any interaction being impossible under the furious beat of the sun's rays. Black being a non-light, the black dog is coloured by the reactions of the grass; its dominant tint is therefore deep purple; but it is also attacked by the dark blue arising from neighbouring spaces of light. The monkey on a leash is speckled with yellow, its personal quality, and dotted with purple and ultramarine.' It is an entirely intellectual approach to colour, based not on perception, but on a belief that the effect of colour can be measured scientifically. Writers on art, from classical times onwards, have always maintained that colour is the sensuous and emotional element in painting, and it is perhaps questionable whether Seurat's attempt to make it intellectual was not running counter to a fundamental law of art. He would have replied with the statement of Sutter that 'the laws of aesthetic harmony in colour can be taught as the rules of musical harmony can be taught'; but, to my eye, his science has produced the same effect as the harmonic theories of Schönberg, where a vast number of instruments only succeed in making an indeterminate noise, without clarity or resonance. And there is a self-consciousness about the whole performance, which would chill our sympathy, did we not remember that when it was painted Seurat was only twenty-six.

From the time of the *Grande Jatte* to his death in 1891 Seurat gave the best of his energies to working out his theories in large figure compositions. But, fortunately for us, he continued to paint landscapes in the summer 'to wash', he said, 'the studio light from his eyes'. Although they lack some of the freshness of his earlier landscapes, they still combine truth of observation with extraordinary clarity and firmness of design. In such a work as the *Pont de Courbevoie* [116] the intervals are subtler and more conclusive than ever, and are a complete justification of the mathematical *mystique* by which Seurat has established his proportions. But sometimes, in these last landscapes, the design is almost too wilful, and we see how easily they became

the source of a new kind of academism. Moreover, his developed pointillism had the curious effect of neutralising his colour, so that a proliferation of dots gives, at a distance, the effect of a very pale water-colour. Finally his determination to digest the most unpromising subject, and to find everywhere the peculiar shapes which interested him, led to the suppression of that poetic quality which marked his early sea pieces. This is as Seurat wished. When friends praised his paintings, he said, 'They see poetry in what I have done. NO: I apply my method and that is all there is to it.' And we are reminded that Valéry, after writing his first poems, said, 'Je m'en fiche de la poésie' and devoted fifteen years of his life to mathematics. It is difficult for anyone who is not French to know how far this claim to settle all the problems of art by the intellect alone is really sincere. Personally I believe that when true poets like Seurat and Valéry claim to be moved solely by logic they are performing an act of homage to the great Cartesian ideal and to what M. Ozenfant once called 'le sec de la grande tradition française'. But perhaps this is an insular prejudice, and the French are right when they tell us that our grosser palates will never taste the true flavour of this noble and exquisite dryness.

Seurat was so secretive that his friends and disciples knew nothing about his private life, and were not allowed to enter his studio; but they might have deduced from his later works that he aimed at being a great designer and not simply a disintegrator of colour. Unfortunately Signac, Luce, Cross and van Rysselberghe continued to paint very commonplace landscapes in blue and orange dots which completely smothered Seurat's influence at a time when, in spite of his early death, it might have been valuable; and Juan Gris, who rediscovered him, also concentrated on one aspect of his genius, his skill in arranging and diversifying geometric shapes. In doing so Juan Gris was acting in conformity with the needs of the time, for a similar limited use was being made of the far greater resources of Cézanne.

Without comparing the two men as painters, there is no doubt that Cézanne was the richer and more abundant temperament. Painters with different aims can find in him inspiration and support for their own particular endeavours, and as a result he has often been considered sectionally, which is exactly how he should not be considered. We run the risk of doing this by treating Cézanne's landscapes as part of a return to order, and to correct the balance we should begin by recalling those sumptuous, thundery picnics and bathing-parties, of which the Pellerin collection has several

examples. These Baudelairean orgies show that Cézanne's genius was based on a colossal sensuality. They attempt the only style in which an exuberant young romantic could express such violent emotions, the style of Delacroix. But Cézanne's peculiar limitations as an artist, his inability to paint from memory or to use the stylistic tricks of other painters, led to a complete travesty of his model. In particular he was incapable of using the traditional devices by which post-Baroque artists had achieved the illusion of depth. In the Pellerin *Baignade* serpentine recessions have been rolled out flat. On the other hand, his power to reduce what he sees to interesting shapes is already very impressive, and we see how he felt that a picture must exist as a design of flat patterns even before it creates an illusion of depth.

Cézanne's earliest important landscape, *The Cutting* at Munich [117], gives a clear idea of his strength and weakness at this time. Compared to Seurat's exquisitely neat and lucid compositions it is a very crude affair. But it has a stunning boldness and largeness of vision. It also foreshadows one of the chief characteristics that separate Cézanne from the impressionists – the frontality of his attack. The powerful horizontals which run parallel to the picture plane, and support the simplified mass, produce an immediate assault on the eye, differing both from the carefully contrived 'leads in' of the Baroque landscape, and the balanced design of classical.

One other landscape done at this period is worth studying, *Les Quais*; it is a well-designed picture, with Cézanne's usual sense of pattern; but the important thing about it is its realism – and I use that word in the sense in which it was used by Cézanne's boyhood friend, Émile Zola. Here, for the first time, we see Cézanne subduing his imagination in the interest of the facts. It was this process which was to occupy him during the next twenty years. The first pictures in which this process of self-discipline is apparent are the studies of still life, and it is easy to see why he should have chosen this subject for his technical and spiritual exercises. From the fact that the objects represented keep still, they are susceptible of a high degree of realisation; from the fact that they can be arranged, they are the most convenient raw material of pictorial architecture. And being free from any literary or dramatic interest they force the painter to rely for his effect on pictorial qualities alone.

During this period Cézanne almost gave up landscape painting. Although he was friendly with the impressionist group, and interested in their colouristic experiments, he was alarmed by the changeable conditions of

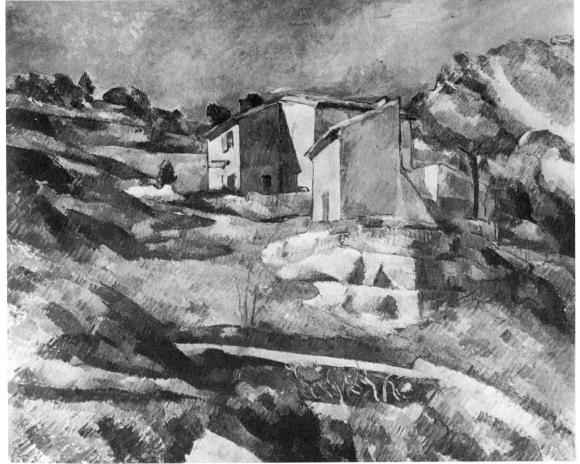

open air. Much of his time was spent in the Louvre making copies of Rubens and Delacroix, and the innumerable pencil studies of antique and Baroque sculpture which were presumably unknown to those critics who used to maintain that he could not draw. These studies show a progressive mastery in realising form without sacrificing flat pattern, but Cézanne had not yet found a means of carrying this into his painting. He had recognised that he could not express his grand conception of the world through imagery, halfinvented, half-remembered from the old masters; he could only do so by setting down with complete truth the visual sensations conveyed to him by natural objects. The technique of his friends, the impressionists, offered him a means of registering every shade of visual sensation, but for a time Cézanne thought that they were too much concerned with the surface of things. Such a judgment could not survive acquaintance with the grave and thoughtful work of Camille Pissarro, which, even as late as 1872, retained the elements of classic composition. Moreover Pissarro, who was the oldest of the group, had lulled Cézanne's suspicions by the understanding he had shown of his crude beginnings. So in 1873 he was persuaded to join Pissarro at Auvers.

The humble spirit in which he attempted to learn the impressionist style is shown by the fact that he made a careful copy of a Pissarro; and it was characteristic that when, about thirty years later, one of Cézanne's pictures was at last hung in the Salon, he put 'élève de M. Pissarro' in the catalogue after his name. Even if the original Pissarro had not survived, we could guess that the Cézanne was a copy because the composition is contrary to his usual practice. He has followed Pissarro's scheme of perspective with the road running away diagonally into the background. This was the conventional scheme of landscape composition taught in schools, but it was foreign to Cézanne's direct and frontal approach to nature; how foreign we can see by comparing it with an authentic Cézanne composition of almost the same date, the landscape of the Jas de Bouffan in Winter in the Lecomte collection. The lines of the foreground run parallel to the picture plane and the composition is broken almost in the middle by a strong vertical line, yet it achieves an effect of depth by perfect understanding of the colour value.

As with anyone learning a new style, Cézanne's first impressionist pictures are less satisfactory than those which immediately preceded them. In the famous *Maison du Pendu* of the Camondo collection his colours have

lost something of their force and brilliance, and no doubt it was admitted into the Louvre because it looked as unlike a Cézanne as possible. The massive forms are characteristic of him, but they are painted with Pissarro's palette which lulled the suspicions of the authorities. Quite soon, however, Cézanne was able to adapt the new language of impressionism to his own purpose. In the Mur d'Enceinte (one of the few pictures he felt worthy of a signature) he uses a broken touch to give the vibration of light, but the architectural composition might belong to his work at any period. It is the beginning of his famous attempt to 'do Poussin over again from nature', and in fact it is by no means dissimilar from a Poussin composition in its balance of verticals against a parallel horizon, and its use of distant architecture as a nucleus. It is, however, less closely knit in design than his landscapes afterwards became, and much less closely painted. Ten years later a rough statement, like the foliage of the overhanging branch, would have been clarified; and, although the sense of light in the background is vividly rendered, Cézanne is not yet able to give every inch of his canvas a living texture.

This he achieved through a struggle to integrate his natural sense of flat pattern with his consciousness of solid form, a struggle so fiercely sustained that it gives a feeling of tension to every inch of his canvases. As a result the objects depicted, no less than the brush strokes, begin to take on some dominating shape, like trees on the coast which have all bent before the same relentless wind, or rocks twisted into unity of rhythm by the same seismic upheaval. Such unifying distortions are common to all art, but they are usually smoothed over or concealed, whereas in Cézanne's work they are presented with the uncompromising directness of all his utterances. Criticism has not agreed how far such distortions were calculated, how far instinctive, and perhaps the question is unanswerable. All art involves selection and control of natural appearances which must reflect the artist's whole temperament, and in the choice of his dominant forms Cézanne was simply expressing his own vision of nature. But in the use of these forms he was no doubt perfectly conscious of his intentions. For this strange man, whose views on life, according to M. Vollard, were orthodox to the point of absurdity, was, where art was concerned, a profound and original thinker; and even in this period of dominant naturalism he had the insight to define painting as a harmony parallel with nature.

It is easiest to learn Cézanne's principles of design, as he himself learnt

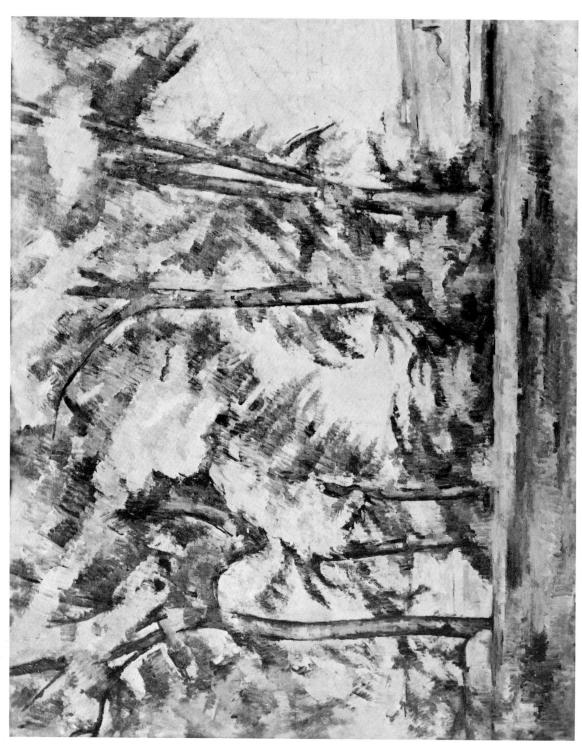

118 Cézanne, Trees at the Jas de Bouffan, (Les Grandes Arbres)

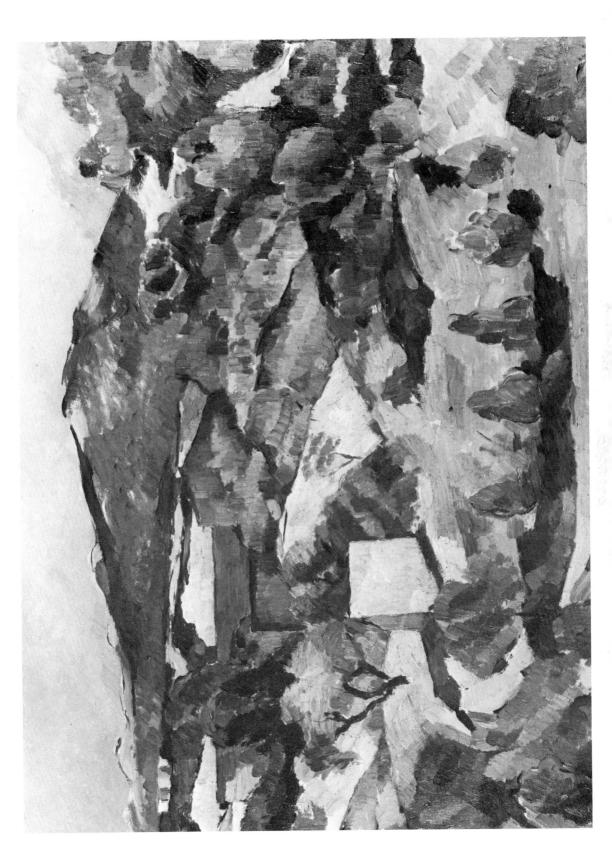

119 Cézanne, Mountains at L'Estaque

them, from his paintings of still life. But very soon he was able to transfer them to the more complex and evasive subject of landscape. As his design becomes more intellectual, his compositions are built up on straight lines rather than curves. In such a picture as the *Wooden Bridge* even the foliage is reduced to straight lines. But these straight lines, for example in the trunks of the trees, are frequently interrupted. It is as if Cézanne put them up as scaffolding, but then feared that they would arrest the movement of the picture and lead to too great insistence on contours. He recognised that an uninterrupted line implies a point of focus on the edge of the object and so makes impossible any movement in space forward or backward; and even in his first pencil notes he will always interrupt an outline and start it again a fraction further in or out.

His interest in the problems of construction is seen most clearly in those landscapes of Provence in which he gave the scenery of his native country the eternal harmonies of a classical landscape – of Tuscany or Greece [117]. The scenery of Provence has, in fact, rather the same character as that of Greece, but until Cézanne no one had realised its pictorial possibilities. Just as Claude and Poussin had made generations of painters feel that the Campagna provided the only scenery worthy of a serious landscape painter, so that even if they could not afford a journey to Rome they must transform their native countryside into a reflection of the Alban Hills, so, for thirty years, Cézanne's vision of Provence influenced landscape painters all over the world. But it did so only because he had spent his boyhood with his friend Zola tramping over the red earth, sleeping on it and gazing up through the pine trees for days and nights on end.

This triumph of vision is inseparable from a triumph of style. The landscapes of L'Estaque and the farm houses near Mont-Sainte-Victoire show, for the first time, one direction which Cézanne's mature style was to take – the direction which after his death was to lead to Cubism. The motives which led him to adopt this way of painting are quite simple, and are latent in all his early work. He wished to render the solidity of objects without degrading his colour or weakening his design by continuous modelling. The only means of doing this was to split up his planes into a number of small facets, each of which could, by its colour, make us aware of a new direction of the planes. This cubist, or perhaps we might say prismatic, approach to individual forms was also inherent in his compositions as a whole – in his strategy, as well as his tactics. It is this which distinguishes

him from the impressionists; for impressionism also offers a means of rendering continuous modelling by colour which was developed by Seurat; but underlying all impressionism is the belief that the unity of a picture depends on the enveloping atmosphere rendered by a continuous weft of colours; whereas Cézanne wished forms to retain their identity and cohere in an architectural relationship. To achieve this he began by choosing subjects in which the forms went some way to meet this kind of simplification [119]. His pictures of Gardanne are an example of pictorial architecture so obvious that they led many painters to believe that the way to produce a valid construction was to paint a Provençal village on a hill. They have nearly all failed, not because they lacked skill in composition, but because they lacked the essential truth of Cézanne's vision. They could never have admitted the two shabby looking houses on the left of the view of Gardannes: indeed it is hard to say immediately by what art they are made to contribute to this grandiose design. To show how entirely personal to Cézanne this composition was, it is worth comparing it with the landscape of the Jas de Bouffan in winter, already referred to. We find the same general scheme - the horizontal low down, running almost across the picture, the main vertical plumb central (deplorable from the academic point of view), the same arc going up from the right, and the same high buttress on the left. So the two shabby houses existed in Cézanne's imagination before he ever visited Gardannes, and might, under different circumstances, have been Roman Senators.

Cézanne's mastery of his means of expression made him independent of what one may call Cubistic subjects. He was able to apply it to such apparently fugitive effects as trees in the wind and achieve masterpieces of construction, in which the feeling for life and movement is actually greater than in a Monet, because it is felt throughout the whole design [118]. In spite of great simplifications – there is no attempt to delineate a leaf – these trees are remarkably true to nature compared to the self-consciously stylish work of those who have derived from Cézanne, even to that of such serious artists as Derain and Marchand.

As usual with Cézanne a change in vision was accompanied by a change of technique. The first Provençal landscapes were painted in thick, regular touches, so that the whole surface has the consistency of enamel [117]. Cézanne felt that this was too rich a mixture, clogging the freedom of his responses, and after 1882 he began to paint more thinly with a palette confined to relatively few colours – pale greens, earth colours and that

marvellous modulation of blues which was to remain a favourite medium of expression all his life. This new technical freedom was expressed in an increased use of water-colour. He had made use of water-colour from 1875 onwards, but in later life this medium began to influence his use of oils.

Cézanne's water-colours are amongst the most perfect of his works. And, here again, one must suppose that they were unknown to those critics who have maintained that he was a clumsy or heavy-handed painter. It is true that his figure pieces are in a grave and massive style, but he was also capable of the utmost delicacy. Often these water-colours seem to be almost Whistlerian in their elegance, but Cézanne's touches of colour were applied on a very different principle. Their decorative effect is, so to say, a byproduct. Their intention is to record for his own satisfaction the nodal points in a composition, and by nodal points I mean those places where the junction of the planes is of the greatest importance. The direction of these planes he represents by touches of pure colour, pale blue, pink, sienna and green, and his knowledge of their effect on one another is so sure that a very few of such transparent touches are sufficient to create an effect of great solidity.

It is in his drawings and water-colours that one recognises most clearly Cézanne's faculty of seeing both in depth and pattern at the same time. Sometimes the point he selects for notation is a piece of the background, sometimes an internal plane, yet all are related in space and subservient to a design. Out of a very complex subject he is able to select a few beautiful shapes and set them down with such certainty that we are not conscious of the white paper in between them, but only of their harmonious relation to each other.

Yet this is also the period in which Cézanne's wish to discover order in appearances becomes less insistent. His freer technique led to more spontaneous-looking expression of his sensations, so that often the structure of a picture is almost entirely concealed. And in the 1890s, there reappears in his painting the element of romanticism which was his point of departure, and which the long period of classic constructions had seemed almost to destroy. Such a picture as the *Bridge* in Moscow, although it retains the rich texture and firm construction of the '80s, shows a re-emergence of drama. After twenty years of restraint this extremely passionate man feels sure enough of himself to speak out.

It was about this time that Pissarro, who had never forgotten the power

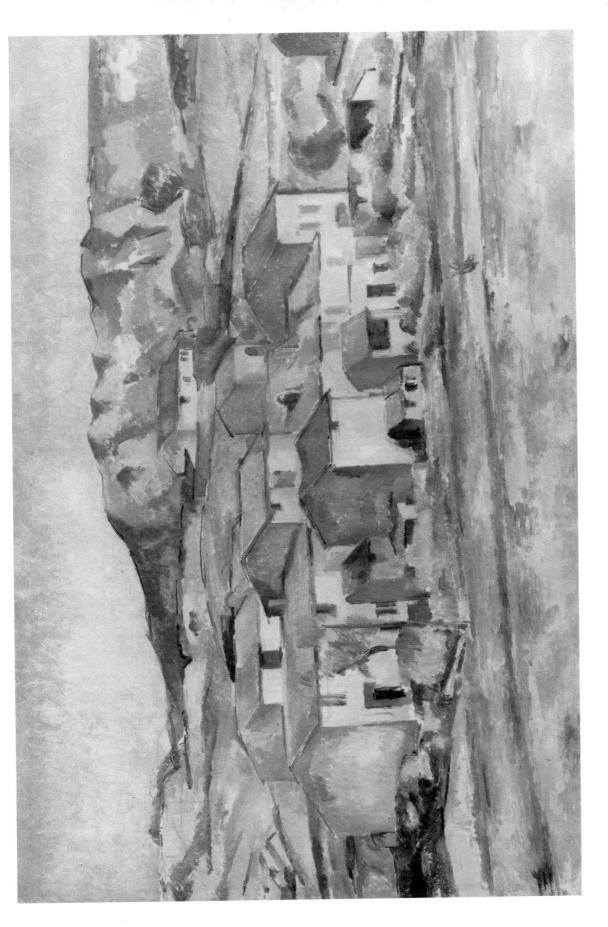

120 Cézanne, Mont-Sainte-Victoire

of Cézanne's early work, advised his young friend Vollard to seek out the old hermit in Provence and persuade him to hold an exhibition. This took place, in Vollard's galleries, in 1895, and immediately the great French painters of the time recognised that the *farouche* companion of their youth was their master. Monet, Renoir, Degas, and of course Pissarro himself, spent what little money they could afford in buying his pictures. It is sometimes said, by ignorant people who do not like his work, that admiration for Cézanne was a fashion engineered by art dealers; whereas the exact reverse is true. Only some time after his work had been discovered and purchased by artists and their friends did the dealers and critics, very slowly and reluctantly, use it for their own ends.

But the fame for which Cézanne had striven so violently in his youth came too late to give him pleasure. He was prematurely aged and had become almost insanely suspicious of interference. The struggle to solve so many conflicting problems of painting and thereby express himself had cost him his friends, and everything else which life had to offer; and now that he was almost in sight of realisation he was terrified lest some outside influence should deflect him.

His inner life at this time was evidently of great turbulence, and expressed itself by agitated, cursive handling, very similar to that of his earliest work, but in complete contrast to the delicacy and precision of his middle period. This is evident in his water-colours, and is intensified in his oils, where the paint is applied with a disturbing ferocity. His concentration involved a narrow choice of subject. His landscapes were practically confined to the Quarry of Bibémus, a motive which seems to have provoked the greatest violence, a nearby building (the Château Noir), which he used as a studio, and the Mont-Sainte-Victoire. Of the mountain he made innumerable studies, and we feel that the painting of this motive became for him like a ritual act of worship in which he could achieve perfect self-realisation [120].

Cézanne, in one of his letters, says that he believes these late works, if exhibited, 'will give a correct notion of the progress of his studies'; and anyone who has understood his intentions will agree with him. It is more surprising to realise that they are also the works in which he believed himself to have the clearest understanding of nature. 'Je deviens comme peintre', he writes in 1906, 'plus lucide devant la nature.' It is true that in his very latest work some of his turbulence has died down, and serene lucidity of design has taken its place. But I am not sure that this is what Cézanne

meant, for he goes on to say 'but with me the realisation of my sensations is always more painful'. A superficial critic might think the exact reverse: that Cézanne had acquired complete mastery of the means of expression, but treated nature only as a pretext. Such a view would completely misrepresent the whole nature of his art. Although he had striven so hard for order and for the durability of the old masters, his late letters are full of references to his 'petite sensation'; and he says more than once that the basis of art was 'une sensation forte devant la nature'. At first this looks as if he was subscribing to the aesthetic of impressionism. But there is, of course, a profound difference. Cézanne is not thinking solely of an optical sensation, but of the reaction of his whole being, of that tempérament, which he used to pronounce with such ferocious rolling of the 'r'.

By 'plus lucide devant la nature', I think he meant that his own passionate imaginative life, which as a young man he had tried to express by the creation of fantastic images, could now be revealed in every stroke with which he recorded his visual sensations. He had brought his inner and his outer vision into focus. Or, to change the metaphor, he had succeeded in his own definition of art; he had created a harmony parallel with nature. The unifying factor was his own temperament; but this could only exert itself unconsciously on the raw material of things seen, experienced as shape and colour and wrestled with to secure their maximum realisation. In so far as modern art involves a readiness to override nature - to defy appearances in the interests of emotion, then Cézanne was far from being a modern, for no Pre-Raphaelite ever looked at nature more earnestly. In this he was at one with the great landscape painters of the past, with Bellini, Rubens and Poussin. His followers recognised only the other side of his achievement, the power to use visual appearances almost as an architect uses stone from a quarry to make a harmonious construction. So the peculiarity of style which Cézanne evolved so painfully in order to express his 'petite sensation devant la nature', which was in fact his feeling that the subject must be seen in pattern and depth at once, and that form must be rendered by colour, this miraculous style created with the patience and self-sacrifice of a Milton or a Flaubert, was seized from its context and became an instrument in the renunciation of nature - which is the subject of the Epilogue.

121 Gauguin, Martinique Landscape

EPILOGUE

This book should end by asking how far the modes of vision which it examines throw some light on the landscape painting of the present day; but before crossing the rickety bridge which leads from the historic past to the future, it would be wise to look back and recall what we have seen. In the west landscape painting has had a short and fitful history. In the greatest ages of European art, the age of the Parthenon and the age of Chartres Cathedral, landscape did not and could not exist; to Giotto and Michelangelo it was an impertinence. It is only in the seventeenth century that great artists take up landscape painting for its own sake, and try to systematise the rules. Only in the nineteenth century does it become the dominant art, and create a new aesthetic of its own.

In course of this development the concept of landscape changes from things to impressions. Man first shows his consciousness of nature when his art is still symbolic; and since nature is so vast and inapprehensible he continues to treat her symbolically even after he has achieved an almost scientific realism in the representation of plants and animals. Flowers, leaves, individual trees, are all 'things' which can be thought of in isolation. A mountain is a 'thing' when its form is sufficiently egregious to mark it off from the range. From these individual elements the first landscapes are put together.

In the landscape of symbols the details are combined decoratively or as expressive pattern. The fusion of these elements into a total impression is achieved through the perception of light. From Leonardo to Seurat painters, as well as critics, have maintained that the rendering of light is part of the science of painting; but Hubert van Eyck, John Bellini, Claude, Constable and Corot, show us that the representation of light owes its aesthetic value to the fact that it is the expression of love. 'As the air fills everything and is not confined to one place, as the light of the sun overfloods the whole earth, so God dwells in everything and everything dwells in Him.' Now it was this mystical sense of the unity of creation expressed by light and atmosphere which, however unconsciously, provided a basis of pictorial unity for the impressionists; and the claims to science, which they some-

times felt called on to make in defence of their intuitions, were only a nineteenth-century way of stating the same belief, for at that time science was still based on the assumption of some underlying natural order - a belief that, as Pythagoras said, nature is sure to act consistently in all her operations.

So landscape painting, like all forms of art, was an act of faith; and in the early nineteenth century, when more orthodox and systematic beliefs were declining, faith in nature became a form of religion. This is the Wordsworthian doctrine which underlay much of the poetry and nearly all the painting of the century, and inspired its greatest work of criticism, *Modern Painters*. The belief that the inherent sanctity of nature had a purifying and uplifting effect on those who opened their hearts to her influence, was given its most elaborate statement in that extraordinary work, where detailed descriptions of natural forms, leaves, branches, cloud-structures, geological formations, occupying hundreds of pages, seemed quite relevant to contemporary readers, although to an earlier, or a later, century they might seem as remote from art-criticism as theology.

Although this faith is no longer accepted so readily by critical minds, it still contributes a large part to that complex of memories and instincts which are awakened in the average man by the word 'beauty'. Almost every Englishman, if asked what he meant by 'beauty', would begin to describe a landscape - perhaps a lake and mountain, perhaps a cottage garden, perhaps a wood with bluebells and silver birches, perhaps a little harbour with red sails and white-washed cottages; but, at all events, a landscape. Even those of us for whom these popular images of beauty have been cheapened by insensitive repetition, still look to nature as an unequalled source of consolation and joy. Now if this appetite is still so widespread and so powerful, have we grounds for thinking that landscape painting will continue to be a dominant form of art? This question involves another of even greater difficulty; how far can an art form retain its vitality when it rests on the passive consent of the mass of uninformed opinion, but is not supported by the active conviction of an informed minority? The difficulty of this question arises from the fact that never before has there been such a complete divorce between popular and informed taste. And, although in the past popular taste has ultimately always conformed to that of the minority, it may now seem that the extremely esoteric and specialised work which meets with the approval of the few is so lacking in fundamental humanity

that it will die of inbreeding. This is a tenable view, but I believe it to be mistaken. Whether or not the more specialised forms of modern art are permanently valid, we can hardly doubt that the living art of a period must reflect the ideas of the more active spirits, and not of the indifferent masses, for whom art is, at best, a mildly satisfying social convention. Let us, therefore, consider how far the beliefs and modes of expression which, in the last fifty years have shown most vitality, are likely to influence the art of landscape painting.

I suggested in the first chapter that changes in art take place for both internal and external causes. Up to a point art seems to follow its own laws, laws depending on what, in the widest meaning of the term, we may call technical considerations; and it may always be given a new direction by individual genius: but beyond this point art will reflect the fundamental assumptions, the unconscious philosophy of the time. I will take first, as being less speculative, the causes within the art itself. The painting of landscape cannot be considered independently of the trend away from imitation as the raison d'être of art. To a certain limited extent this trend was a reaction. For almost five hundred years artists had been applying their skill to the imitation of nature. During this time numerous methods of representation had been mastered and refined, culminating with a method which rendered light by a new combination of science and subtlety of vision. By 1900 the more adventurous and original artists had lost interest in painting facts. By a common and powerful impulse they were driven to abandon the imitation of natural appearances.

The spread of photography, which, as I have said, had no positive influence on the birth of naturalism, may have had a certain negative influence on its demise. It is true that by the time landscape photography became usual practically all the impressionists had ceased to paint in a photographic manner. Still, photography was bound to undermine the assumption that art was chiefly concerned with the imitation of appearances, and the shortcomings of photography have been frequently, not always honestly, used by apologists of abstract art. In another and more subtle manner photography has had a greater influence, because, by familiarising us with works of art and culture, it has enabled artists to enlarge the range of their aesthetic experience far beyond the range of their direct experience of nature. The number of solutions has increased out of proportion to the data. Thus photography has helped to create a museum art. Of course

artists had been drawing inspiration from antiquity ever since the Renaissance, but the works which inspired the great tradition of classicism were all in a single, consistent style. They were part of an acknowledged order, and it was often their consistency, rather than the beauty of the individual objects, which had led artists to refer to them. But towards the end of the nineteenth century museums began to admit works of all ages and countries; and artists, instead of finding in them a consistent language, began to look for those works in each style that could give the shock of pleasure which had come to be called aesthetic. Museum art, therefore, in the sense in which I am using it, implies the existence of the pure aesthetic sensation. It implies that the value of art depends on a mysterious essence or elixir which can be isolated, almost tapped off from the body or husk of the work; and this elixir alone is worthy of pursuit.

Dangerous as purism is to all the arts, it is particularly troublesome in landscape painting which depends so much on the unconscious response of man's whole being to the world which surrounds him. It is curious that the greatest disciple of nature should have foreseen the danger of museum art as early as 1822, when Constable wrote to Fisher: 'Should there be a National Gallery (which is talked of), there will be an end of the art in poor old England. The reason is plain: the manufacturers of pictures are then made the criterions of perfection instead of Nature.' Constable's statement is a little exaggerated (he had just been looking at David's Coronation of Napoleon) and is coloured by his obstinate insularity. We may amend it, and say that when painters began to pin up in their studios photographs of Romanesque carvings, Negro masks and Catalan miniatures, a direct response to nature became extremely difficult. Once we have developed a craving for an aesthetic essence we find it in its purest and most concentrated form in the early middle ages, or in the work of primitive peoples; and it is significant that the first artist to state that he was aiming directly at 'pure' aesthetic responses was Gauguin. In a letter of the 80s, he said1: 'I obtain by arrangements of lines and colours, using as pretext some subject borrowed from human life or nature, symphonies, harmonies that represent nothing real in the vulgar sense of the word; they express no idea directly, but they

¹This is, of course, an extension of the theories formulated by Edgar Allan Poe almost fifty years earlier and expressed in his famous essay, entitled 'The Poetic Principle'. Whistler had gone far towards a similar position in the *Ten O'clock Lecture*, 1885.

should make you think as music does, without the aid of ideas or images, simply by the mysterious relationships existing between our brains and such arrangements of colours and lines.' It was Gauguin, too, who succeeded in giving to an exotic style the vitality of a new creation. Perhaps museum art had been inevitable ever since the Gothic revival, but in its earlier forms it was relatively harmless. The polite archaisms of Burne-Jones were too narrowly fashionable to affect the course of art for better or worse. But Gauguin did not borrow mediaeval properties. He forced himself to see symbolically. How difficult it was to do so is proved by his flight to Tahiti. He had to take an immense journey in space in order to achieve a journey in time. But he succeeded, and his Tahitian landscapes are true successors to the tapestry landscapes of the fourteenth century [121].

Very soon after Gauguin had re-created the landscape of symbols by an act of will, another artist reached the same destination by the opposite route. This was the Douanier Rousseau, whose extreme simplicity of character had led him unconsciously to the same result as Gauguin's restless intelligence. He was, as we know from his sketches a born painter; but he thought that these well-balanced statements of tone were unworthy of exhibition because they did not contain all the leaves and grasses, twigs, flowers and fruits which he could see if he looked carefully, and therefore felt bound to put in. He also thought that mere landscape was not sufficiently interesting - it should include some remarkable building, like the Eiffel Tower, or some remarkable event, like the 14th July; or, best of all, it should represent something that the ordinary man could not have seen for himself, like the jungle, which he had seen when he had been in Mexico in the '60s [122]. The Douanier's views on painting would have met with more agreement in the middle ages, and even in the Renaissance, than would those of Monet, but of course he himself was unaware of this, and believed himself to be perfectly up to date. He said to Picasso: 'Nous sommes le deux plus grands peintres de l'époque - toi dans le genre égyptien, moi dans le genre moderne.' Now in spite of his inability, late in life, to adapt himself to all the complex conventions of the modern world, no one who cares for the painting of the fifteenth century can fail to see that the Douanier was very different from the innumerable Sunday painters who have claimed recog-

¹It has now been established that the Douanier never left France, and that his jungle scenes were derived from the *Grande Serre* in the *Jardin des Plantes* which is only a hundred yards away from the lions' cages.

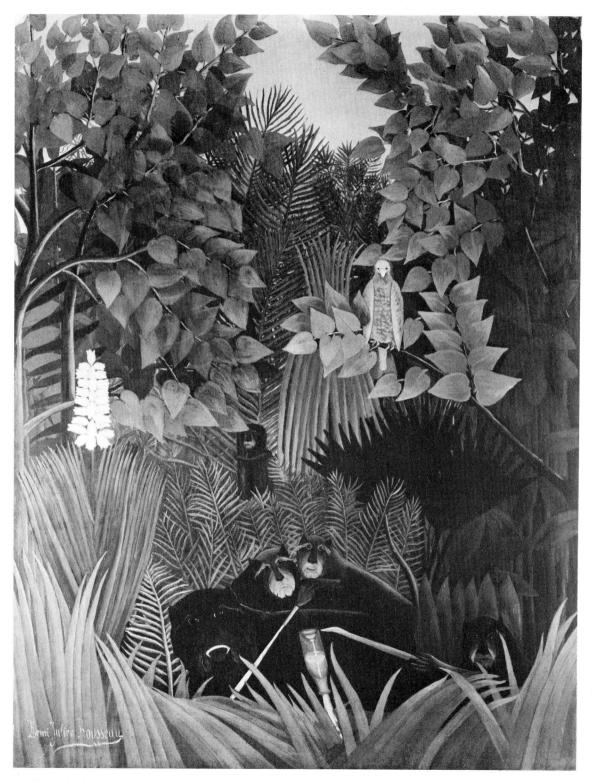

122 Douanier Rousseau, The Merry Jesters

nition since his time. He was not only a natural pattern-maker but could, at times, command a grandiose imagination. Two of his great pictures, now hanging in the nineteenth-century section of the Louvre, stand out in a room of masterpieces. But, as with Gauguin, he was something unprecedented in the history of art. Never before, as far as I know, has a great painter been completely oblivious of the style, or styles, of his time, and instinctively painted in the manner of four hundred years earlier. The apprenticeship system alone would have made it impossible; but even had he done so no one would have recognised his merits. For until museums and photography made styles of all sorts familiar and comprehensible to us, people were so deeply immersed in the style of their own time that any other seemed as ridiculous as the hats of twenty years ago. The gentle Douanier, no less than the savage Gauguin, is a symptom of museum art.

An ironic fate diverted the influence of Cézanne into the same direction. In spite of his expressed desire to make an art which should be durable like that of the museums, he was, in practice, the most earnest and scrupulous follower of nature, and his method of splitting up planes into facets and building his composition out of a number of simplified – sometimes rectangular – shapes, was a means to the full statement of his visual sensation, not an end. It is true that one of Cézanne's letters contains a famous sentence about cones and cylinders, which was used by Picasso and Braque to prove that he supported the *theory* of cubism. But like many of the aphorisms which have inspired belief, this loses some of its force if quoted in its proper context. 'Tout dans la nature se modèle selon la sphère, le cône et le cylindre. Il faut s'apprendre à peindre sur ces figures simples, on pourra ensuite faire tout ce qu'on voudra.' Curiously enough this corner-stone of cubist theory does not mention cubes at all, but only those forms which provide exercise in continuous modelling, and so are the contrary of cubist. However, the second part of Cézanne's sentence makes it clear what he meant. In his time elementary lessons in composition were taught by making the student draw arrangements of spheres, cones and cylinders. I was taught on this method myself by an old gentleman who was certainly no cubist, but remembered the doctrines of his youth in Paris of the 1870s.

But although it is quite clear that Cézanne never envisaged cubism, or any other form of so-called abstract art, one cannot deny that his late work goes a long way towards abstraction. In his series of Bibémus and the Château Noir the vitality of the design has an effect on our minds very remote from

TOWDRIAGN . I

that of a Provençal house seen through pine trees.¹ The recognition of Cézanne's simplified forms and faceted planes, coincided with the discovery of negro art, in which nature really is reduced to cylinders and ovals, and to an interplay of concave and convex. There is even a curious similarity between the ways in which Cézanne and a negro sculptor feel the character of planes. And so Cézanne's *petite sensation* was transformed into the most cerebral and museological of all styles – cubism.

Whatever the merits of cubism, it is clearly not a style in which landscape, as we have defined it, will play a leading part. It is true that Picasso and Braque, encouraged by Cézanne's pictures of Provençal towns, attempted some landscapes in which houses are simplified into cubes. If Picasso soon gave up this type of landscape it is partly because he saw that cubism must be a consistent medium of distortion applied throughout, irrespective of its point of departure: the effect of the subject going half-way to meet it was artificial and unconvincing: and partly because Picasso is essentially a painter of still lives and figure compositions, a designer in large forms which fill the canvas, and in his gigantic oeuvre his landscapes are much the weakest part. Braque's landscapes are purely decorative, and, as pretexts for design, less satisfactory than a plate of lemons and a jug. And although Mondrian, the painter who achieved the purest of all abstractions, tells us that he drew some of his original inspiration from waves and beaches [123], we cannot seriously consider the more austere forms of abstract art as a possible basis for landscape painting.²

In the *Philebus* of Plato, Socrates says, 'I will try to speak of the beauty of shapes, and I do not mean, as most people would suppose, the shapes of living figures, or their imitations in painting, but I mean straight lines and curves and the shapes made from them, by the lathe, ruler or square. They are not beautiful for any particular reason or purpose, as other things are, but are eternally, and by their very nature, beautiful, and give a pleasure of their own quite free from the itch of desire: and in this way colours can give a similar pleasure.' This passage has been much quoted by supporters of pure abstraction; I repeat it here because it is a link between the influence of the scientific attitude on the pure aesthetic idea, and the influence of science on

¹ A visit to the quarry of Bibémus shows that Cézanne copied exactly the shapes of the rocks and of the abandoned blocks of stone (1974).

² Mondrian for many years painted landscapes of great distinction which are evidently the basis of his later style (1976).

the actual forms of abstract art. The forms which Plato says are of their nature beautiful are geometric forms. In other words the eternally beautiful is that which can be measured or stated analytically in other terms. These are naturally the kind of forms which are useful to science, and since science has been the dominating intellectual activity of the last hundred years, they have influenced art. It may even seem a weakness that the wonderful creations of engineering have not influenced art more deeply. Such was the opinion of the Italian futurists, and in that absorbing document, the First Futurist Manifesto, published in 1910, Signor Marinetti declared that 'A Racing Motor Car, its frame adorned with great pipes, like snakes with explosive breath, a roaring motor car that seems to be running on shrapnel, is more beautiful than the Victory of Samothrace.' Whether or not we agree, it is evident that a picture of the motor car will not necessarily be beautiful - the motor car, as Signor Marinetti claims, is itself the work of art. And this, I suppose, is the reason why the very striking combinations of straight lines and curves, cones, spheres and cylinders, which go to make up an engine, and which would no doubt have delighted Socrates, have had a disappointing influence on art. All the creative skill which occupies itself with that kind of design has gone into engineering.

Now of all forms of art, landscape painting is clearly at the furthest remove both from Platonic geometry and from the engineering art which is an elaborate application of the same principles.

But, could not landscape painting exist as something complementary to the art of slide-rule and lathe – something for which we should crave all the more hungrily, because it was excluded from the Platonic approach? Here, too, it seems to me that science has intervened by radically altering our concept of nature. Throughout this book, when I have used the word 'nature', I have meant that part of the world not created by man which we can see with our unaided senses. Up to fifty years ago this anthropocentric definition did well enough. But since then the microscope and telescope have so greatly enlarged the range of our vision that the snug, sensible nature which we can see with our own eyes has ceased to satisfy our imaginations. We know that by our new standards of measurement the most extensive landscape is practically the same size as the hole through which the burrowing ant escapes from our sight. We know that every form we perceive is made up of smaller and yet smaller forms, each with a character foreign to our experience. It is true that this knowledge has left some mark

on modern painting. Many of Paul Klee's water-colours remind us of life under a microscope, the magnified section of stalk, or some other strange and beautiful specimen of our enhanced vision. No artist has ever had longer antennae than Klee, and not content with exploring every corner of the museums, they also trembled over scientific laboratories. A scientist with an interest in art who could trace these sources of inspiration in Klee's work, would make a valuable contribution to the study of modern imagery. I reproduce [124] a pastel executed in 1880, by Mr Underhill, a fellow worker in Professor Poulton's laboratory, which was presumably intended as a document in marine biology; anyone seeing it in the original is immediately reminded of Klee and early Miró. But although these artists have refurnished their repertoire of forms from the laboratories, this does not by any means compensate for the loss of intimacy and love with which it was possible to contemplate the old anthropocentric nature. Love of creation cannot really extend to the microbe, nor to those spaces where the light which reaches our eyes has been travelling to meet us since before the beginning of man. Of course we can contrive to forget these almost incredible facts in front of a fine prospect, just as we can forget the starvation in the world in front of a good dinner. But the creation of great works of art must rest on something more than this salutary animal accommodation to the responses of the moment.

And in the last few years nature has not only seemed too large and too small for imagination: it has also seemed lacking in unity. To anyone but a higher mathematician, nature no longer seems to act consistently in all her operations. In the last few years we have even lost faith in the stability of what we used hopefully to call 'the natural order'; and, what is worse, we know that we have ourselves acquired the means of bringing that order to an end. Leonardo da Vinci, who used to sign himself 'disciple of experience', left among his latest writings the sentence, 'Nature is full of an infinity of operations which have never been part of experience'. And he illustrated his consciousness of the infinite, unknown destructive powers of nature in the series of landscape drawings which I referred to in an earlier chapter.

I said that these drawings, in addition to expressing Leonardo's state of mind, reflected a general fear that the world was coming to an end, which had inspired the Apocalypses of the late fifteenth century and the paintings of Grünewald. It is a fear which seems to take possession of Western man every five hundred years, and as it is supposed to be connected with the Millennium, it is known to historians as Chiliasm. Our belief in Chiliasm

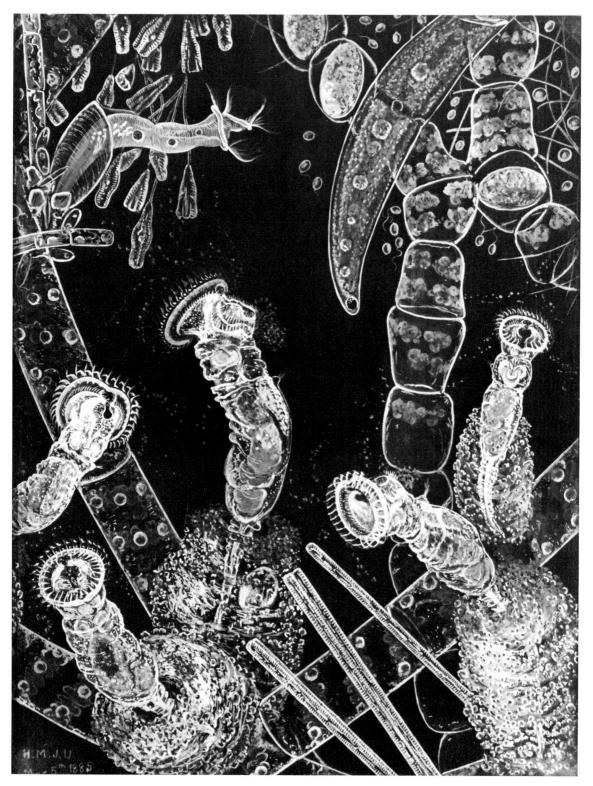

124 Underhill, Marine Biology

has come fifty years early; but then our new religion has provided a great deal better grounds for it than the old one did.

Can we escape from our fears by creating once again the image of an enclosed garden? No. The artist may escape from battles and plagues, but he cannot escape from an idea. The enclosed garden of the fifteenth century offered shelter from many terrors, but it was based on a living idea, that nature was friendly and harmonious. Science has taught us that nature is the reverse; and we shall not recover our confidence in her until we have learnt or forgotten infinitely more than we know at present. The Brahmin who shocked Tennyson by wanting to destroy a microscope was as wise as the Chinese when they confined the use of gunpowder to fireworks.

At the end of Chapter Six I said that the best hope for a continuation of landscape painting consisted in an extension of the pathetic fallacy, and the use of landscape as a focus for our own emotions. The great artists of Chiliasm, like Grünewald, were expressionists, and it is possible that the emotions of excitement and awe which this terrible new universe arouses in us will find expression in some such way as the old forest fears found expression in northern art. Ultimately our expanded concept of nature may even enrich our minds with new and beautiful images. In our new wars of religion let us hope that we may be permitted another Grünewald, or, at least, another Bosch. But will he be tolerated? Bosch's work was collected by Philip II, who was more tolerant and less efficient than our new tyrants. Expressionism is the art of the individual and is his protest against the restraints of society: and whether such an art can exist in the future is a question for economists, sociologists, physicists and crystal-gazers. As an old-fashioned individualist I believe that all the science and bureaucracy in the world, all the atom bombs and concentration camps, will not entirely destroy the human spirit; and the spirit will always succeed in giving itself a visible shape. But what form that will take we cannot foretell.

INDEX

Abate, Niccolò dell', 57, pl. 59, 95 Abstract art, 235-8 Acis and Galatea (Claude), pl. 77, 129 Acland, Sir Henry, viii Adoration (Bosch), pl. 37, 55 Adoration of the Lamb (van Eyck), 29, 35 After the Deluge (Turner), 197 Agony in the Garden (Bellini), 49 Alberti, Leon Battista, 43-7, 65, 109 Albertus Magnus, 8, 16 Allegory (Bellini), pl. 69, 113, 131 Altdorfer, Albrecht, pl. III, pl. 46, pl. 48, 73-8,95, 103, 190, 197, 198n. Ancona altarpiece (Titian), 119 Angelico, Fra, 29 Angers tapestries, 13 Annunciation (Leonardo da Vinci), 87 Anselm, St., 3, 6 Antibes, trees near the Mediterranean (Monet), pl. 101 Antonello da Messina, pl. 34, 48 Arcadian movement, 114 Ascanius and the Stag (Claude), pl. 74, Astrologer, The (Giorgione), 116n. Attila (Raphael's fresco in the Vatican), Augustine, St., 10 Autumn, 135 Avignon frescoes, 13, 21

Baignade (Cézanne), 216
Baignade (Seurat), 208, 210–12
Baldovinetti, 44
Banks of a River (Ruysdael), pl. 40
Barbizon School, 138, 154, 164–5
Battle of Alexander (Altdorfer), pl. III
Battle of Anghiari (Leonardo da Vinci), 93
Baudelaire, Charles, 161, 189
Beach at Sainte-Adresse (Monet), pl. 100
Beccafumi, Domenico, 84
Bellini, Giovanni, pl. I, pl. 34, pl. 35, 47–53, 59, pl. 69, 96, 109, 113, 130–1, 229

Bembo, Pietro, 114 Beowulf, 73-4 Berckheyde, Gerrit, 64-5 Birdcatcher (Rubens), 103 Birdsnester (Breughel), 57 Blake, William, 139-43 Blanc, Charles, 210 Blind Men (Breughel), 57 Boccaccio, Giovanni, 8, 13, 16 Bosch, Hieronymus, 17, pl. 37, 54-6, 73, 78-80, 197, 241 Boudin, Eugène, 168, 205 Bourdon, Sebastien, 138 Braque, Georges, 237 Breughel, Pieter, 21, 22, 35, pl. 38, pl. 53, 55-9,84-7 Bridge (Cézanne), 224 Bridge at Courbevoie (Seurat), pl. 116 Bridge of Narni (Corot), 158 Brighton Beach (Constable), pl. 90 British art, 107, 138-44, 147-54, 181-96 Broederlam, Melchior, 87 Brunelleschi, Filippo, 43-7, 61, 64 Buttermere with a Rainbow (Turner), 189 Byzantine art, 17

Calais Pier (Turner), 182 Camera lucida in Dutch art, 65 Camera obscura, Alberti's, 44-5, 47 Campagnola, Giulio and Domenico, 8on. Campin, Robert, pl. 24, 35n., 39 Canal with a Rowing Boat (Rembrandt), Canaletto, Antonio, pl. 44, pl. 45, 65-7 Canterbury Psalter, pl. 2 Capelle, Jan van der, 64 Caravaggio, Polidoro, pl. 65, 95 Carracci, Annibale, 109, 120-22 Cennini, Cennino, 21 Census in Bethlehem (Breughel), 57 Cézanne, Paul, 96, pl. 117, pl. 120, pl. 119, pl. 120, 135-8, 168, 172, 200, 203-8, 215-27, 235-7, pl. VIII

Charon's Boat (Patenier), pl. 51 Chenal de Gravelines (Seurat), pl. 115, 209 Chiliasm, 239-41 Christus, Petrus, 35n., 48 Claude, 31, pl. 75, pl. 76, pl. 77, pl. 78, 103, 115, 122-9, 138-9, 148, 160, 168, Claude glass, 178 Cliffs at Étretat (Courbet), pl. 97 Composition (Mondrian), pl. 123 Constable, John, 64, 71, pl. 88, pl. 89, pl. 90, 96, 147–58, 161, 168, 182, 200 229, 232 Cornfield (Constable), 151 Cornfield (Poussin), 135 Corot, Jean-Baptiste, 29, pl. 92, pl. 93, pl. 94, pl. 95, 138, 153–61, 165–72, 205, 229 Corsali, Andrea, 77 Cottage in a Cornfield (Constable), pl. 90, Courbet, Gustave, pl. 96, pl. 97, 161-7 Cozens, Alexander, 107, 124 Cozens, John Robert, pl. 86, 107, 139 Crossing the Brook (Turner), 182 Crucifixion (Antonello da Messina), pl. 34, 48 Cubism, 222-3, 235-7 Cutting, The (Cézanne), pl. 117, 216 Cuyp, Albert, 64 Cypresses (van Gogh), pl. 111, 200, 202

Dali, Salvador, 87
Dante, 8, 10
Daubigny, C.F., pl. 98, 157, 167–8, 205
David, Gherard, 54
David, Jacques-Louis, 232
Decline of the Roman Empire (Claude), 128
Dedham Vale (Constable), 148
Degas, H.G.E., 21n., 172, 200, 226
Dejeuner des Canotiers (Renoir), 179
Delacroix, E., 154, 208
Deluge (Poussin), pl. 79
Deluge (Leonardo da Vinci), pl. 79, 93
Derain, André, 223
Destruction of Sodom (Millet), pl. 85, 138
Destruction of Sodom (Turner), 182

Diogenes (Poussin), pl. 80, 131
Disney, Walt, 73, 75
Divine Comedy, 8
Domenichino, 120
Dossi, Dosso, 84
Dou, Gerard, 59
Drawing of Trees (Claude), pl. 75
Durandus, 5
Dürer, Albrecht, pl. 27, pl. 28, pl. 29,
41–2, 75, 84, 87, 93
Dutch art, 59–65

Eadwine's Psalter, 1,6

Egremont, Lord, 188
Elsheimer, Adam, pl. 67, 103-5
Entombment (Carracci), 120-22
Entrance to the Village of Voisins (Pissarro), pl. 113
Ernst, Max, 73
Eruption of the Island of St. Vincent at
Midnight (Turner), 197
Étretat (Daubigny), pl. 98
Evening Star (Turner), 173
Expressionism, 73 et seq., 196, 202, 241
Eyck, Hubert van, pl. 21, 29, 33-5, 39, 43, 48, 167, 229
Eyck, Jan van, pl. 20, pl. 22, pl. 23, 35, 39, 48

Fabriano, Gentile da, 22–3, 29 Fall of Icarus (Breughel), pl. 53, 87 Fall of the Giants (Romano), pl. 59 Fallacies of Hope (Turner), 182, 190, 194, 197 Feast of the Gods (Bellini), 130 February Fill Dyke (Leader), pl. 99, 170 Fête Champêtre (Giorgione and Titian), pl. 68, 112, 116, 118 Finding of Paris (Giorgione), 115 Fire at Sea (Turner), pl. 108, 196 Fisherman's Hut on a Lake (Dürer), pl. 28 Flemish art, 22, 29–31, 33–43, 47, 45–9 Flight into Egypt (Carracci), 120 Flight into Egypt (Claude), pl. 78 Flight into Egypt (Elsheimer), pl. 67, 103 Flight into Egypt (Gentile da Fabriano), 29

INDEX

Flight into Egypt (Tintoretto), pl. 60, 96 Florentine art, 8-9, 43-7, 77 Ford, The (Corot), 157n. Forest Fire (Piero di Cosimo), pl. 49, 77 Francisco de Holanda, 54 Francis, St., 69 Franck, Sebastian, 53 French art, 9, 22, 122-38, 154-79, 205 et seq. Frescoes, pl. 1, 13, 21, 27, pl. 59, pl. 65, 93, 210, 212 Friedrich, Caspar David, pl. 87, 143 Frosty Morning (Turner), 182 Fry, Roger, Vision and Design 122 Fuseli, Henry, 68–71, 105 Futurist Manifesto, First, 238

Gainsborough, Thomas, pl. II, 21n., 67-8, 124, 147 Gare St. Lazare (Monet), pl. 104, 187 Gathering of the Ashes of Phocion (Poussin), pl. 83 Gauguin, Paul, pl. 121, 176, 232-5 Gautier, Théophile, 167 Gelée, Claude. See Claude Géricault, Théodore, 84 German art, 73-5 Giorgio, Francesco di, 44n. Giorgione da Castelfranco, pl. 51, 53, pl. 68, pl. 70, pl. 71, pl. 72, 80–4, 112–22 Giotto di Bondone, 9 Girtin, Thomas, 147 Giulio Romano, pl. 59, 93 Goes, Hugo van der, pl. 25, 39, 57 Gogh, Vincent van, 73, pl. 109, pl. 110, pl. 111, pl. 112, 176, 181, 197-202 Good and Bad Government (Lorenzetti), 9 Gothic art, 21, 27-31, 87, 95 Gothic Revival, 101 Goyen, Jan van, 64 Gozzoli, Benozzo, pl. 17, 27 Grandes Arbres, Les (Cézanne), pl. 118 Grande Jatte, sketch for (Seurat), pl. 114 Granet, F.M., 157 Greco, El, 17n., pl. 63, pl. 64, 96-100, 198n.

Grünewald, Mathis, pl. 47, 73–5, 84n., 197, 198n., 202, 239–41 Guardi, Francesco, pl. 45, 55, 67

Hagar and Ishmael (Claude), 148 Hals, Franz, 59 Hampton Court (Sisley), 172 Hannibal Crossing the Alps (Turner), 182 Hay Wain (Constable), 151, 154, 212 Hazlitt, William, 131-6, 188 Hellenistic painting, 1-2, 17 Heyden, Jan van der, pl. 43, 65 Hiroshige, 198 Hobbema, Meindert, 59, 60, 64 Hooch, Pieter de, 64 Horoscope (Giorgione), 116n. Hortus Conclusus, 15-16, 27 Hospice de la Phare at Honfleur (Seurat), Hours of Milan (Jan van Eyck), pl. 20 Hours of Turin (Hubert van Eyck), pl. 21, Houses at L'Estaque (Cézanne), pl. 117 House of Livia, frescoes from, 3, pl. 3 Huber, Wolf, 197 Hunt the Wood (Uccello), pl. 18 Hunters in the Snow (Breughel), 56

Illuminated manuscripts, 1–3, 17, 22, 33, 87
Illusionist, the, 1
Impression, An (Monet), pl. VII
Impressionism, 168–79, 198–200, 205–6, 210–12, 218–23
Ingres, J. A., 138, 208
Interior at Petworth (Turner), 177, 188
Isenheim altarpiece, pl. 47, 74, 84n.
Italian art, 22–31, 43–54, 80–4, 109–18

Jacob and Laban (Claude), 128 Jas de Bouffan in Winter (Cézanne), 218 223 Jones, Inigo, pl. 66, 105 Journey of the Magi (Gozzoli), pl. 17, 27

Klee, Paul, 239 Koninck, Philip de, 60

Gris, Juan, 215

Labours of Hercules (Pollaiuolo), 44 Lady with the Unicorn (tapestry), pl. 9 Lake, The (Corot), pl. 95, 160 Landscape decorations (Veronese), 95-6 Landscape drawing (Leonardo da Vinci), pl. 57 Landscape with Orpheus and Eurydice (Abate), pl. 59 Landscape with Rainbow (Rubens), pl. IV Landscape with the Roman Road (Poussin), 130n. Landucci, 93 Leader, B. W. pl. 99, 170 Leaping Horse, sketch for the (Constable), pl. 88 Leonardo da Vinci, pl. 57, 80, 87–93, 229, 239 Light and Colour (Turner), pl. 105, 190 Limbourg, de, brothers, pl. 16, 19n., 22, 56 Limbourg, Pol de, 22, 29 Lippi, Filippino, 176 Livre de Chasse (Gaston Phébus), pl. 15, 21 Livre du Coeur d'Amours Épris, 87 Lomazzo, Giovanni Paolo, 109 Lorenzetti, Ambrogio, 9 Lorenzetti, the, 8, 9 Lot and his Daughters (school of van Leyden), pl. 54 Lotto, Lorenzo, pl. 52, 84 Lower Norwood (Pissarro), pl. 99 Lucas van Leyden, pl. 50, 78 Luce, Maximilien, 215

Machiavelli, 93
Madonna (Leonardo da Vinci), 87
Magnasco, Alessandro, 96, 105
Maiden's Dream (Lotto), 84
Maison du Pendu (Cézanne), 218
Maitre de Flemalle, 39
Malvern Hall (Constable), 147
Manet, Édouard, 172, 176, 212
Mannerism, 93–107
Mantegna, Andrea, 49, pl. 56, 87
Marcantonio, 80
Marchand, Jean, 223
Marine Biology (Underhill), pl. 124

Marinetti, Signor, 238 Martinique Landscape (Gauguin), pl. 121 Martyrdom of St. Sebastian (Pollaiuolo), pl. 30, 47, 53 Massacre of Skios (Delacroix), 154 Massacre of the Innocents (Breughel), 57 Mediaeval art, 3-31 Memlinc, Hans, 48 Metsu, Gabriel, 64 Michallon, A. E. 157 Michelangelo, 54, 138 Mieris, Frans van, 59 Mill, The (Rembrandt), 60 Millet, Francisque, pl. 85, 138, 198 Milton, John, 135 Miniatures, 16, 33-5 Miraculous Draught of Fishes (Witz), pl. 26, 39 Misanthrope (Breughel), 57 Mr. and Mrs. Andrewes (Gainsborough), pl. II, 67 Modern Painters, viii, 49-53, 186, 230 Mola, Pierfrancesco, 96 Mona Lisa (Leonardo da Vinci), 92 Monaco, Lorenzo, 21, 87 Mondrian, Piet, pl. 123, 237 Monet, Claude, pl. VII, pl. 100, pl. 101, pl. 104, 167-77, 179, 205, 212, 226 Mont-Sainte-Victoire (Cézanne), pl. VIII, pl. 119, pl. 120 Montefeltro portrait, reverse of (Piero della Francesca), pl. 32, pl. 33 Moore, George, 212 Morning (Claude), 128 Moser, Lucas, 103 Moulin de la Galette (Renoir), 212 Mount Sinai (El Greco), pl. 63 Mountains at L'Estaque (Cézanne), pl. 119 Mur d'Enceinte (Cézanne), 219 Museum art, 231-5

Nativity (Baldovinetti), 44 Nativity (Campin), pl. 24, 39 Nieuwerkerke, Count of, 164–5, 178 Night scene for Luminalia (Inigo Jones), pl. 66

INDEX

Noli me Tangere (Titian), 118 Norham Castle (Turner), pl. 107, 194

Occupations of the Months, pl. 19 Odysseus series, 1, 95n. Old Town Hall, Amsterdam (Saenredam), pl. 42,67 Orcagna, 8 Orpheus and Eurydice (after Giorgione), pl. 50, pl. 59 Ovid, 109

Pacioli, Luca, 43 Palazzo Colonna frescoes (Gaspard Poussin), 138 Palmer, Samuel, pl. 86, 139-43 Paolo, Giovanni di, pl. 14, 17, 87 Paradise Garden, pl. 16, 16-17, 112 Paradoxa, 53 Patenier, Joachim, 21, pl. 36, pl. 51, 54, 55-6,78 Pater, Walter, 114, 116 Paul Veronese, 54, pl. 61, 95-6 Peace, Burial at Sea (Turner), 194 Perspective, 43-7, 130 Perugino, Pietro, 47 Petrarch, 8n., 9–10, 17–18, 21 Phébus, Gaston, pl. 15, 21 Philemon and Baucis (Rubens), pl. 62, 100, Photography, 170-2, 231 Picasso, Pablo, 233-7 Piero della Francesca, pl. 32, pl. 33, 43, 44n., 47, 53, 73, 209, 210 Piero di Cosimo, pl. 49, 77 Pisanello, 27 Pissarro, Camille, pl. 99, pl. 113, 138, 168-73, 205, 208, 212, 218, 224-6 Plato, 238 Pollaiuolo, Antonio, pl. 30, pl. 31, 44, 47,53,59 Pondin a Wood (Dürer), pl. 29 Pont de Courbevoie (Seurat), pl. 116, Portinari altarpiece (van der Goes),

Poussin, Gaspard, pl. 84, 138 Poussin, Nicolas, 21n., pl. 79, pl. 80, pl. 81, pl. 82, pl. 83, 122, 128–38, 145, 154, 170, 190, 205, 209, 219, 222

Quais, Les (Cézanne), 216 Quais Marchands à Rouen (Corot), 158 Quarry, The (Daubigny), pl. 98

Rain, Steam, Speed (Turner), pl. 103, 187 Rape of Dejanira (Pollaiuolo), pl. 31, 47 Rape of the Sabines (Poussin), 130n. Raphael, 53, 54, 80n., 138 Raphael's Dream (Giorgione), 80 Ravine (van Gogh), 200 Rembrandt, pl. 39, 59–61, 103, 138 Renaissance art, 109 et seq. Reni, Guido, 56 Renoir, P. A. 172-6, 179, 226 Rest in the Flight into Egypt (Patenier), pl. 36, 55-6 Resurrection (Bellini), pl. 34, 53, 130 Richmond Terrace (Canaletto), pl. 45 Road near Albano (Gaspard Poussin), pl. 84 Robaut (Corot), 157n. Romano, Giulio, pl. 59 Rosa, Salvator, 56, 103n., 105-7 Rousseau, Le Douanier, 3, 233-5 Rousseau, Théodore, pl. 91, 138, 154 Rout of San Romano (Uccello), 206n., 212 Rubens, Peter Paul, pl. IV, 61, pl. 62, pl. 67, 100-5, 150, 198n. Ruskin, John, viii, 49-53, 138, 182, 186, 194, 198 Ruisdael, Jacob van, 35, pl. 40, 59, 64, Rysselberghe, Théo van, 215

Sacred and Profane Love (Titian), pl. 73, 118
Saenredam, Pieter, pl. 42, 64–5
St. André-du-Morvan (Corot), pl. 94
St. Anne (Leonardo da Vinci), pl. 58, 92
St. Anthony Preaching to the Fishes (Paul Veronese), pl. 61, 96
St. Barbara (van Eyck), pl. 23, 35, 39
St. Eustace (Pisanello), 27

pl. 25, 39, 57